MW01130850

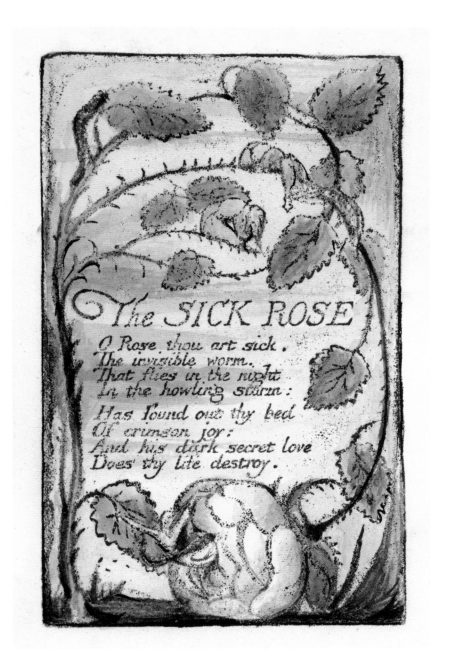

The SICK ROSE

O Rose thou art sick.
The invisible worm.
That flies in the night
In the howling storm:

Has found out thy bed
Of crimson joy:
And his dark secret love
Does thy life destroy.

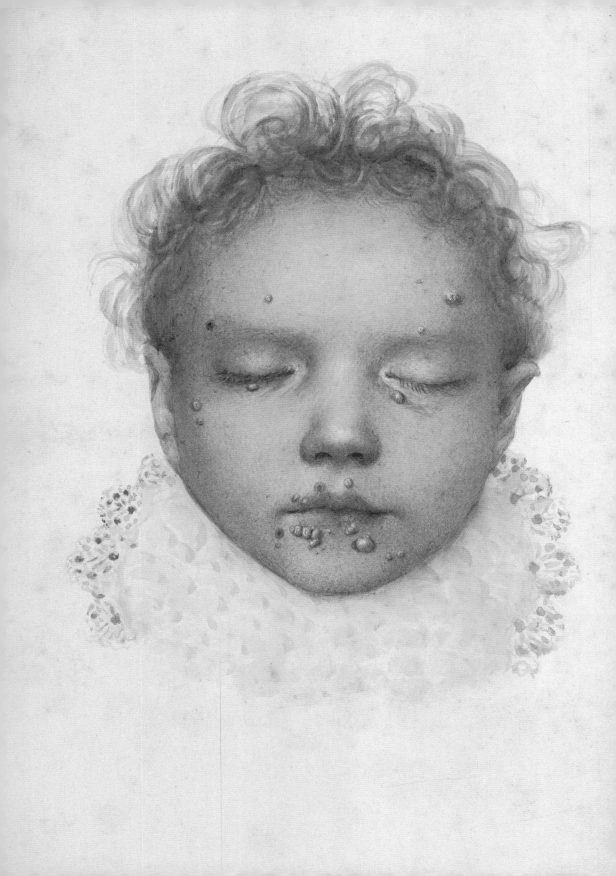

THE

SICK ROSE

or;

DISEASE AND THE ART OF
MEDICAL ILLUSTRATION

RICHARD BARNETT

354 ILLUSTRATIONS, 345 IN COLOR

d·a·p

TO ALEX BARNETT

COVER | A Viennese woman depicted during the latter stages
of cholera in the first European epidemic in 1831. | BACK COVER
Profile view of the face of a male patient, showing small pustules
characteristic of secondary syphilis. | PAGE 1 | William Blake,
'The Sick Rose', plate 48 from *Songs of Innocence and of Experience*
*c.*1789–94. | PAGE 2 | The head of a child with blisters and other
lesions affecting the skin. | OPPOSITE | Patients suffering from
a range of skin diseases, some mild, some extremely disfiguring,
from a French dermatological atlas published in 1806. | PAGES 6–7
Two views of torsos, showing skin lesions below the level of the
umbilicus. | PAGES 8–9 | The heads of two patients: a woman
suffering from severe impetigo on her nose, cheeks and chin,
and a man suffering from sycosis, an inflammation of the follicles.
PAGES 10–11 | The hands of a patient, showing paronychia, an
infection of the nails associated with tertiary syphilis. | PAGES
12–13 | Dissections of a throat, tongue, liver and lung. | PAGES
14–15 | A left foot, showing severe eczema. | PAGES 16–17
The back, torso and thighs of a patient suffering from congenital
syphilis, showing severe rupia and 'syphilitic psoriasis'.

Published and distributed in North America by
arrangment with Thames & Hudson Ltd., London

D.A.P./Distributed Art Publishers, Inc.
155 6th Avenue, 2nd Floor
New York, NY 10013
artbook.com

The Sick Rose © 2014 Thames & Hudson Ltd, London
Design by Daniel Streat at Barnbrook

This book is published in partnership with Wellcome Collection
and the Wellcome Library, part of the Wellcome Trust,
215 Euston Road, London NW1 2BE.

**wellcome
collection**

www.wellcomecollection.org

Wellcome Collection is part of the Wellcome Trust, a global
charitable foundation dedicated to achieving extraordinary
achievements in human and animal health. The Wellcome
Trust is a charity registered in England and Wales, no. 210183.

All the images reproduced in this book are reproduced courtesy
of the Wellcome Library, except where stated. For further
information about individual images, see pages 248–51.

A CIP record for this book is available from the Library of Congress

ISBN 978-1-938922-40-4

Printed and bound in China by Toppan Leefung Printing Limited.

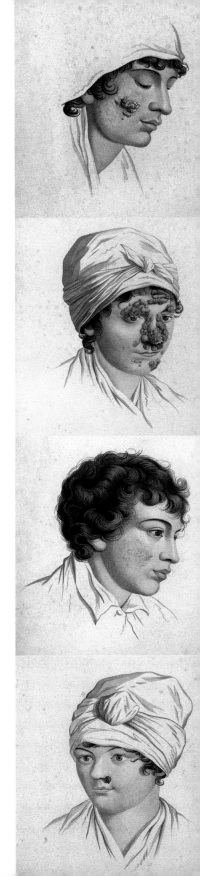

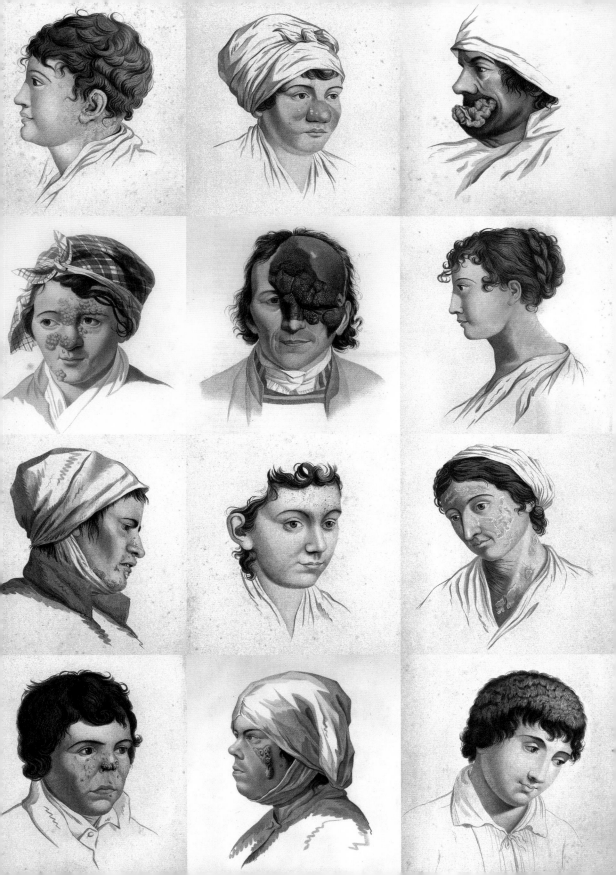

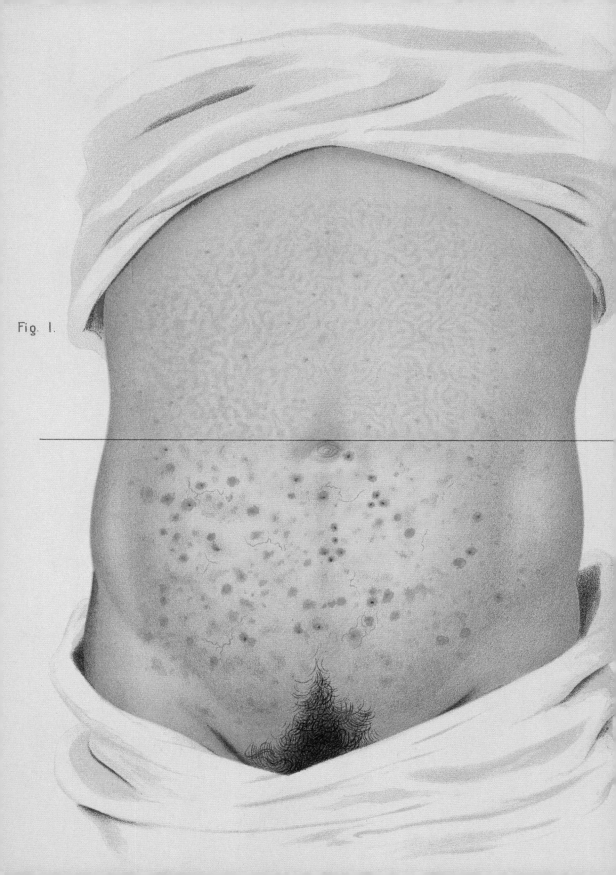

Fig. I.

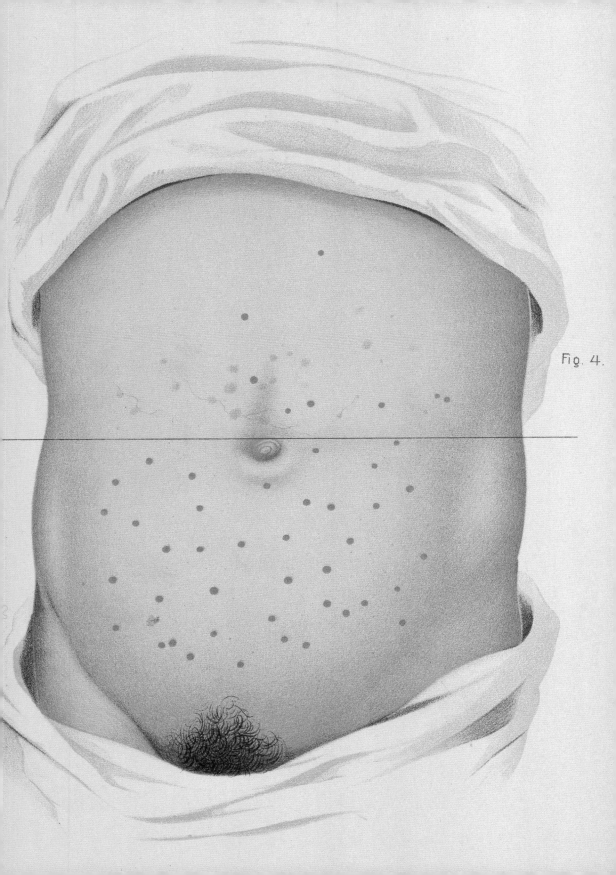

Fig. 4.

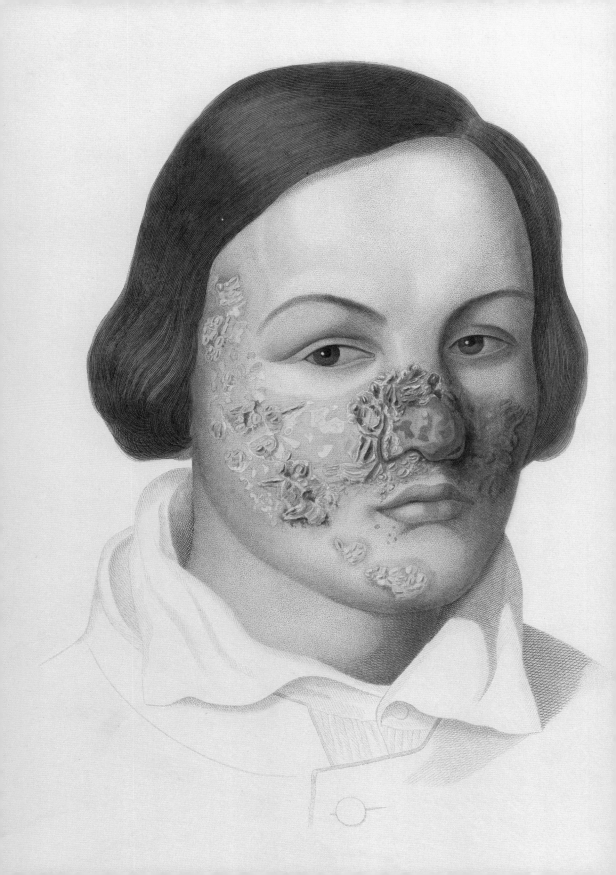

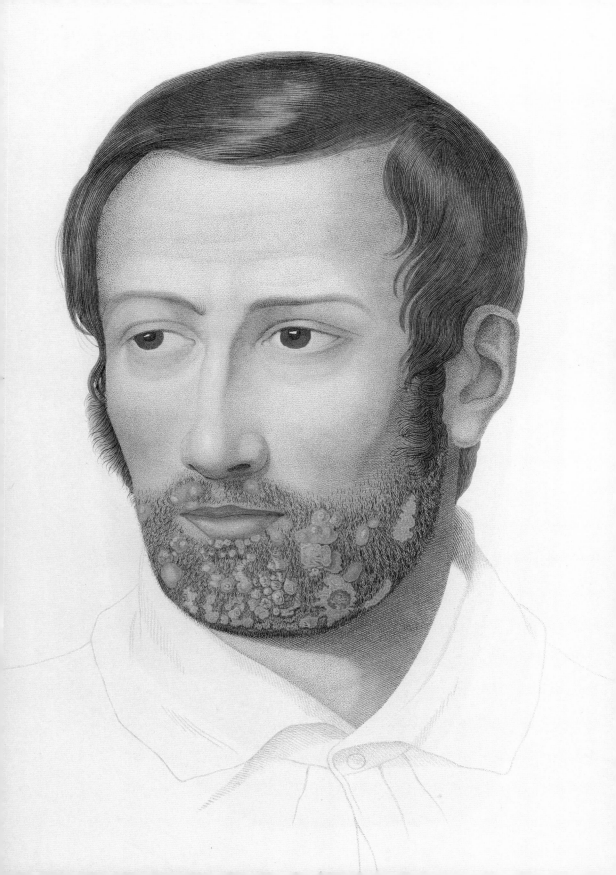

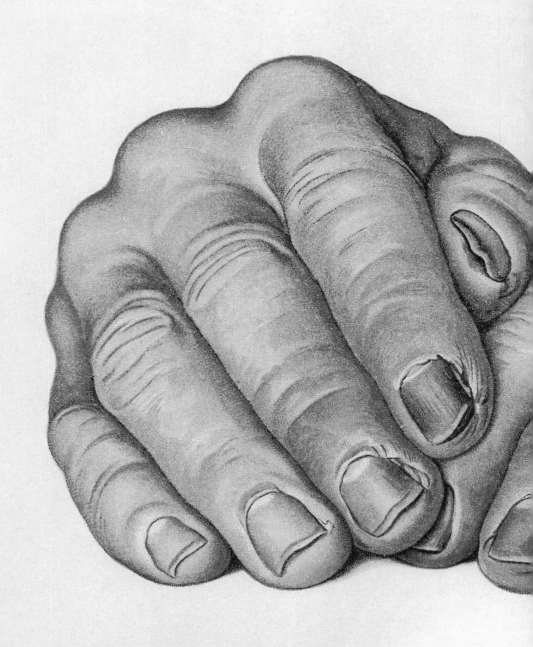

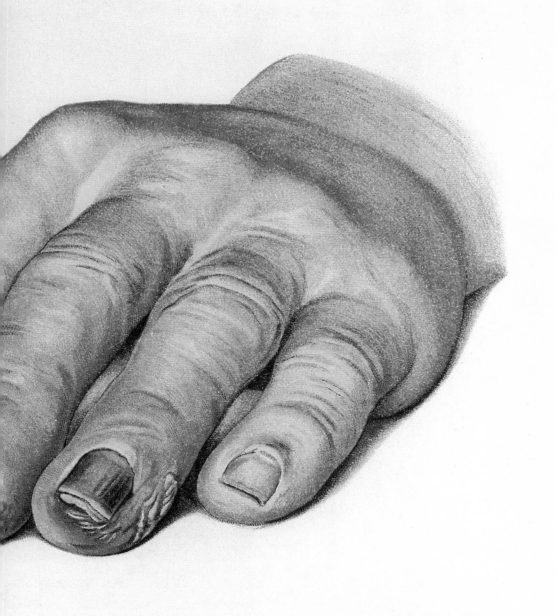

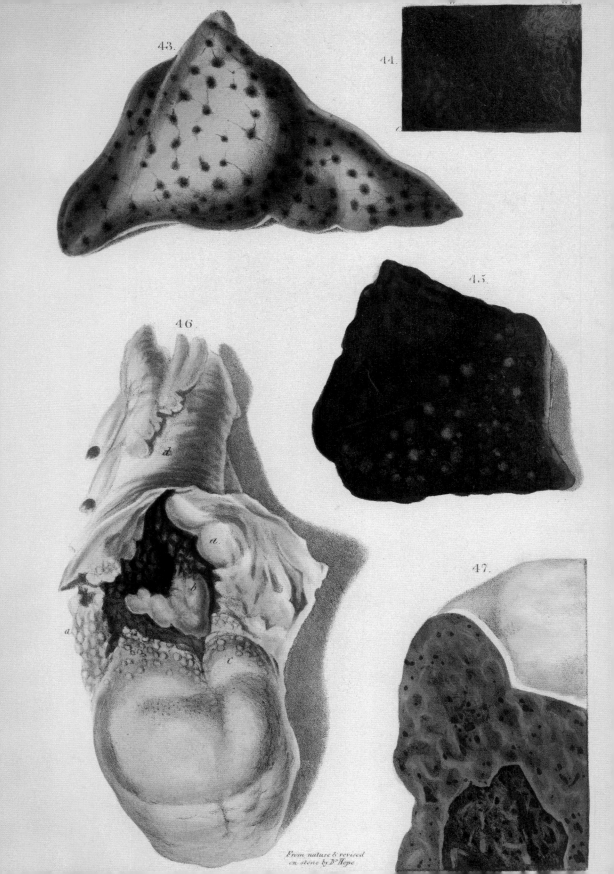

From nature & revised
on stone by Dr Hope

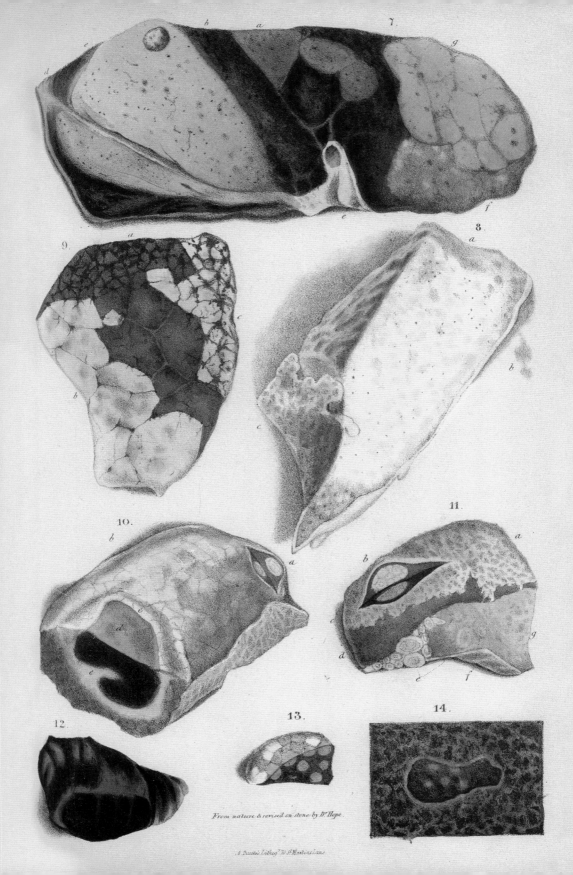

From nature & revised on stone by D.r Hope.

J. Basire's Lithog.y 70 S.t Martins Lane.

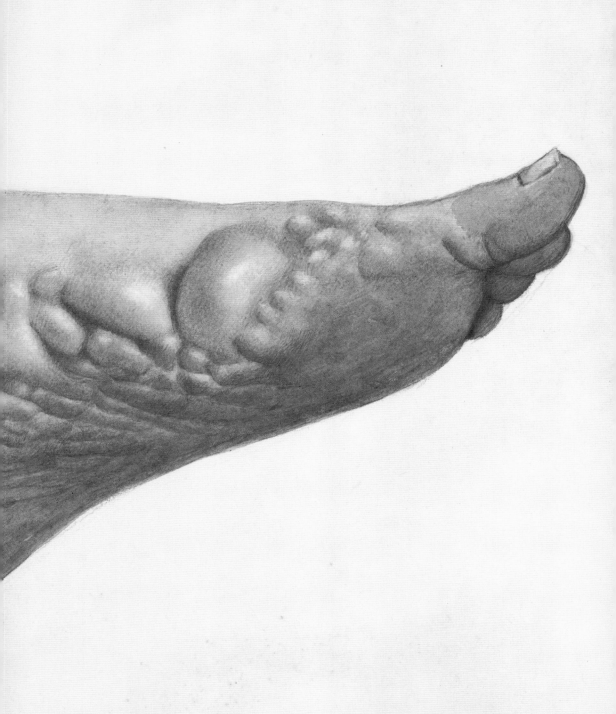

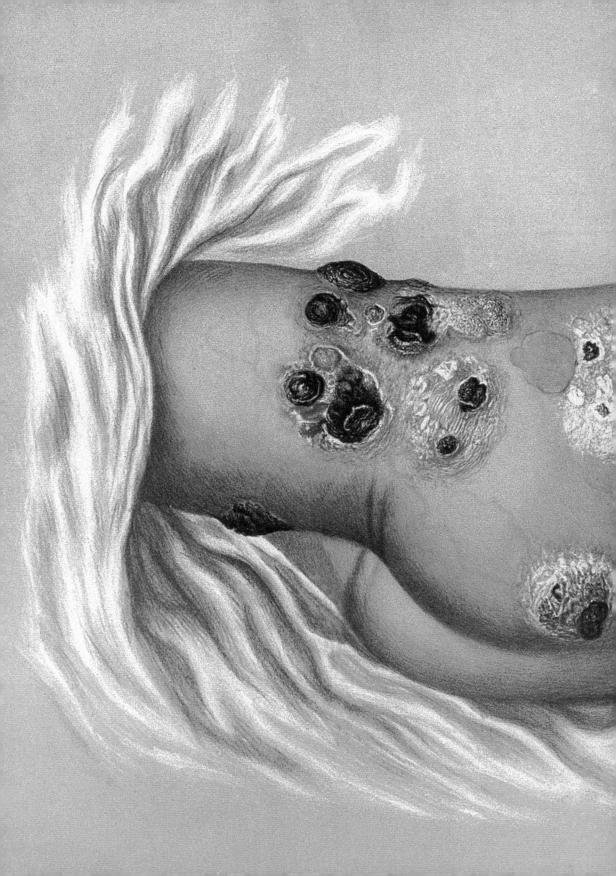

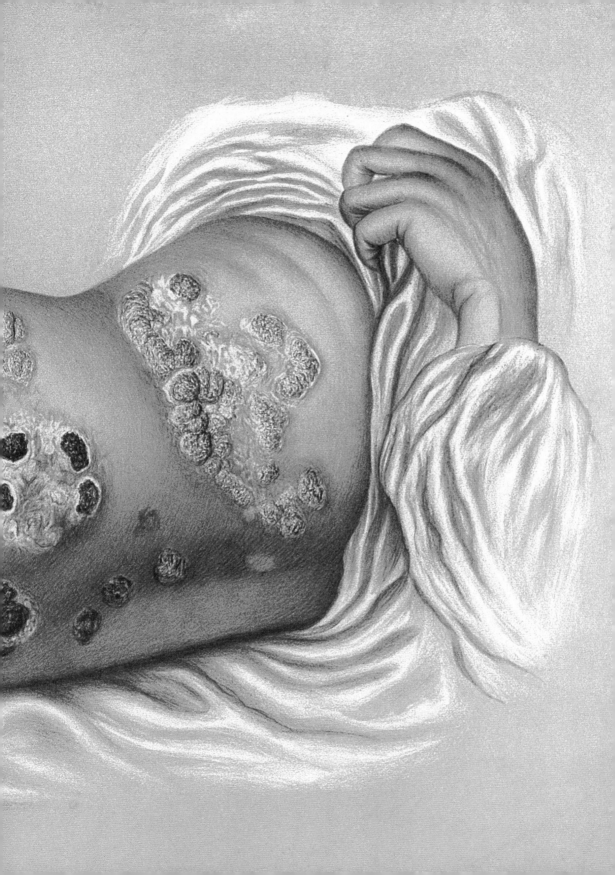

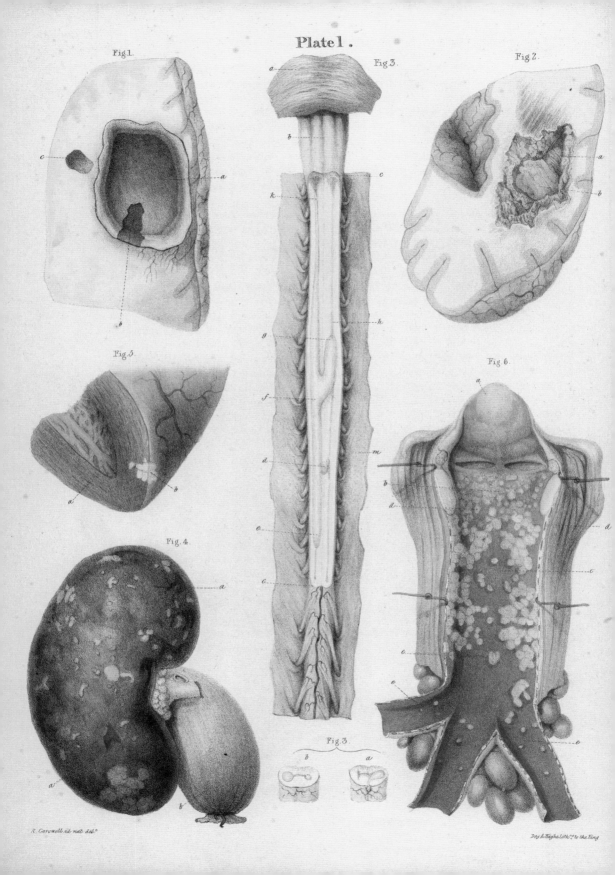

Plate 1.

Fig 1.

Fig 3.

Fig 2.

Fig 5.

Fig 6.

Fig 4.

Fig 3.

R. Carswell ad nat. delt.

Day & Haghe Lith. rs to the King

CONTENTS

OPPOSITE | Various pathological processes and infections thought to result in the accumulation or release of pus.

DISENCHANTED FLESH

MEDICINE AND ART IN AN AGE OF REVOLUTION

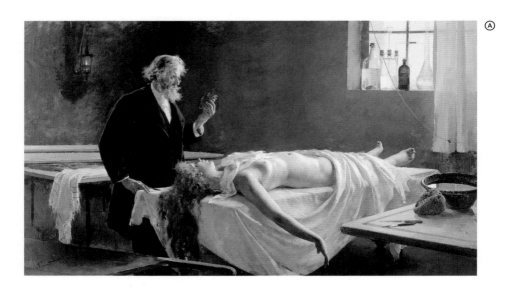

The English essayist William Hazlitt died in poverty in 1830, just as European physicians were beginning to experiment with the first achromatic microscopes, and a few years after the French inventor Nicéphore Niépce had made the first permanent photo-etching. As a young man Hazlitt had trained as a painter, and in his writings – still some of the finest prose in the language – he returned again and again to the question of truth in representation. How should an artist depict the flesh and the soul, and what thoughts and feelings should such a depiction evoke? In 'On Imitation', published in *The Examiner* in 1817, he turned his own penetrating gaze to the subject of anatomical illustration:

> 'THE ANATOMIST IS DELIGHTED WITH A COLOURED PLATE, CONVEYING THE EXACT APPEARANCE OF THE PROGRESS OF CERTAIN DISEASES, OR OF THE INTERNAL PARTS AND DISSECTIONS OF THE HUMAN BODY. WE HAVE KNOWN A JENNERIAN PROFESSOR AS MUCH ENRAPTURED WITH A DELINEATION OF THE DIFFERENT STAGES OF VACCINATION, AS A FLORIST WITH A BED OF TULIPS, OR AN AUCTIONEER WITH A COLLECTION OF INDIAN SHELLS.... THE LEARNED AMATEUR IS STRUCK WITH THE BEAUTY OF THE COATS OF THE STOMACH LAID BARE, OR CONTEMPLATES WITH EAGER CURIOSITY THE TRANSVERSE SECTION OF THE BRAIN...AND OVERCOMES THE SENSE OF PAIN AND REPUGNANCE, WHICH IS THE ONLY FEELING THAT THE SIGHT OF A DEAD AND MANGLED BODY PRESENTS TO ORDINARY MEN. IT IS THE SAME IN ART AS IN SCIENCE.'

But how should we understand this tension between 'the beauty of the coats of the stomach' and 'the sight of a dead and mangled body'? Should we seek to resolve or 'overcome' it, or should we practise what Hazlitt's admirer, the medical-student-turned-poet John Keats, called *negative capability* – the capacity to be 'in uncertainties, mysteries, doubts, without any irritable reaching after fact and reason'?

The images in this volume embody one kind of answer to this question. This book is about a revolution in the ways that Western medical practitioners have seen the human body, and the ways in which they have known disease. In the hundred years or so in which these images were made – from the last decade of the eighteenth century to the first decade of the twentieth – Western medicine began a conversation with modernity in many forms: science, technology, industrial society, urban life, mechanized warfare, the long shadow of imperialism. In doing so it decisively abandoned an ancient consensus about the structure of the body and the meaning of disease.

For elite Classical, Renaissance and Enlightenment medicine, health was a balanced constitution composed of four humours. A surfeit or insufficiency of blood, black bile, yellow bile, or phlegm lay at the root of all diseases. Physicians – learned, humane, attuned to all the failings of the flesh – would negotiate a diagnosis and a course of treatment with their genteel or aristocratic patient-masters. Surgeons, the carpenters of the body, would be on hand to carry out messy and painful physical interventions. Blood might be let, bile might be purged, a change of air or diet might be advised, but most of all physician and patient would watch and wait. Interrupting the natural course of a disease, trying to outstrip the body's own powers of healing, might itself be fatal.

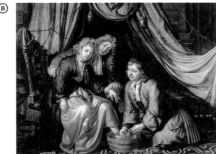

A little more than a century later, on the eve of World War I, medicine was for most (though not all) of its practitioners no longer a learned art. Physicians and surgeons had signed up to an uneasy covenant with the new sciences of physiology and bacteriology. In learning the disciplines of the laboratory and the microscope they entered a strange, compelling world, one in which localized physical lesions or invasions of bacteria disrupted tissues composed of cells. To borrow a word from the sociologist Max Weber, this new world was founded in a vision of the body 'disenchanted'. No timeless mysteries, only temporary ignorance; no vital force or soul, only an endless dance of enzymes and substrates. In a century obsessed with, even haunted by the possibility of progress, the practitioners of scientific medicine offered themselves as the shock troops of the future perfect.

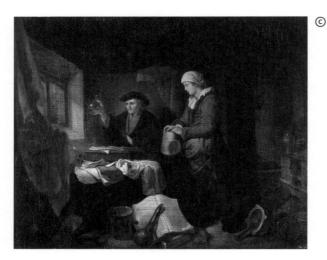
©

This book follows a single strand of the Western medical tradition – illustration of the diseased human body – through this jarring encounter with modernity. Like their prede-cessors, nineteenth-century physicians, surgeons and anatomists built close relationships with artists, craftsmen and publishers. The images that emerged from these collaborations are beautiful and morbid, sublime and singular. They are icons of a certain kind of clinical objectivity, but their aura of objectivity is the result of countless human interventions, conscious and unconscious. They give us, so to speak, the outside of the inside; they are insistently concerned with surfaces, but surfaces that in life and health are never seen.

These images can seem to epitomize progress in a century of light, but they also carry an ineradicable whiff of the morgue, of the exercise of state power over paupers and criminals, of the body violated, of nakedness revealed. They are founded in the practices of dissection, and they are parasitic upon the dead, sometimes the body-snatched or executed. They present an uncanny spectacle of the dead body articulated: not only prepared and mounted for display, but also made to speak (in a voice that is not wholly their own). Most of all they instantiate a revolutionary concept of clinical authority – one rooted in the dead patient's body rather than the living patient's voice.

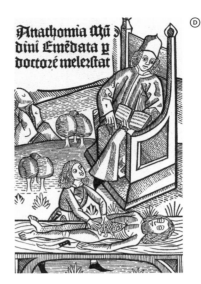

Anathomia Mū dini Emēdata p doctozē melerstat

THE THEATRE OF ANATOMY

At some point in the late thirteenth or early fourteenth century, in the school of arts and medicine at the University of Bologna, anatomists began to open up dead human bodies before an audience of scholars. They worked, metaphorically speaking, with a knife in one hand and a treatise in the other. This resurgence of systematic anatomy ran in parallel with the translation of anatomical texts by the Roman physician and surgeon Claudius Galen. Appropriately enough for a movement that mingled Classical philosophy with Catholic theology, Renaissance anatomy drew inspiration from three axioms, two pagan and one Christian. The Book of Genesis taught that man was created in the image of God; the Greek philosopher Protagoras maintained that man was the measure of all things; and a Classical proverb urged all men to 'know thyself'. Galen's re-workings of Hippocratic humoral theory were taken up in texts like the influential *Anathomia corporis humani* (1316) by the Bolognan anatomist Mondino de'Luzzi, and for more than four centuries they served as the theoretical backbone of Western medical thought.

For a later generation, notably the Brussels-born peripatetic Andreas Vesalius, Galen's injunction that all anatomists should make their own observations led them to challenge his own descriptions of human anatomy (which seem to have been taken from studies of apes and pigs). In his *De Humani Corporis Fabrica* (1543) Vesalius depicted his own dissections of executed criminals in Padua and Bologna, crafting what he saw as a heavily corrected and far more detailed revision of Galen's anatomical morphology. Over the next century, anatomists such as the Italian Hieronymus Fabricius and his English pupil William Harvey overturned many more of Galen's precepts – most famously Harvey's demonstration in *De Motu Cordis* (1628) that blood was not made in the liver, but pumped around the body by the heart.

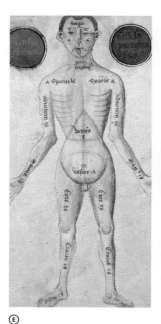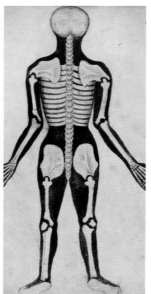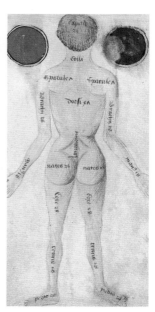

Ⓔ

Though the broad principles of Hippocratic humoralism continued to dominate medical thought, seventeenth-century natural philosophers began to undermine Classically-derived notions about the deep structure of the body and its place in the order of things. In different ways René Descartes, Thomas Hobbes and Isaac Newton each recast the universe as a space in which matter moved and interacted according to universal laws. The fundamental components of life might not be humours but particles, and the body might be refigured materialistically as a machine, a matrix of pipes, pumps and levers. In a mechanistic cosmos physicians and surgeons were more like clockmakers or mechanics, repairing broken joints and replacing worn-out cogs.

This medical materialism chimed with wider currents in Western culture, usually drawn together under the rubric of the Enlightenment. The ideology of the Enlightenment, set out in works by writers such as John Locke, David Hume and the Marquis de Condorcet, was threefold. It was rational, seeking to place learning, society and government on a sound footing of reason. It was empirical, making and testing knowledge through observation and the senses, rather than mere theorizing. And it was genteel, proposing education and conversation, rather than repression and violence, as the tools for running societies. Most of all, it raised the tantalizing possibility that people and cultures could progress, enjoying more freedoms, better health and longer lives. This stirring rhetoric must be set against the harsher and more compromised realities of eighteenth-century culture and politics, not least the continuing European involvement in slavery. But anatomy, surgery and medicine became tied up with politics and philosophy, in the construction of a new 'science of man' as the basis for an enlightened society.

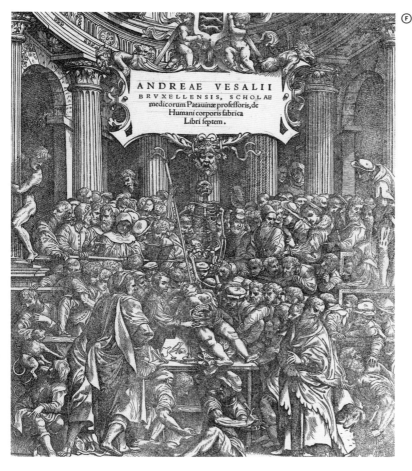

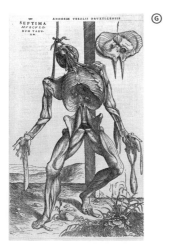

Under these influences medicine began to move away from the humoral holism of Hippocratic thought, coming instead to see disease as a form of specific physical wear and tear. Texts like Giovanni Morgagni's *De Sedibus et Causis Morborum* (1761) and Matthew Baillie's *The Morbid Anatomy of Some of the Most Important Parts of the Body* (1793) leavened the tradition of observational anatomy with an emphasis on classifying the pathologies that characterized different tissues. Morbid anatomy made the dead body speak – and nowhere more clearly than in the hospitals and morgues of revolutionary Paris.

THE BRIGHTNESS OF DEATH

'YOU MAY TAKE NOTES FOR TWENTY YEARS, FROM MORNING TO NIGHT AT THE BEDSIDE OF THE SICK…AND ALL WILL BE TO YOU ONLY A CONFUSION OF SYMPTOMS, WHICH, NOT BEING UNITED IN ONE POINT, WILL NECESSARILY PRESENT ONLY A TRAIN OF INCOHERENT PHENOMENA. OPEN UP A FEW BODIES; THIS OBSCURITY WILL SOON DISAPPEAR, WHICH OBSERVATION ALONE WOULD NEVER HAVE BEEN ABLE TO DISSIPATE.'

These sentences, from the Parisian anatomist Marie-François-Xavier Bichat's *Anatomie générale appliquée à la physiologie à la medicine* (1801), have become a kind of retrospective manifesto for what historians have come to call 'Paris medicine'. Forged in the newly secular-ized city hospitals of the French Revolution, Paris medicine made pathological anatomy the

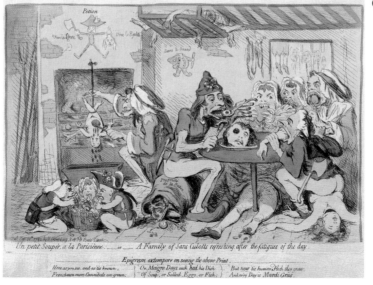

Ⓗ

foundation of medical thought, education and practice. Citizen-physicians and citizen-surgeons studied together in these hospitals, as self-consciously radical as the *sans-culottes* on the streets outside. The images they made seem to echo the English satirist James Gillray's disturbingly corporeal caricatures of French revolutionaries – another band of radicals with designs on the body politic.

Elite physicians from the Renaissance to the Enlightenment had based their diagnoses on the concerns and complaints of wealthy patients, for whom physical examination would have been an unwarranted intrusion by a social inferior. Bichat mocked these medical servants, sitting patiently at the bedsides of the wealthy and listening to stories of sickness. In large urban hospitals, crammed with the sick, voiceless poor, his students could diagnose and dissect on a near-industrial scale, learning to correlate symptoms in life with lesions in death. These lesions were (at least in principle) amenable to surgical intervention in ways that generalized humoral imbalances were not, and the clinical gaze of Paris medicine gave fresh prominence to surgeons and their craft. New instruments like the stethoscope, new techniques for recording symptoms like the fever chart, new statistics compiled from thousands of standardized case records – all these were used to visualize disease within the patient's body and distinct from the patient's voice. Through the nineteenth century the idea of Paris medicine as an origin myth was made to serve many different ends. American physicians, for example, took it up partly as a means of distancing themselves from British medicine in the aftermath of the War of Independence. But disparate groups of practitioners across Europe, the United States and their colonies could endorse

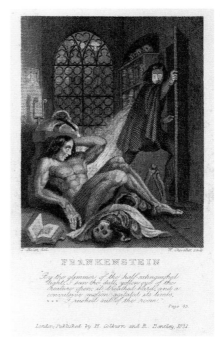

FRANKENSTEIN

By the glimmer of the half-extinguished light, I saw the dull, yellow eye of the creature open; it breathed hard, and a convulsive motion agitated its limbs.
. . . I rushed out of the room!
Page 43.

London, Published by H. Colburn and R. Bentley, 1831.

the rhetoric of this shared enterprise, creating – to use Benedict Anderson's phrase – an 'imagined community' of professionals around the notion of a new, materialist scientific medicine [1].

Practically, as a corpus of thought and technique, and symbolically, as an emblem of modernity, Paris medicine was the single greatest intellectual force acting on the Western medical tradition in the nineteenth century. Under its influence physicians and surgeons could conceive of the body not as a unified whole but as a collage of tissues. Indeed one might, following Laurence Talairach-Vielmas, see the monster in Mary Shelley's *Frankenstein* (1818) as a living display of anatomical specimens, skilfully articulated and tragically articulate [2]. Medicine, like Victor Frankenstein, was learning to dismantle the body, to subvert its integrity, even to rethink the meaning of life and death.

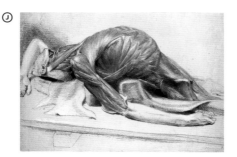

It is no coincidence that most of these depictions of health and disease were made and used in dissecting rooms, the characteristic spaces of a clinical order in the ascendant. But the mere opening up of human bodies was, in itself, no more a route to clinical expertise than was the front window of a butcher's shop. Bichat's radical empiricism went along with a pervasive concern for what might be called the disciplining of observation. Atlases of anatomy and pathology were central to the enterprise of collective empiricism that Lorraine Daston and Peter Galison have seen at work across European science and medicine in the eighteenth and nineteenth centuries.

These books could be used to teach a shared 'disciplinary gaze', through which 'the mastery of scientific practices' was linked to 'the assiduous cultivation of a certain kind of self' [3]. For the leaders of the medical profession in the nineteenth century dissection was as much a rite of passage, a moral and sentimental education, as a tool of clinical instruction. Experience of the dead body was, they argued, central to the formation of medical and surgical character. A good doctor was detached and analytical, thoughtful and reflective, aware of (though never overwhelmed by) the enormous responsibilities and privileges of the profession. Conversely, even the most detailed anatomical knowledge was useless if its possessor panicked or fainted, if they were too nervous to hold a knife or too bloodthirsty to stop cutting. Dissection moulded the bodies of dissectors, making clear eyes and fine fingers, a sharp brain, a stout heart and – most of all – a strong stomach. Images of the human body in health and disease – or rather the use of these images while teaching and in practice – built a community of clinicians with shared

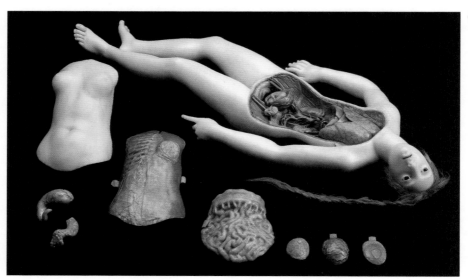

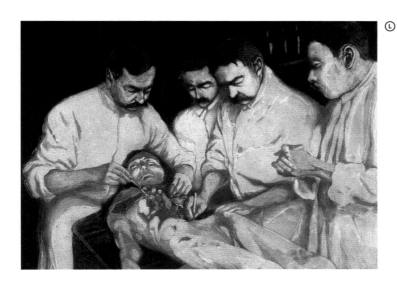

skills, principles and values, who could observe their patients' bodies in the same consistent and coherent manner.

And the books in which these images appeared were changing. Eighteenth-century anatomical works tended to be grand affairs: oversized and exquisitely bound, printed on fine paper and published in editions of a few hundred, mostly for subscribers. But with the expansion of medical education in the early nineteenth century, publishers began to mass-produce cheap, practical textbooks for impecunious students. A valued anatomical or pathological treatise would be lugged around in a satchel and propped against a cadaver on the mortuary table. Spattered with blood, scribbled-on and dog-eared, these books were not part of the student's dress uniform, so to speak, but rather a piece of field kit – a map, perhaps, trusted and used to destruction in the bloody business at hand.

These books, and their illustrations, can be read as a rich microcosm of Daston and Galison's concept of collective empiricism. They are the fruit of a sophisticated collaboration between anatomists and artists, engravers and printers, publishers, professors, teachers and students – not forgetting the bodies of the dead. For attentive readers like William Hazlitt they raised intriguing questions about the nature of medical knowledge. How did illustrations of the human body inform (and perhaps determine) what a student or an anatomist might actually see on the operating table or in the morgue? What aesthetic and cultural values were inscribed in these images, and by whom? And – one of the oldest questions in Western art – how could a picture come to seem more truthful, more eloquent, than a real human body?

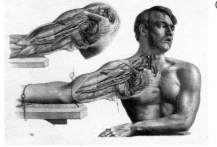

HEADS, HANDS AND EYES

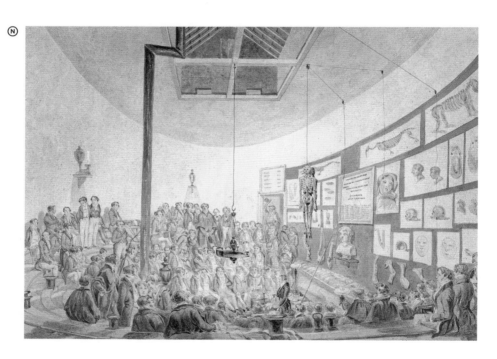

The pursuit of anatomical reality, with the naked eye or a lens, a scalpel or a pen, has never been straightforward. Turning a person into a thing – a cadaver on a dissecting table, a specimen in a jar, an illustration in a textbook – demands labour, and not merely the physical skills of cutting and mounting, preserving and engraving. It requires the intellectual labour of reducing confusion and imperfection to comprehensible order, and the cultural labour of bridging contentious boundaries between life and death, personhood and object, speech and silence. The objects and images that result from these effortful transformations are always hybrids – literally, in that they combine bone and metal, tissue and paper, blood and ink, but also metaphorically, in that they show the once-living body transformed by craft, context and theory, a confluence of art and anatomy.

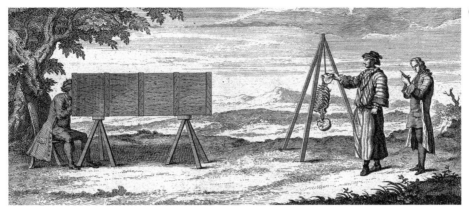

From the eighteenth to the mid-twentieth century most European academies of art had professors of anatomy on their staff. William Hunter, for example, taught at Joshua Reynolds's Royal Academy in London from 1768 until his death in 1783. The lecture rooms of less exalted schools might have a skeleton dangling from a rope, alongside a muscular écorché – a cast in plaster or bronze of a flayed human body, usually set in a classical pose. Painters could point to their own tradition of anatomical enquiry reaching back to Leonardo and Michelangelo, and in works like George Stubbs's *The Anatomy of the Horse* (1766) they pursued comparative anatomy with as much vigour as Hunter. Anatomists and artists shared a common concern with the human body, its form and movement, and the question of how to represent this convincingly in two dimensions.

Making medical images was, then, a fundamentally collaborative business, requiring many distinct and complementary kinds of expertise. A physician or surgeon or anatomist would decide what aspect of anatomy or pathology was to be addressed. He would secure a supply of bodies or body parts and a private space in which to dissect them, and prepare specimens for illustration.

A draughtsman would make detailed drawings, noting colours and textures, and an engraver would cut woodblocks or copper plates, as mirror images of the final illustrations. A compositor would lay out the text and images, a printer and binder would make the book, and a publisher would underwrite production and sell the finished volume.

These collaborators occupied a curiously equivocal position; they were not quite, perhaps, the invisible technicians in Steven Shapin's studies of early modern natural philosophy, but for the most part they were certainly not given equal status or credit [4]. So when anatomists claimed authorship of these texts, when they put their names on the title page of a book containing the contributions of many artists and craftsmen, what precisely were they asserting? Their skill as dissectors, certainly; perhaps more importantly, the anatomical or pathological knowledge they had gained through dissection, and were now setting down in a book. But in order to make this claim, and to make it persuasively, they had also to assert control and, tacitly, acknowledge its difficulty. How could the impression of an objective clinical gaze be sustained when it had passed through several fallible pairs of eyes and hands?

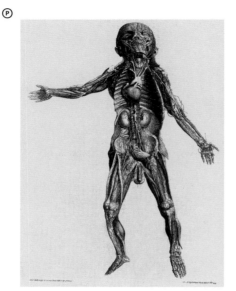

One solution to this conundrum was to give artists a clinical gaze of their own. In preparing his *Icones Anatomicae* (1752) the Göttingen anatomist Albrecht von Haller made more than fifty dissections of particular anatomical regions, in an effort to show his draughtsmen precisely what was typical and what atypical. Haller was drawing on a classic Enlightenment ideology – expressed most vividly in the taxonomic atlases of the Swedish naturalist Carl Linnaeus – in which the particular, accidental features of individual specimens were discarded by illustrators in order to reveal the underlying ideal forms of organs, leaves or rocks. Others experimented with mechanical styles of objectivity, like the camera obscura used by the Dutch artists van der Gucht and Shinevoet to make drawings for the English anatomist William Cheselden's *Osteographia* (1733). Cheselden, though, was not convinced that the camera obscura captured an acceptable version of anatomical truth. He carefully corrected the tracings, bringing them closer to his projected ideal.

For most anatomists, however, the answer was more prosaic: choose the best artists, work closely with them, and supervise their efforts at every stage. Another Dutch draughtsman, Jan van Riemsdyck, came to London in 1750 and drew for many leading anatomists, most notably William Hunter. The genesis of Hunter's masterpiece, his *Anatomy of the Human Gravid Uterus Exhibited in Figures* (1774), shows just how time-consuming this process could be. Hunter prepared dissections and wrote text for each image; Riemsdyck made sixty-one drawings, under Hunter's scrupulous eye, along with three other draughtsmen who drew one or two specimens each; sixteen engravers cut plates under the supervision of Sir Robert Strange, a Scottish artist and a friend of Hunter; and the book was printed by John Baskerville of Birmingham, an innovative printer and type designer. Hunter, too, drew on different modes of objectivity. Each of the thirty-four plates represented a particular specimen, not an idealized type, but he took pains to inject some parts with wax, giving what he saw as a more realistic shape, and he instructed his engravers to soften the sharp edges of dissected flesh.

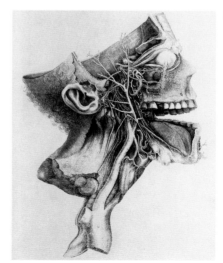

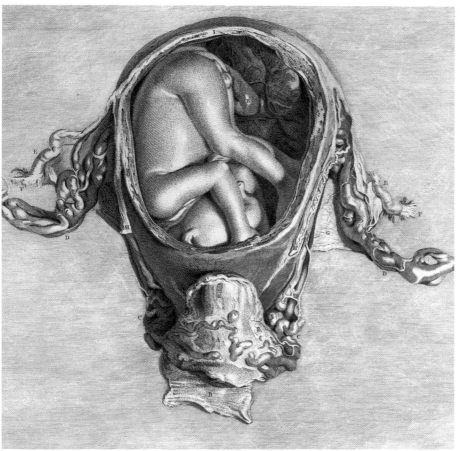

Some anatomists were able to cut this Gordian knot by making their own drawings and engravings for their texts. When he was not teaching anatomy to the painter Edwin Landseer, the Scottish artist and surgeon Charles Bell produced fine drawings and watercolours for *The Anatomy of the Brain* (1802). Even Bell, however, was no engraver, and his published images bear the (small) signature of the English craftsman Thomas Medland. And the coloured lithographs in *Pathological Anatomy* (1838) were based on sketches by its author, the physician and artist Robert Carswell – himself a talented printmaker.

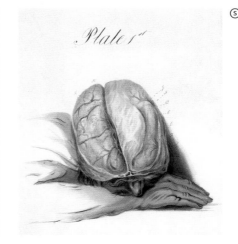

MECHANICAL EYES

Carswell's use of colour lithography, a technique developed in Germany in the late eighteenth century, and taken up for medical publishing in Paris a generation later, reflected a wider technical and artistic shift in the making of medical images. The first full-colour anatomical atlas, *Myologie*, had been published in the 1740s by the French anatomist Jacques Fabien Gautier d'Agoty, but used a separate mezzotint plate for each colour, and its illustrations were gloomy and difficult to decipher. Lithographs were lighter, clearer, more amenable to mass reproduction, and were quickly taken up in London's 'flowering of anatomical book publishing' in the first half of the nineteenth century [5].

But speaking to the Medical and Physical Society of St Thomas's Hospital in London in 1885, the artist and anatomy lecturer William Anderson argued that this flowering had come abruptly to an end. Anatomists and physicians could no longer rely on fallible human artists to represent their discoveries. Scientific and medical image-making should, like so much else in the nineteenth century, be isolated from the bias and imprecision of human craft through automation. Anderson urged his audience to endorse the impersonal, mechanical eye of the camera as the route to true objectivity.

Anderson, though, was already behind the times. Within a decade of its invention in the 1830s and 1840s some European doctors had begun to use photography in their practice, typically for recording case histories of individual patients in fracture clinics and asylums. By the late 1880s photolithography enabled the mass reproduction of photographs in books and journals; indeed, one US doctor complained in the 1890s that his colleagues had gone 'photo-mad'. But this was not a case of one clearly superior technology replacing an outdated and inferior predecessor. As a scientific medium, photography was far from perfect, and Anderson's notion of photography as a neutral, objective medium was itself flawed.

From the very first years of photography it was abundantly clear that photographs were not always truthful. Spirit photographs, along with many other stunts and hoaxes, proved that the camera could lie. Equally, however, the eyes of the viewer had to be guided, and this could not be

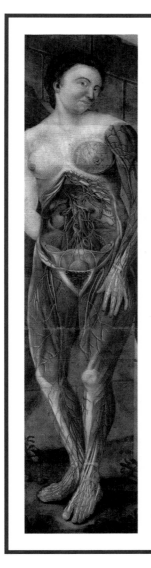 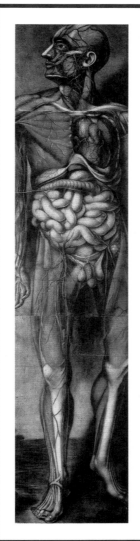 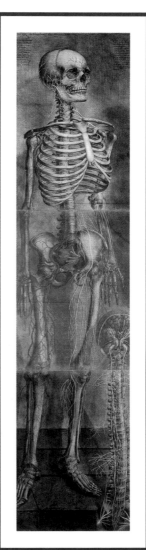

done without some degree of human intervention. In an engraving or a lithograph the artist could use shading and texture to bring out the significant parts of a specimen, while an un-retouched photograph gave near-equal emphasis to everything in its field of view. The adoption of photography reflected the changing state of science and medicine at the end of a revolutionary century; it embodied what Daston and Galison have termed the techno-scientific ethic of 'self-elimination' [6]. Photography offered a seemingly objective way of capturing what was fleeting, what might escape mere human attention, what might or might not actually be there. It pretended to permanence and in doing so alluded to mortality; the ghost of the *vanitas*, along with the rather more solid spooks faked up by fraudulent mediums, haunted the black bellows of the camera.

From the 1830s doctors and scientists had been pushing their notions of objectivity in another direction, using microscopes to take the clinical gaze of Paris medicine beyond the limits of the naked eye. The credibility of the microscope as a clinical tool was closely linked with the acceptance of cell theories of life and germ theories of infectious disease. Debates over these theories echoed centuries of argument over the truthfulness of anatomical specimens and images. How could anyone be sure that the stains and waxes used to prepare microscope slides were not distorting natural structures or introducing artefacts? And how could microscopists, gazing in isolation down the barrels of their instruments, build an international community with common rules of interpretation? Even the most illustrious international gatherings were not immune to these arguments. When the Italian Camillo Golgi and the Spanish Santiago Ramón y Cajal shared the 1906 Nobel Prize in Physiology or Medicine for their work on the fine structure of the brain, each used his acceptance speech to dismiss the other's interpretation of what they had seen down their microscope. Against this background, it becomes less surprising that one of the most influential nineteenth-century texts on human anatomy featured images in a medium that would have been familiar to Vesalius.

Why has *Gray's Anatomy* – or, more properly, *Anatomy, Descriptive and Surgical, by Henry Gray FRS* (1858) – come to symbolize medical illustration in the first age of photography? Its plain, uncoloured woodcut images are (as Benjamin Rifkin has put it) 'authoritative but utterly devoid of opinion or personality', closer in spirit to an engineering blueprint than a painterly still life ⑦. In her study of *Gray's Anatomy* Ruth Richardson observes that, for Victorian readers, woodcuts called up the avant-garde neo-medievalism of the Pre-Raphaelites. They also seem to reach forward, evoking the kind of mechanical objectivity that by the end of the century would come to be associated with scientific photography. Perhaps this is the key to their endurance: these images gesture towards past and future, while evoking so keenly the atmosphere of their own time.

Gray, a precocious young anatomist and surgeon, met his future collaborator and illustrator, the artist and surgeon-apothecary Henry Vandyke Carter, at St George's Hospital medical school in London in the late 1840s. They worked together on illustrations for Gray's prize-winning essay on the spleen, published by the London firm JW Parker & Sons in 1854. Parker had worked as University Printer in Cambridge, and in 1837 published *The House I Live In* – a children's guide to human anatomy, couched in Biblical language and explaining the body as the creation of a loving Christian god. Parker commissioned Gray and Carter to produce an anatomical textbook in 1855. With an eye to his potential readership, Gray borrowed the title from a course he taught at St George's.

The two men worked together on specimens, probably beneath the barrel-vaulted glass roof of a purpose-built dissection room at the medical school behind St George's Hospital. Carter's drawings were engraved by Butterworth & Heath, another West End firm which had produced banknotes and woodcuts for art journals, and printed by John Wertheimer a mile or two away in Finsbury Circus. Deeply impressed by Carter's work, Parker seems to have invited him to be a co-author, but the first edition bore only one name on the spine. Within three years Gray was dead, carried off by smallpox, leaving few records of his life beyond his published works. And, as Richardson has pointed out, *Gray's Anatomy* has at its heart another great silence – that of the voiceless, dissected dead.

RAW MATERIAL

Paris medicine made the bodies of the dead more eloquent than the voices of the living, but it also turned dead bodies into a resource, recruited in the service of the nation-state. As medical education came to depend on dissection, states began to reframe the rights and responsibilities of their citizens. Public hospitals would treat anyone without charge, regardless of their rank or wealth, and in return citizens were expected to give their bodies, during life and after death, in the service of the state and the medical profession. Among other things this new settlement was intended to replace what might be called the Enlightenment's mixed economy of the dead – another layer of invisible technicians that included judges, executioners, undertakers, bodysnatchers and the odd gang of murderers (Burke and Hare in Edinburgh, Bishop and Williams in London).

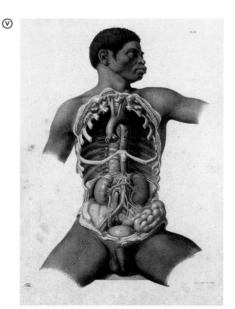
(v)

From 1752 the sentence for murder in English courts included public dissection, but this source of bodies had severe limitations. The wombs and foetuses depicted in William Hunter's *Anatomy of the Human Gravid Uterus*, for example, were almost certainly cut from bodysnatched corpses, as visibly pregnant women were (at least notionally) never hanged.

England's 1832 Anatomy Act abolished the dissection of executed criminals, but allowed that anyone who died unclaimed in a hospital or workhouse could be taken for dissection in a recognized anatomy school. The remarkable growth of burial insurance societies in the years after 1832 reflects the increasingly desperate efforts of the nation's urban poor to ensure some degree of dignity for themselves in death. The Act effectively put the resurrection men out of business, but it turned what had been 'a coercive *post-mortem* punishment specific to murder' into 'one specific to poverty' [8].

But this was, apparently, not a fit matter for discussion in the pages of textbooks illustrated with dissections carried out on the corpses of unclaimed paupers. *Gray's Anatomy* – which, Richardson has estimated, required the bodies of four or five men, one or two women, at least one child, and various body parts from operating tables or the morgue – is silent on how these bodies were obtained. Objectivity demanded the obliteration of identity; the dead became nothing more than the raw material of clinical expertise, consummate and involuntary invisible

technicians. In other nations race, as much as poverty, determined the source of bodies. James M. Edmonson and John Harley Warner have shown that medical schools in the United States tended to obtain bodies from African-American cemeteries in poorer neighbourhoods [9]. Many were quite open about the fact that their departments of anatomy were filled with wealthy white students dissecting the cadavers of poor black locals, even after legal frameworks for donating and claiming bodies were introduced in the late nineteenth century.

In considering dissection, many writers have reached for Julia Kristeva's concept of the abject: that which is within us, but is monstrous and taboo, that which must be destroyed in order to preserve the (seeming) integrity of our lives [10]. It is not difficult to see abjection in the marginalized and silenced bodies of the dissected poor, or to imagine the high white walls and sharp, unforgiving tools of the dissection room as the instruments of abjection. But the images made from those raw materials in that setting portray not the abject but the 'abhuman' – a term coined by W. H. Hodgson in his works of Edwardian weird fiction, and recently revived by the Gothic scholars Kelly Hurley and David Punter [11]. An abhuman body has failed to hold itself together; it is falling apart, it reveals what should be hidden, it is therefore on the way to becoming something terrible.

What is abhuman is also a site for the exercise of power, intellectual, symbolic and practical. In an age when European nation-states were acquiring global empires, often by force, we might also see echoes of the geographical atlas in the anatomical atlas – two very different kinds of map, but both giving a seemingly neutral god's-eye view of contested and conquered territories. The anatomical gaze is an imperialist gaze, looking to

understand and order, dominate and control. Power in these images is not nakedly expressed, though, but refracted through a set of aesthetic conventions. Early modern anatomical illustrations adopted the pious and painterly modes of Renaissance and Baroque art – écorchés posed within pastoral vistas, skeletons kneeling in prayer – and, most famously in Rembrandt's series of anatomical lessons, the lineaments of bourgeois portraiture. Through the eighteenth and early nineteenth centuries these conventions were replaced by a set of rules derived from the practices of mass dissection, less painterly but just as carefully chosen to induce the desired effect. Single body parts replaced whole, articulated cadavers. Folded cloth concealed the severed edges of specimens, just as it softened the edges of a portrait or bust. Faces, if they were shown at all, were depicted in a state of sleep or death. A narrow palette of colours picked out different tissues and components: red for arteries, blue for veins, yellow for nerve fibres, a deep Carpaccio-esque crimson for muscles.

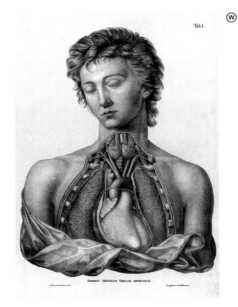

Tab.I.

The conventions expressed in these illustrations were no more or less objective than any other representation of the human body. They were products of aesthetic and scientific traditions in flux, the results of artists and anatomists seeking to connect the facts of a single dead body with the wider truths on which medicine was coming to insist. Nineteenth-century images of anatomy and pathology were, as a rule, far less concerned with natural theology, the depiction of a human body made in the image of a benevolent God, but they were no less freighted with meaning beyond their overt medical content. The ambition and progressive orientation of scientific medicine brought new immediacy to the ancient resonances of the *vanitas*, the inescapable triumph of death. Doctors and scientists could interrogate death in the morgue and the laboratory, they could turn a timeless eschatological truth into a biochemical fact, they could replace eternity with the deep time of stars and rocks. But the images they made still speak of transience, the frailty of the flesh, the passing away of all things.

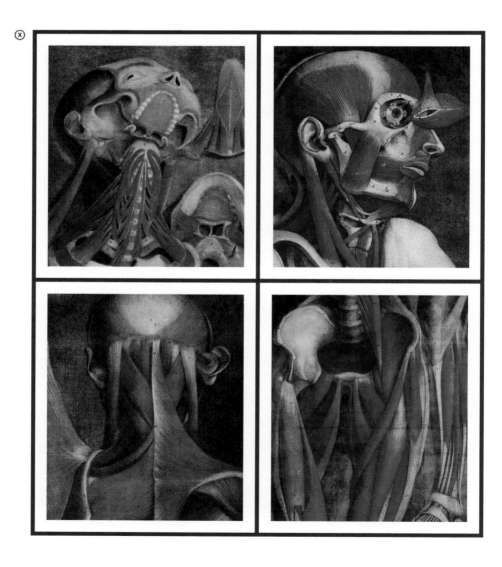

[1] Benedict Anderson, *Imagined Communities* (revised ed.), Verso, 1991. [2] Laurence Talairach-Vielmas, 'Collecting the Materials: Anatomical Practice and the Material Body in Frankenstein', in Claire Bazin (ed.) *Frankenstein Galvanised*, Red Rattle Books, 2013. [3] Lorraine Daston & Peter Galison, *Objectivity*, Zone Books, 2007, p. 40. [4] Steven Shapin, 'The Invisible Technician', *American Scientist* 77, 1989, pp. 554–63. [5] John L. Thornton & Carole Reeves, *Medical Book Illustration: A Short History*, Oleander Press, 1983. [6] Daston & Galison, 2007, p. 301. [7] Benjamin Rifkin, Michael J. Ackerman & Judy Folkenberg, *Human Anatomy: Depicting the Body from the Renaissance to Today*, Thames & Hudson, 2006. [8] Ruth Richardson, *Death, Dissection and the Destitute: The Politics of the Corpse in Pre-Victorian Britain*, Routledge & Kegan Paul, 1987, p. 183. [9] John Harley Warner & James M. Edmonson, *Dissection: Photographs of a Rite of Passage in American Medicine: 1880–1930*, Blast Books, 2010. [10] Julia Kristeva, *Powers of Horror: An Essay on Abjection*, Columbia University Press, 1982. [11] Hodgson seems to have coined 'abhuman' in *The Night Land*, Eveleigh Nash, 1912. For more recent scholarly usage, see David Punter, *The Literature of Terror*, 2 vols, Longman, 1996, and Kelly Hurley, *The Gothic Body: Sexuality, Materialism, and Degeneration at the Fin de Siecle*, Cambridge University Press, 2004.

(A) In this 1890 oil painting by Enrique Simonet Lombardo, an anatomist contemplates the heart he has removed from the body of a woman. (B) This late seventeenth- or early eighteenth-century oil painting by Matthijs Naiveu depicts a Dutch woman attended by two practitioners: one takes her pulse while another bleeds her foot. (C) In this nineteenth-century oil painting, after a seventeenth-century original by Hendrik Heerschop, a physician examines a flask of urine. (D) A medieval physician reads from a textbook of anatomy and directs a surgeon in the dissection of a corpse. (E) Three late-medieval views of the human body from a pseudo-Galenic work, *Anathomia*, written in the mid-fifteenth century. (F) The title page of Andreas Vesalius's *De Humani Corporis Fabrica*, originally published in 1543. (G) A partially dissected human body suspended from a noose, from Vesalius's *Fabrica*. In the top-right-hand corner is a dissected diaphragm. (H) James Gillray's 'Petit souper, a la Parisienne; – or – A family of sans-culottes refreshing, after the fatigues of the day' (1792). (I) An engraving by William Chevalier after Theodor von Holst from the 1831 edition of *Frankenstein*. (J) This 1815 chalk drawing by Charles Landseer, made in the dissecting room, shows a lateral view of the trunk of a flayed corpse. (K) A wax model, with removable organs, made in Florence in the late eighteenth century by the leading Italian anatomical waxworker, Clemente Susini. (L) Aquatint (1904) by R. Perrette shows students dissecting the abdomen of a cadaver. The foreshortening of the body owes much to Rembrandt's seventeenth-century paintings of dissections. (M) A mid-nineteenth-century coloured engraving of the muscles and blood vessels in the shoulder. (N) Robert Blemmer Schnebbelie's 1830 sketch of an anatomy lesson at the Hunterian Anatomy School in London. (O) The title page of William Cheselden's *Osteographia* (1733) shows Cheselden's camera obscura being used to prepare a sketch of an articulated spine, ribcage and skull – suspended upside-down to correct the inversion by the lens. (P) Plate from Albrecht von Haller's *Icones Anatomicae* (1752), showing a partially dissected male foetus. (Q) This second plate from Haller's *Icones* shows the arteries of the neck and head. (R) A gravid uterus in the sixth month of pregnancy, partially dissected to reveal the foetus, from William Hunter's *Anatomy of the Human Gravid Uterus* (1774). (S) A dissection of the skull, with the inner membranes partially removed to reveal the brain, from Charles Bell's *The Anatomy of the Brain* (1802). (T) Three plates from the first full-colour anatomical atlas – Jacques Fabien Gautier d'Agoty's *Myologie* (1746–48). Plate 1: a partially dissected female, the skin removed from the legs, arm and breast, and the intestines removed to reveal the uterus. Plate 2: a partially dissected male with the left side of his chest removed to reveal his heart. Plate 3: a skeleton, some of the nerves and arteries of the limbs and neck, and the brain and spinal cord. (U) Four plates from Arthur Hill Hassall's *The Microscopic Anatomy of the Human Body, in Health and Disease* (1852). (V) This lithograph from 1851, showing a dissection of the aorta and major abdominal arteries of a seated black man, is a rare depiction of a non-white cadaver in the Western anatomical tradition. (W) A partial dissection of the chest of a man, with arteries coloured red, from Friedrich Tiedemann's *Tabulae Arterium Corporis Humani* (1822). (X) Details of plates from Gautier d'Agoty's *Myologie* (1746–48), showing the muscles of the neck, face and thighs.

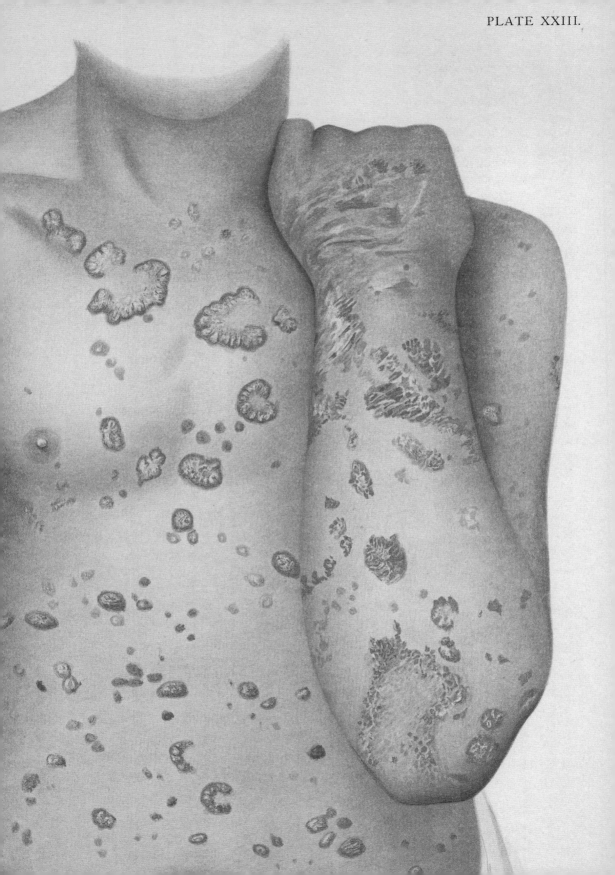

PLATE XXIII.

SKIN

DISEASES

SKIN DISEASES

THE BOUNDARY
OF THE BODY

Disfigurement of the skin has been a sadly commonplace affliction across much of human history – most notoriously in the form of smallpox and leprosy (addressed in separate chapters), but many other conditions left their mark, literally and metaphorically, on their victims. Europe's elite Renaissance and early modern physicians did not much concern themselves with eruptions of the skin, except as markers of underlying disorder, and the body's largest organ was traditionally the province of barber-surgeons.

This conception of the skin, as little more than a protective bag in which the viscera was carried, began to shift in the sixteenth century, with the observation of skin pores. These tiny openings suggested that the skin had other functions in absorption and excretion, and eighteenth-century physicians increasingly prescribed topical ointments and salves as a way of getting drugs directly into the flesh beneath Ⓐ. The establishment of Europe's first school of dermatology in Paris in 1801 reflected fresh interest in the skin itself as a tissue, and the lesions to which it was subject.

In 1795 the Scottish accoucheur Alexander Gordon had noted an analogy between puerperal fever, which killed many women in the days after giving birth, and erysipelas, an acutely painful inflammation of the skin. The incidence of both diseases tended to rise and fall together, and (as he pointed out in his Treatise on the Epidemic Puerperal Fever of Aberdeen [1795]):

'AT THE TIME WHEN ERYSIPELAS WAS EPIDEMIC, ALMOST EVERY PERSON ADMITTED INTO THE HOSPITAL OF THIS PLACE WITH A WOUND, WAS, SOON AFTER HIS ADMISSION, SEIZED WITH ERYSIPELAS IN THE VICINITY OF THE WOUND.... [IT IS] JUST SO WITH PUER-PERAL FEVER, WOMEN ESCAPE IT UNTIL AFTER DELIVERY, TILL THAT TIME THERE IS NO INLET OPEN TO RECEIVE THE INFECTIOUS MATTER WHICH PRODUCES THE DISEASE.'

Gordon urged physicians and midwives to destroy 'infectious matter' by fumigating or burn-ing the patient's clothes and bedding, and by washing themselves after treating infected cases. This thesis was later taken up by the American physician and writer Oliver Wendell Holmes and, in a subtly different form, by the Hungarian obstetrician Ignaz Semmelweis.

Working in the Allgemeines Krankenhaus in Vienna in the late 1840s, Semmelweis observed that two maternity clinics had dramatically different rates of puerperal fever. The First Clinic, in which around ten percent of mothers died, was attended by medical students who also practised dissection; the Second Clinic, which had a mortality rate of around four percent, was staffed by midwives, who had no contact with the dissecting room. Semmelweis used statistics to show that mortality from puerperal fever had almost doubled since the introduction of Paris-style teaching with mass dissection in 1823, and that it declined sharply from May 1847, when he made medical students wash their hands in a chlorine solution before entering the First Clinic. In his view, decaying 'cadaverous particles', rather than any specific infectious agent, were responsible for puerperal fever. These studies provoked an acrimonious debate among European physicians, which did not end with Semmelweis's death in an asylum in 1865. Two decades later the German microscopist Friedrich Fehleisen showed that the same microorganism – *Streptococcus pyogenes* – was responsible for both puerperal fever and erysipelas.

Illustrations, especially colour illustrations, played a particularly important part in the study of skin diseases in the nineteenth century. For many nineteenth-century physicians the greatest challenge was simply that of distinguishing one condition from another. The sheer variety of skin diseases, their multifarious textures and colours, were difficult to capture in prose, or even in monochrome line engravings. *On Cutaneous Diseases* (1808), by the English physician Robert Willan, was one of the first attempts to classify skin diseases, and included many colour mezzotints of conditions like impetigo, psoriasis, scleroderma and pemphigus Ⓑ. Later in the century Christopher D'Alton, artist to the Royal Free Hospital in London, made many vivid and sensitive drawings of patients and their skin diseases, some named and identified, others anonymous and apparently undiagnosed Ⓒ.

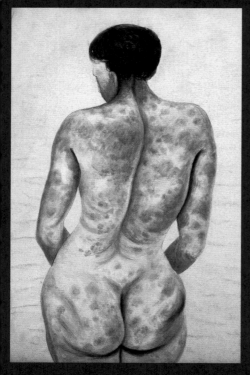

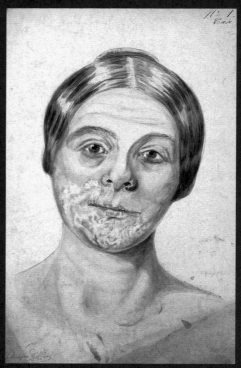

EIGHT ORDERS
of
Cutaneous Diseases.

1. Pimples

2. Scales.

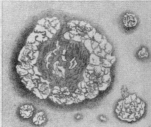

3. Rashes.

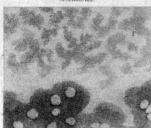

4. Bullæ.

5. Pustules.

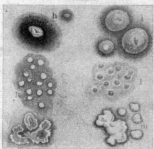

6. Vesicles.

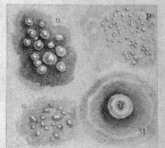

7. Tubercles.

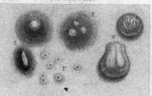

8. Spots.

I.B. delin.

J.Stewart sculp.

The French physician Jean-Louis Alibert, the Viennese Ferdinand von Hebra, and the Hungarian-French Ferdinand-Jean Darier all sought to create grand systems of classification, setting out a language in which keratosis and trichosis could be clearly differentiated from erythema and urticarial Ⓔ. Microscopic studies of the skin revealed its intricate structure, and began to draw out its many interrelated functions: heat exchange, sensation, synthesis. The rise of germ theory, meanwhile, illuminated the processes underlying some of the most feared skin diseases, and in the early twentieth century physiologists began to elucidate the hormones and their role in conditions like eczema. But what was the most important factor in description and treatment – aetiology or appearance, the part of the body afflicted or the pathological reaction behind the symptoms?

More than this, the nineteenth century witnessed a radical shift in the meaning of the body's boundary. Skin – in particular its colour and cleanliness – had always played a central role in the shaping of personal identity and social position, and in the previous century caricaturists had taken great pains to capture the pocked, abraded, coarsened hides of the Enlightenment's jaded pleasure-seekers. For middle-class families in the new industrial cities, however, the skin became a political and an ethical boundary, a tool of individuation and a marker of health, wealth and dignity. This most public organ was also the most intimate, a text telling the story of a life. High collars and long skirts hid more than bourgeois modesty; they concealed a manuscript all too easy to decipher and to judge.

CHAPTER I 48

Ⓐ A selection of eighteenth- and early nineteenth-century pots and jars, used for dispensing salves and ointments for the treatment of skin diseases. Ⓑ This 1851 watercolour by Christopher D'Alton shows the back and buttocks of an unidentified woman, suffering from an undiagnosed skin disease. Ⓒ Another of D'Alton's watercolours shows the head of an unidentified woman with a severe disease affecting the lower part of her face. Ⓓ An early attempt to classify skin disease by appearance: the English physician Robert Willan's 'eight orders of cutaneous diseases', as illustrated in Thomas Bateman's *Practical Synopsis of Cutaneous Disease*, published in 1813. Ⓔ Jean-Louis Alibert's 'Tree of Skin Diseases', from his *Clinique de l'Hôpital Saint-Louis*, published in 1833.

Arbre
des Dermatoses

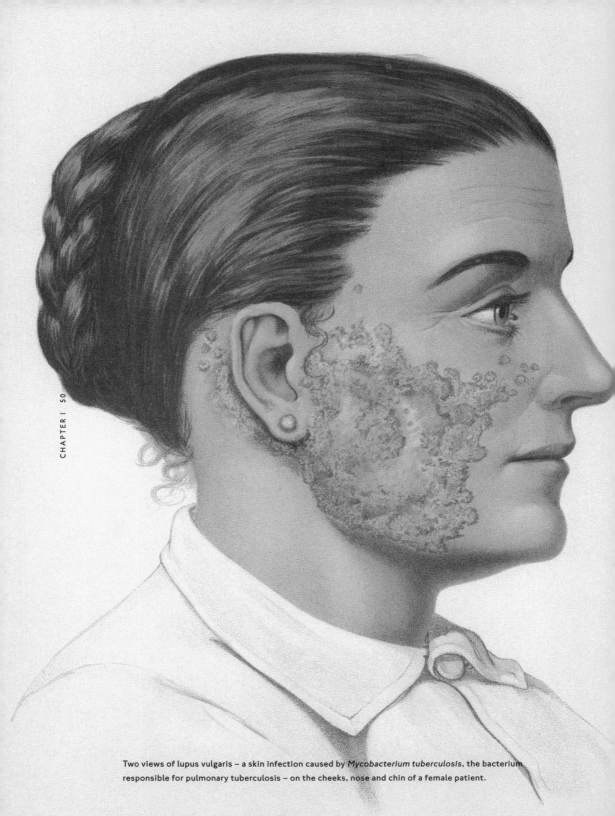

Two views of lupus vulgaris – a skin infection caused by *Mycobacterium tuberculosis*, the bacterium responsible for pulmonary tuberculosis – on the cheeks, nose and chin of a female patient.

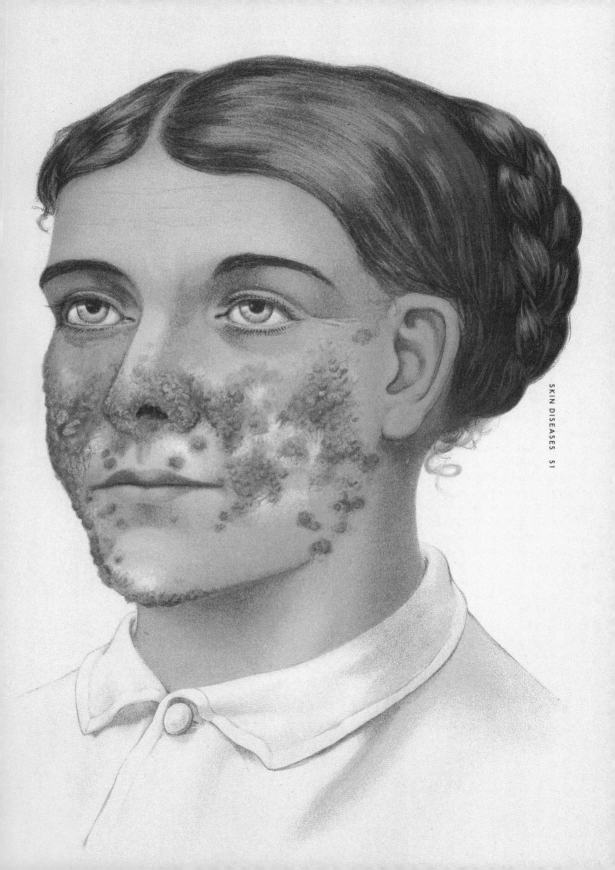

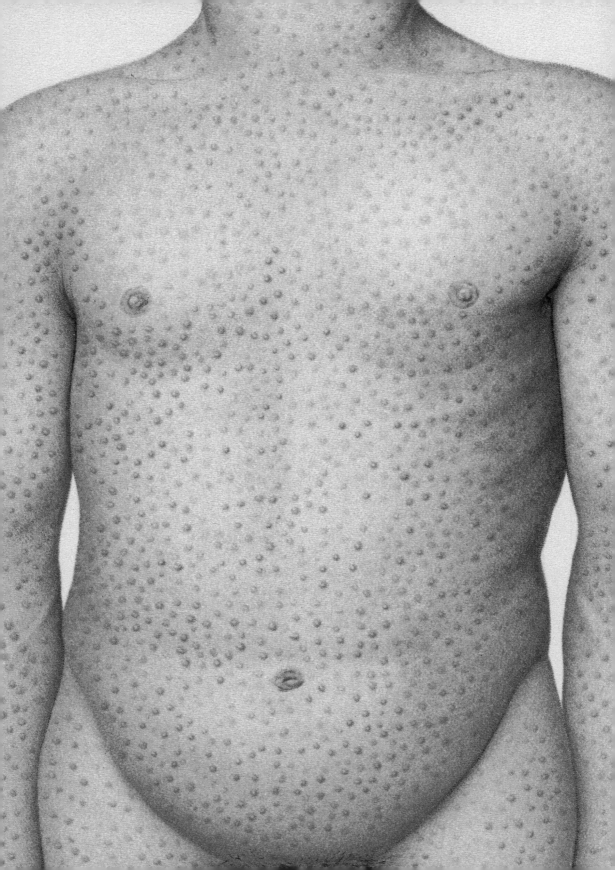

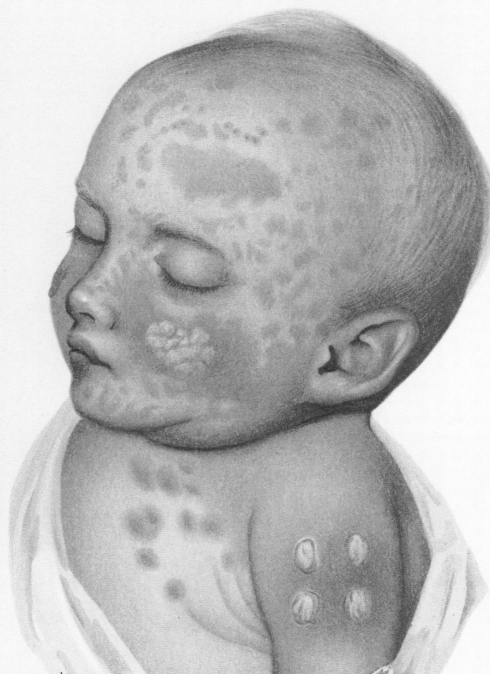

OPPOSITE | Skin disease as a marker of underlying pathology: syphilitic papules, characteristic of the second stage of the disease, covering the torso, arms, thighs and neck of a male patient. ABOVE | The head and shoulders of an infant, showing a severe skin reaction following vaccination. | OVERLEAF LEFT | Various forms of gangrene affecting the skin and underlying tissues. | OVERLEAF RIGHT | Gangrene of the left foot, resulting from frostbite.

Plate II.

Fig. 3.

Fig. 4.

Fig. 2

Fig. 1

Day & Haghe Lith. to the King, Gate St.

R. Carswell ad nat. delt.

PLATE XL.

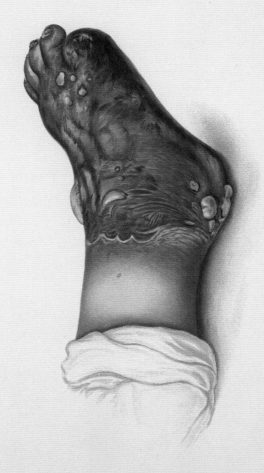

GANGRENE OF FOOT FROM COLD.

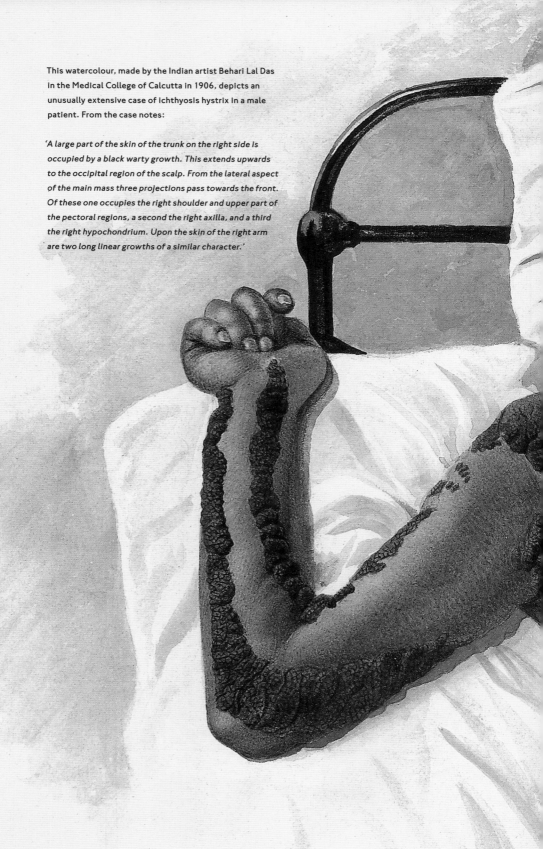

This watercolour, made by the Indian artist Behari Lal Das in the Medical College of Calcutta in 1906, depicts an unusually extensive case of ichthyosis hystrix in a male patient. From the case notes:

'*A large part of the skin of the trunk on the right side is occupied by a black warty growth. This extends upwards to the occipital region of the scalp. From the lateral aspect of the main mass three projections pass towards the front. Of these one occupies the right shoulder and upper part of the pectoral regions, a second the right axilla, and a third the right hypochondrium. Upon the skin of the right arm are two long linear growths of a similar character.*'

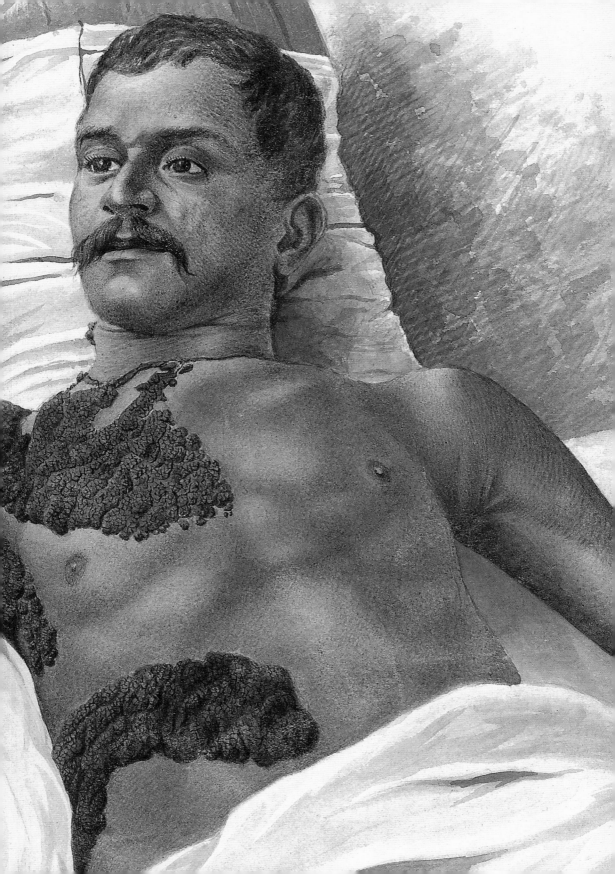

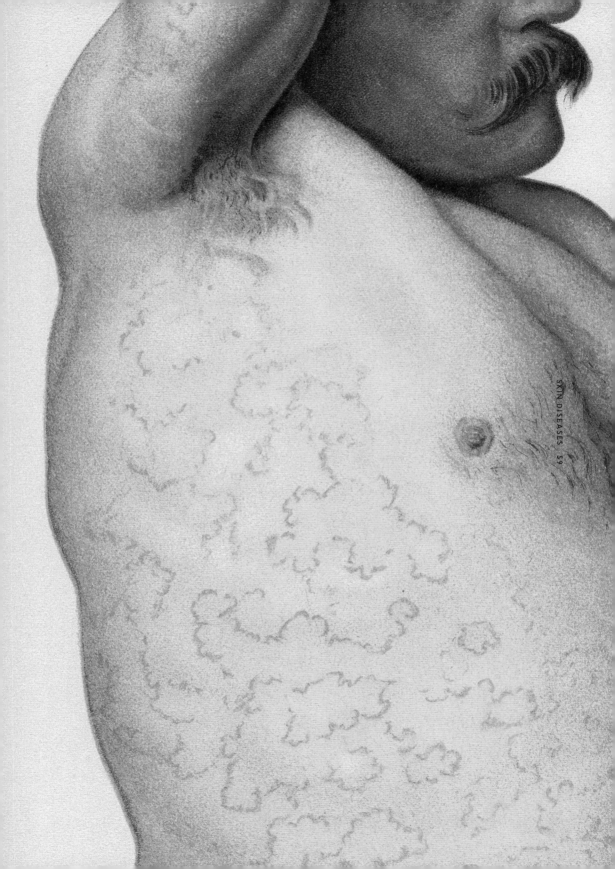

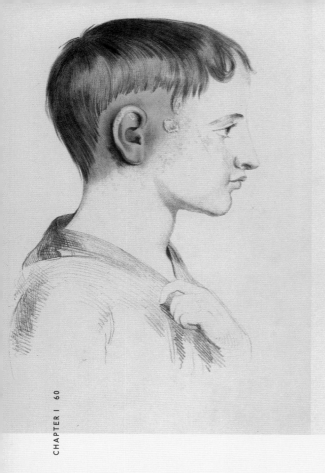

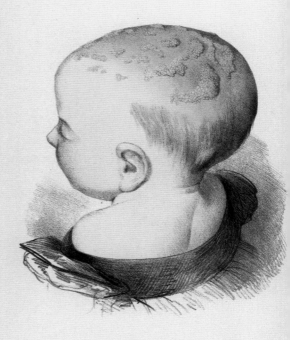

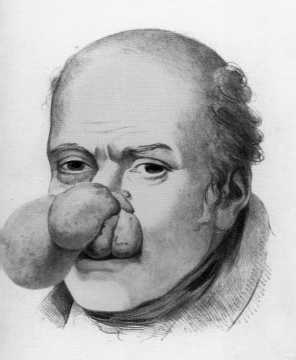

PREVIOUS LEFT | A female patient with unilateral
ichthyosis, covering her abdomen, shoulders, neck, elbow,
hand and thigh. | PREVIOUS RIGHT | A male patient with
erythema covering his abdomen and armpit. | ABOVE AND
OPPOSITE | Illustrations of various kinds of skin disease,
mostly infectious, affecting the face. | OVERLEAF LEFT
The face of a male patient showing rupia, a severe encrusted
rash associated with secondary syphilis. | OVERLEAF
RIGHT | A woman's face, badly affected with lesions
of impetigo on the nose, cheeks and upper lip.

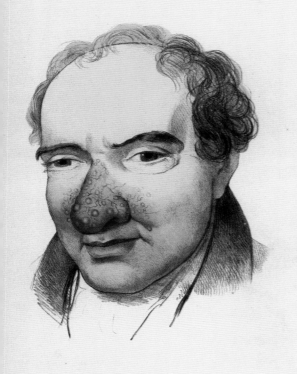
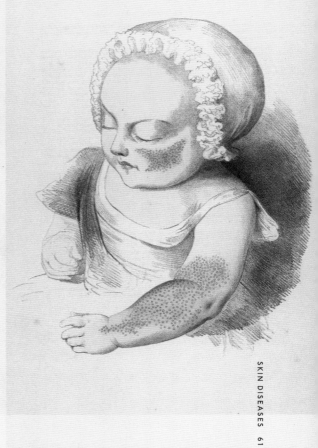

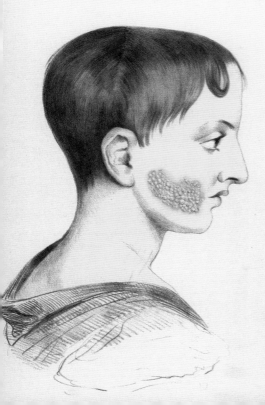
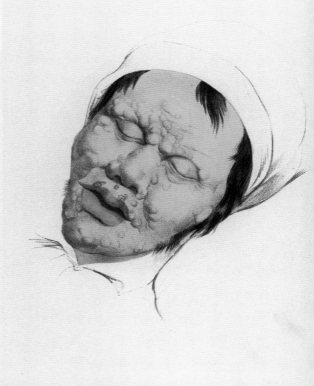

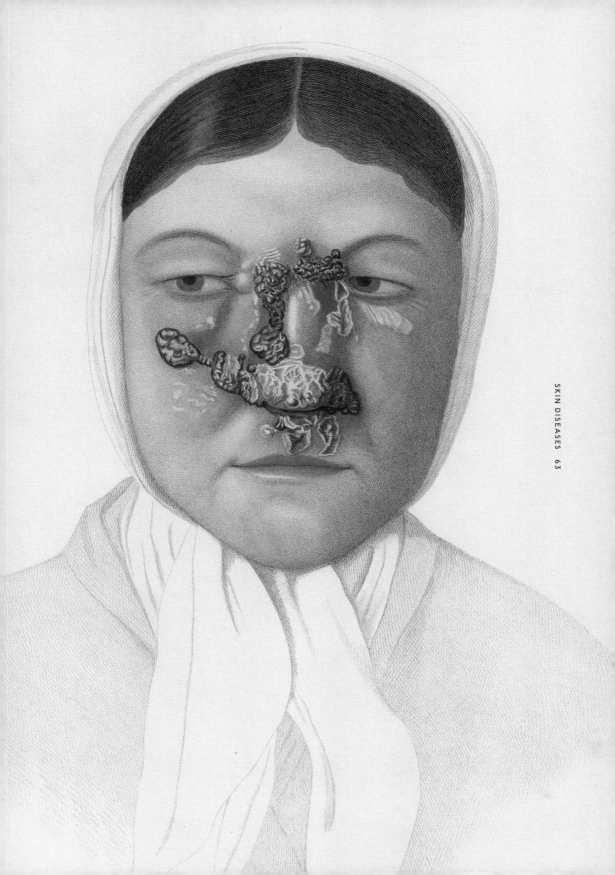

Illustrations of tylosis, an
abnormal thickening of the
skin on the palms of the
hands and the soles of
the feet, and ichthyosis
hystrix, a scaling
of the skin.

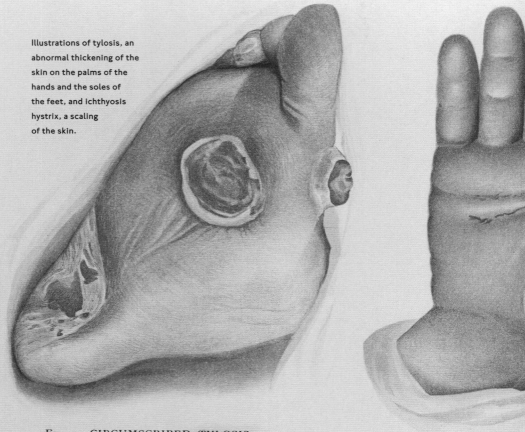

FIG. 5.—CIRCUMSCRIBED TYLOSIS.

FIG. 3.—TYLOSIS

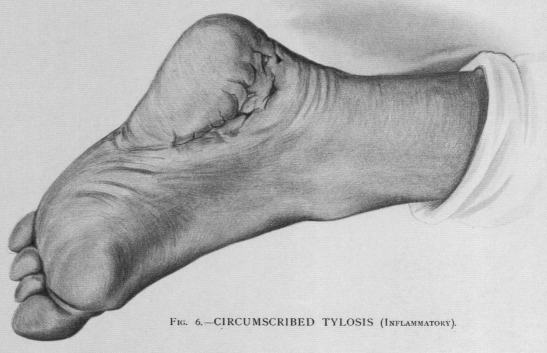

FIG. 6.—CIRCUMSCRIBED TYLOSIS (INFLAMMATORY).

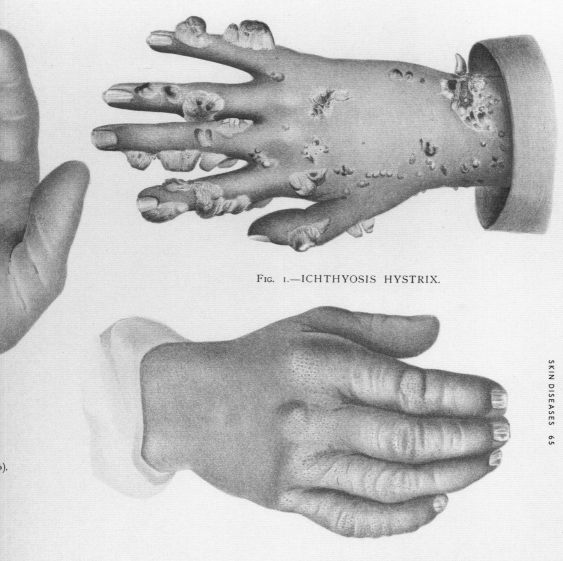

FIG. 1.—ICHTHYOSIS HYSTRIX.

FIG. 4.—TYLOSIS (BACK VIEW OF FIG. 3).

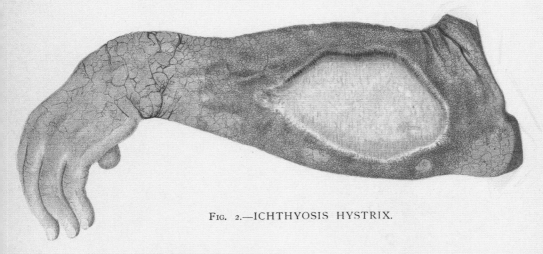

FIG. 2.—ICHTHYOSIS HYSTRIX.

PLATE XLIV.

Fig. I.

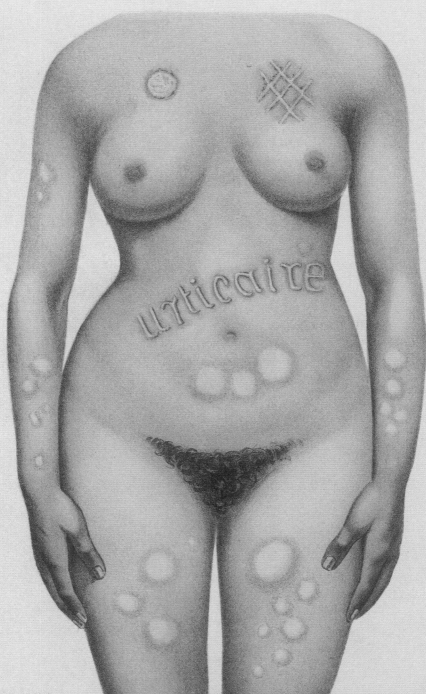

Two striking images of dermatographic urticaria – an inflamed and itchy skin rash caused by scratching the skin. The large circular hives above and the disseminated blotches opposite are more typical expressions of urticaria; the cross-hatching and writing on the body were most likely produced with a needle or pencil.

Fig. 2.

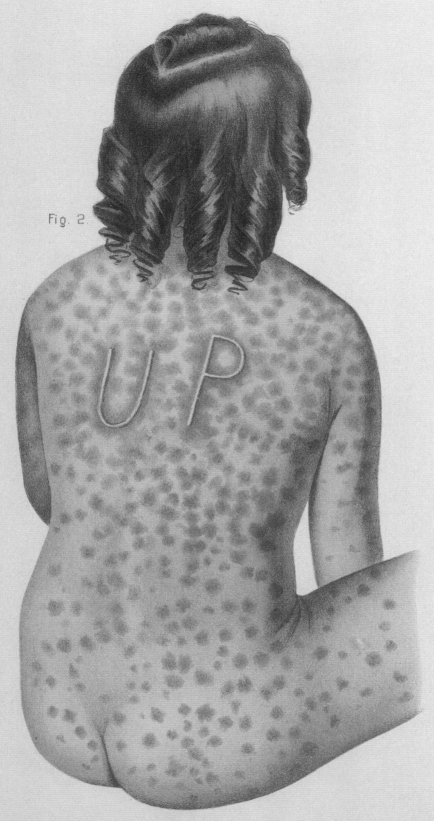

WILLIAM WOOD & COMPANY. Publishers. NEW YORK.

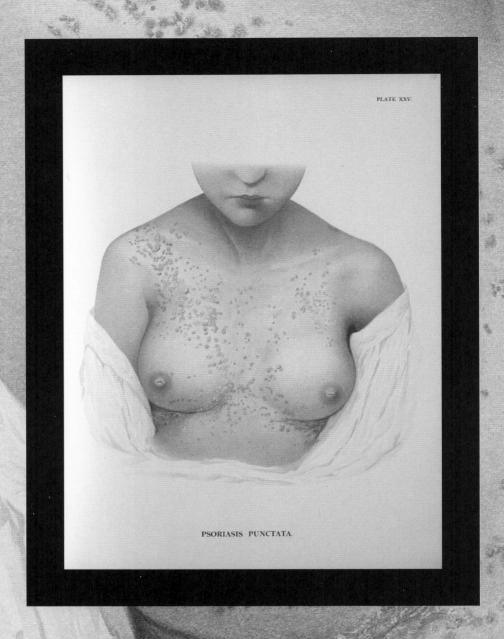

PLATE XXV.

PSORIASIS PUNCTATA.

ABOVE | Punctate psoriasis, affecting the chest and shoulders of a female patient.
OPPOSITE | An extremely severe case of pemphigus foliaceus – now known to be
an autoimmune skin disease producing crusted, scaly lesions – in a young boy.

PLATE XVIII.

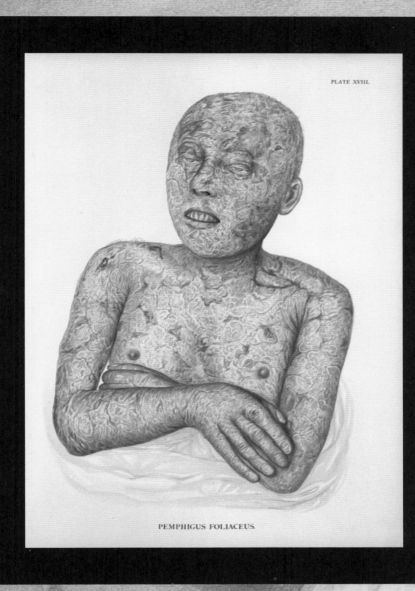

PEMPHIGUS FOLIACEUS.

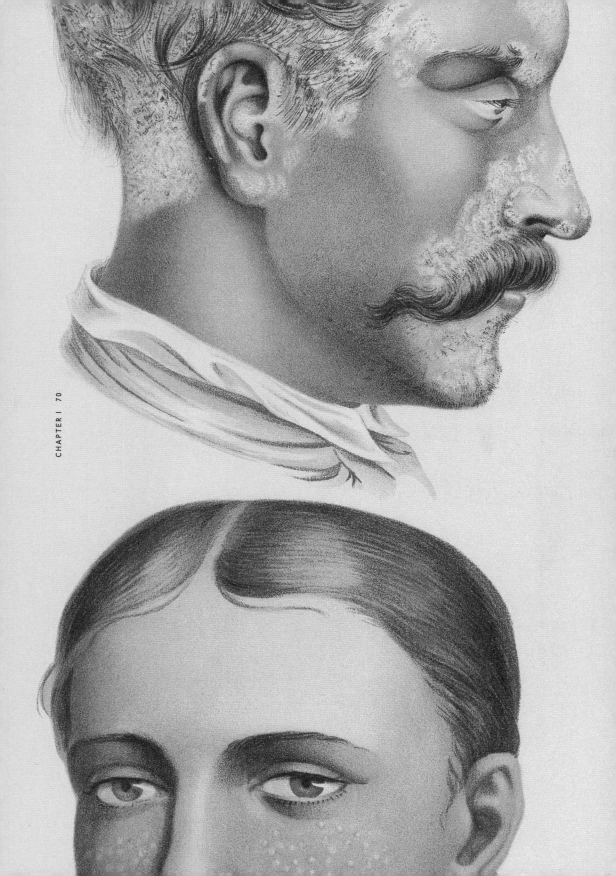

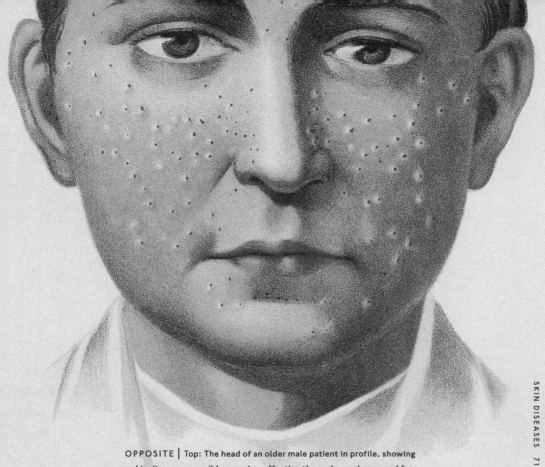

OPPOSITE | Top: The head of an older male patient in profile, showing a skin disease – possibly sycosis – affecting the scalp, eyebrows and face. Bottom: The face of a young woman with skin lesions. | ABOVE | A young man with cheek pustules. | BELOW | An abdomen covered in vesicles.

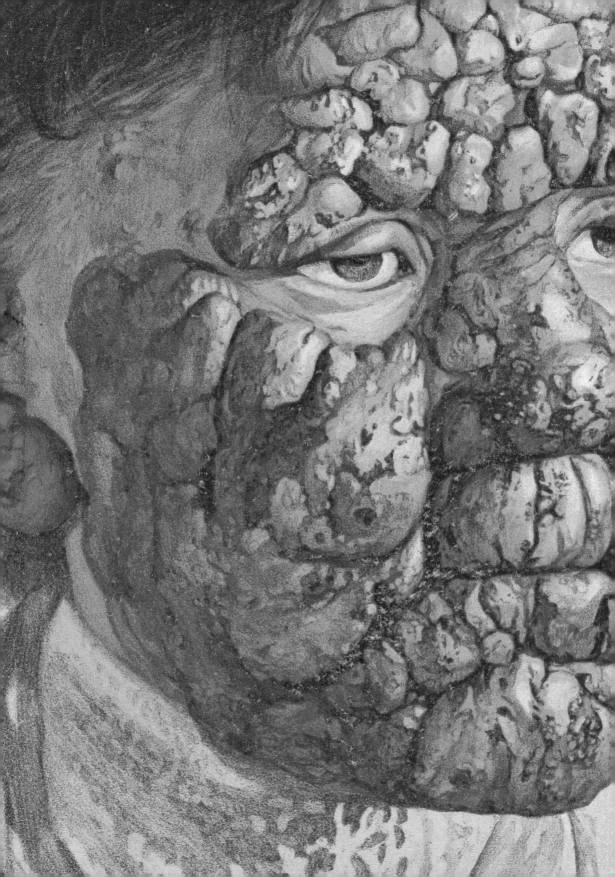

LEPROSY

LEPROSY
MORE THAN SKIN DEEP

As Western doctors made new roles for themselves in tropical colonies, they found themselves treating one of the proverbial scourges of medieval life – leprosy. Historically this term had been applied to a constellation of conditions, and (following the injunctions in the Book of Leviticus) was as much a category of moral uncleanliness and social exclusion as it was a medical diagnosis. In the twelfth and thirteenth centuries the European landscape was scattered with several thousand leprosaria, hospital-chapels in which colonies of lepers were segregated, though their numbers appear to have declined rapidly after the arrival of the Black Death in the mid-fourteenth century and the sixteenth-century Protestant Reformation.

For many medieval physicians leprosy was both a moral and a physical corruption: overindulgence in carnal pleasures spread an excess of cold, wet, heavy black bile through the body, causing flesh to die and rot while the body lingered in life. This was not only a disease but also a metaphor for the frail state of the human soul, portending the foulness of the grave and the agonies of purgatory. Leprosy was a kind of death in life, and some Catholic communities developed ceremonies in which lepers were declared symbolically dead, excluded from communal Christian life, even made to lie in a grave while a priest recited a burial mass. Like the dead, they could own no property, though those indigent lepers who could not find a place in leprosaria were permitted to carry a bell to warn of their approach, a crutch and a bowl for alms Ⓐ, Ⓑ & Ⓒ.

Well into the nineteenth century, this potent moral framing of leprosy continued to inform colonial responses to the disease. From the 1830s physicians in Iceland, Norway and some English ports reported a sharp rise in cases of leprosy, typically among sailors returning from western India. In the second half of the century European doctors, missionaries and administrators sought to present the disease as an 'Imperial Danger' (the minatory title of an 1889 book by the missionary H. P. Wright), undermining the Western presence in Asia and Africa and threatening to make a devastating return to the imperial homelands Ⓔ & Ⓕ.

The rhetoric of 'Imperial Danger' drew on a set of distinctively Victorian preoccupations: social Darwinism, evangelical Christianity, moral and physical hygiene, fears over imperial decline. Missionaries tried to convince native communities that leprosy went hand in hand with sexual sin and physical squalor – in many cases, hardening what had been relatively tolerant or indifferent attitudes to the disease. Administrators and politicians passed laws like the British Leprosy Acts for India, mandating the segregation of lepers. And physicians argued over whether the disease was contagious, constitutional or hereditary (or a combination of all three). In 1873 the Norwegian physician Gerhard Hansen announced that he had identified a bacterium, *Mycobacterium leprae*, in the tissues of lepers at the St Jørgens Hospital in Bergen ⓖ. This claim was not immediately accepted, however, and Hansen's colleagues found enormous difficulties in replicating his work. His bacterium could not be persuaded to grow in artificial cultures, and only very slowly in laboratory mice. Hansen later lost his job after admitting that he had tried to prove his hypothesis by infecting a female patient without her consent.

As with so many other infectious diseases in this period, the discovery of a causal agent did little in the short term to change the treatment of those suffering from leprosy. Hansen's work added weight to the established view that worldwide segregation was the only effective response, a view endorsed by the *Report of the British Royal Commission on Leprosy* (1891), and by delegates at the first International Leprosy Congress, held in Berlin in 1897. The treatments recorded in the Royal College of Physicians' *Report on Leprosy* (1867) reflect the lack of agreement over what might be effective: fresh air, exercise, doses of cod liver oil and quinine, baths salted with ammonia compounds, and the amputation of limbs or digits as they became damaged.

On the other side of the globe, leprosy seems to have been present in Hawaii from the late eighteenth century – possibly introduced by contact with European explorers, possibly with Chinese traders – and its presence was officially acknowledged by the policy of isolation established under the government of King Kamehameha V in 1865. From 1873 the Belgian Catholic priest Father Damien (made Saint Damien of Molokai by Pope Benedict XVI in 2008) oversaw a colony at Kalaupapa on the island of Molokai, holding around a thousand lepers in what was effectively internal exile. Damien contracted the disease and died in 1889, but the tradition of Catholic missionary care for Molokai's lepers continued well into the twentieth century. The last leprosarium in the continental United States was established in Louisiana in 1894, on an abandoned sugar plantation in Carville. The first inmates – five men and two women – lived in bunkhouses built as slave cabins, but in 1921 the US Public Health Service took over the plantation and turned it into the National Leprosarium. A descendent of this institution, the Gillis W. Long Hansen's Disease Center, continues to operate nearby in Baton Rouge, and the Carville site now houses the National Hansen's Disease Museum.

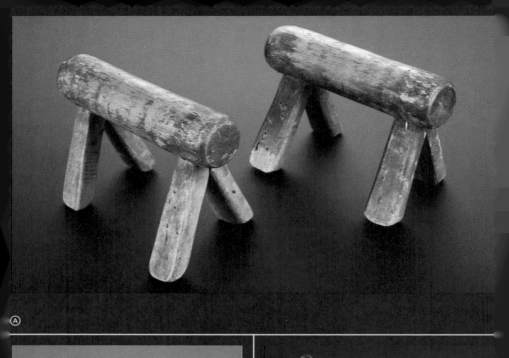

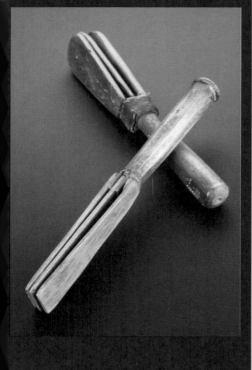

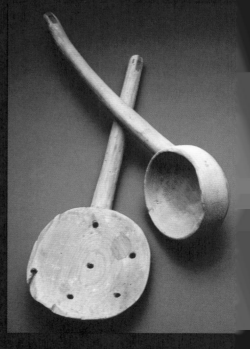

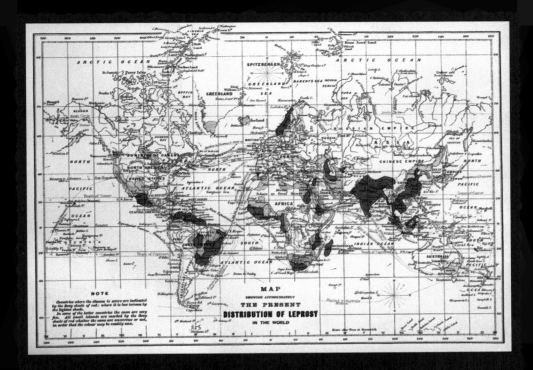

NOTE

Countries where the disease is severe are indicated by the deep shade of red; where it is less intense by the lighter shade.

In areas of the latter countries the cases are very few. All small islands are marked by the deep shade of red whether the cases are numerous or not, in order that the colour may be readily seen.

MAP
SHOWING APPROXIMATELY
THE PRESENT
DISTRIBUTION OF LEPROSY
IN THE WORLD

(D)

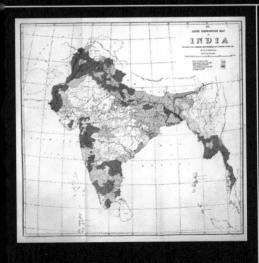

(E)

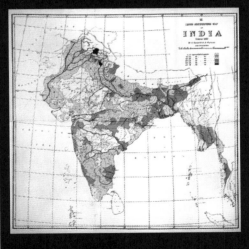

(F)

Other traces remain, here and there, of leprosy's forgotten history in the West. A 2004 Museum of London Archaeological Service dig in the cemetery of St Marylebone in London uncovered the skeleton of a young man, buried some time in the 1830s, with bone lesions suggestive of leprosy, and with part of his right leg amputated. Was he a soldier or a planter who had contracted the disease in the colonies? Or had he returned to England as a young man for schooling, before the disease became florid? We do not know. Having been given a Christian burial in a cemetery used by well-to-do families, though, it seems that this unknown man, at least, was not stigmatized in death.

Ⓐ A pair of wooden crutches, made in England in the early eighteenth century, used by lepers to move without touching the ground. Ⓑ & Ⓒ The (reconstructed) accoutrements of medieval leprosy: copies of a seventeenth-century leper clapper, used by lepers to warn of their approach, and of two long-handled fifteenth-century alms bowls. Ⓓ Leprosy in the global nineteenth century: a map showing the distribution of leprosy around the world in 1891, from George Thin's *Leprosy*, published in 1891. Ⓔ & Ⓕ Leprosy as 'Imperial Danger': maps showing the increase and decrease of leprosy in British India from 1881 to 1891, and the distribution of leprosy in that territory in 1891, from the *Report of the Leprosy Commission in India*, published in 1892. Ⓖ Gerhard Hansen's drawings of cells in a leprous liver, taken from his *Leprosy in its Clinical and Pathological Aspects*, published in 1895.

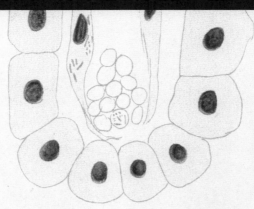

Fig. 1.

Fig. 2.

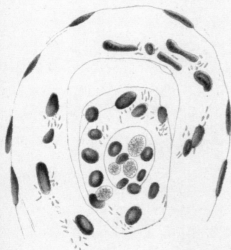

Fig. 4.

Fig. 3.

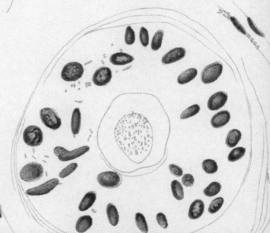

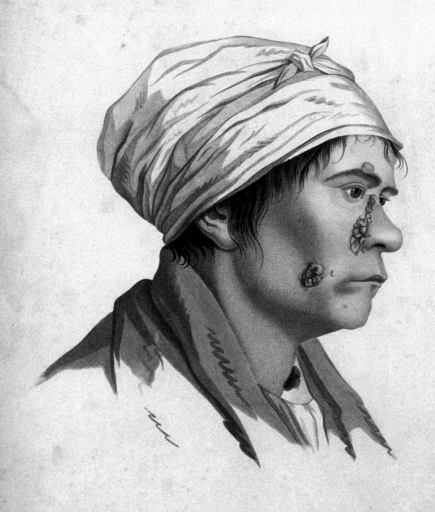

Lèpre Crustacée.

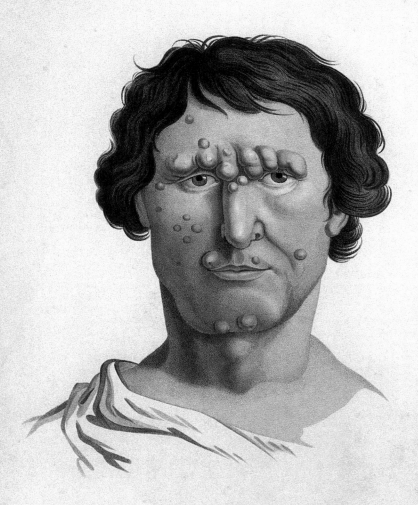

Lèpre Tuberculeuse.

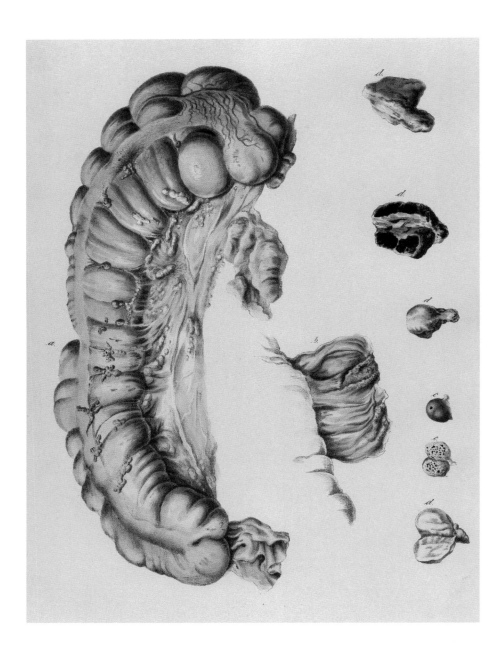

One of the great challenges for nineteenth-century physicians was distinguishing leprosy
from other similar conditions – particularly the various forms of tuberculosis.

PREVIOUS LEFT | A woman with a skin disease labelled 'crusting leprosy', but more likely a form of ichthyosis.
PREVIOUS RIGHT | The head of a man with growths on his forehead, cheeks and chin, labelled 'tubercular
leprosy'. | ABOVE | A dissected colon showing signs of 'tubercular leprosy'. | OPPOSITE | Top: Dissections
showing the trachea and throat. Bottom: Dissection of the lungs affected with 'tubercular leprosy'.

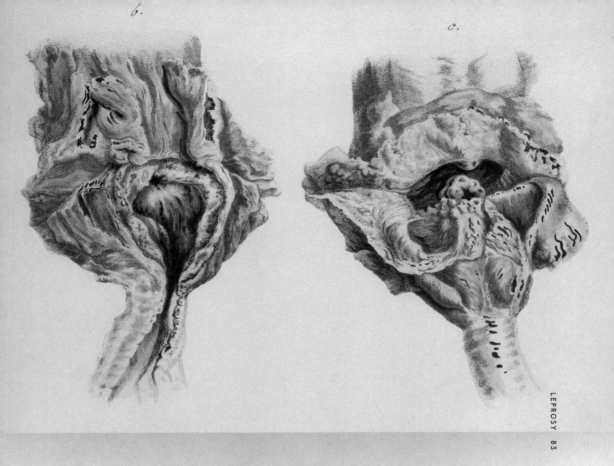

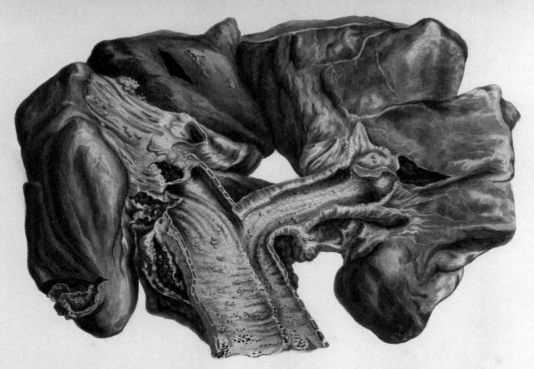

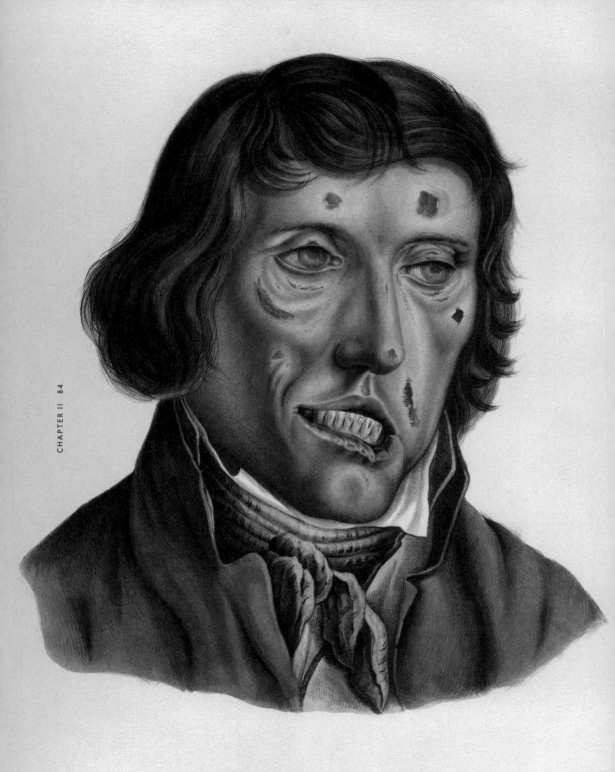

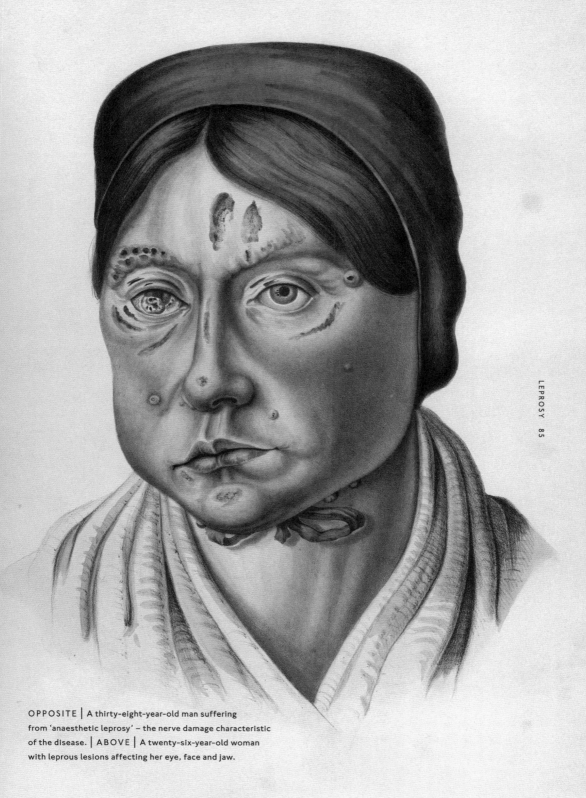

OPPOSITE | A thirty-eight-year-old man suffering from 'anaesthetic leprosy' – the nerve damage characteristic of the disease. | ABOVE | A twenty-six-year-old woman with leprous lesions affecting her eye, face and jaw.

Pl. XIII.

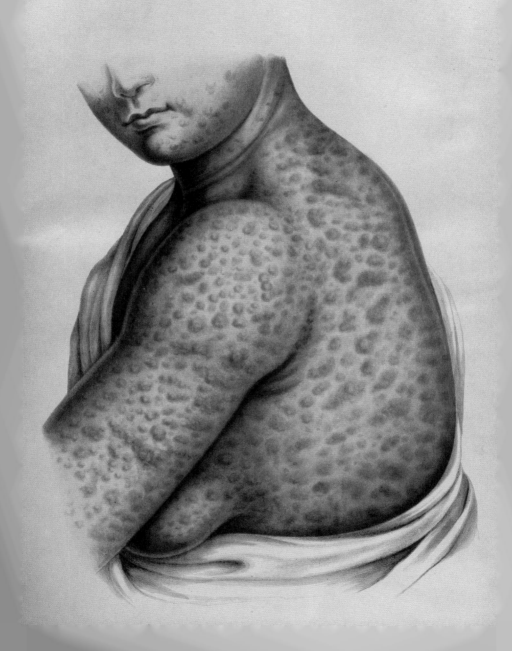

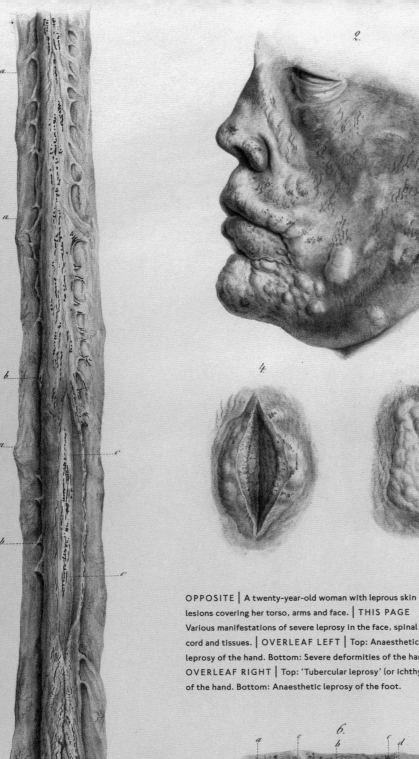

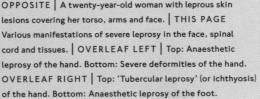

OPPOSITE | A twenty-year-old woman with leprous skin lesions covering her torso, arms and face. | THIS PAGE Various manifestations of severe leprosy in the face, spinal cord and tissues. | OVERLEAF LEFT | Top: Anaesthetic leprosy of the hand. Bottom: Severe deformities of the hand. OVERLEAF RIGHT | Top: 'Tubercular leprosy' (or ichthyosis) of the hand. Bottom: Anaesthetic leprosy of the foot.

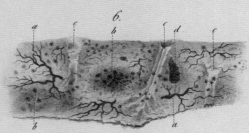

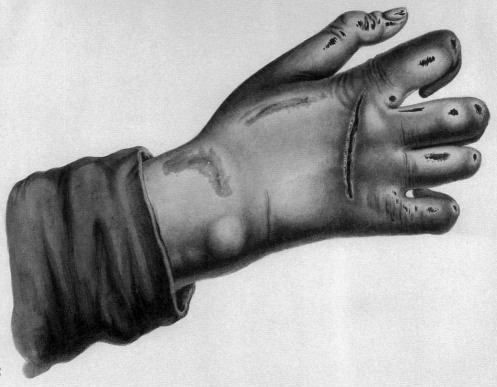

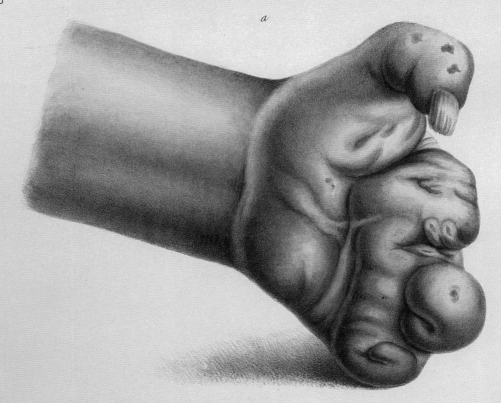

a

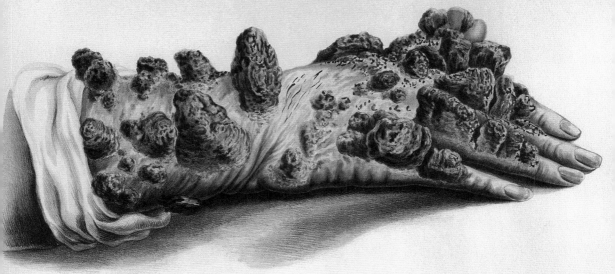

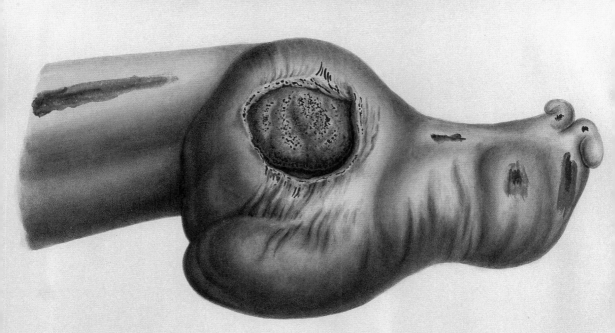

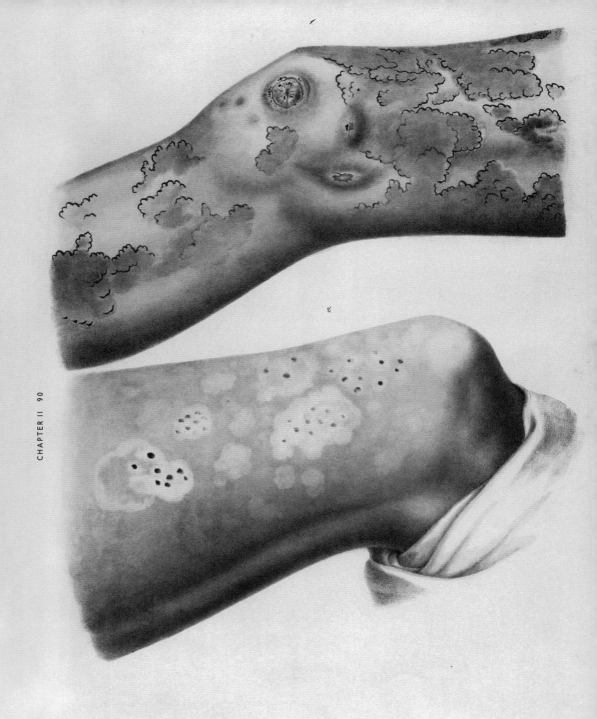

ABOVE | 'Tubercular leprosy' of the leg. | OPPOSITE | A dissection showing anaesthetic and 'tubercular leprosy' of the tongue. | OVERLEAF LEFT | The head of a thirteen-year-old boy, showing severe untreated leprosy. | OVERLEAF RIGHT | The head of a thirteen-year-old girl with leprous lesions affecting her face.

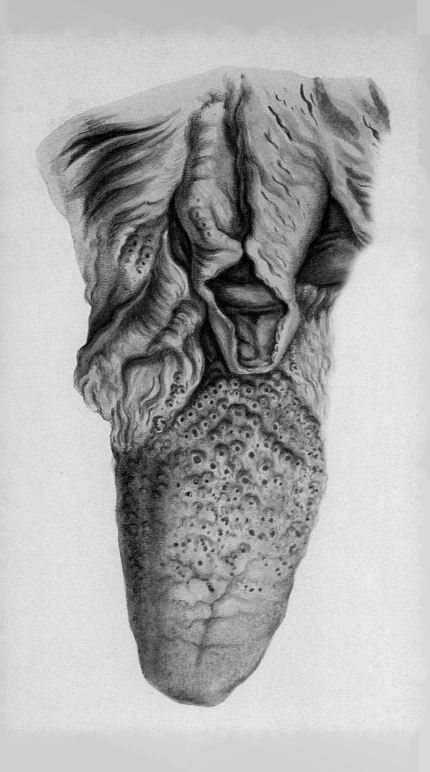

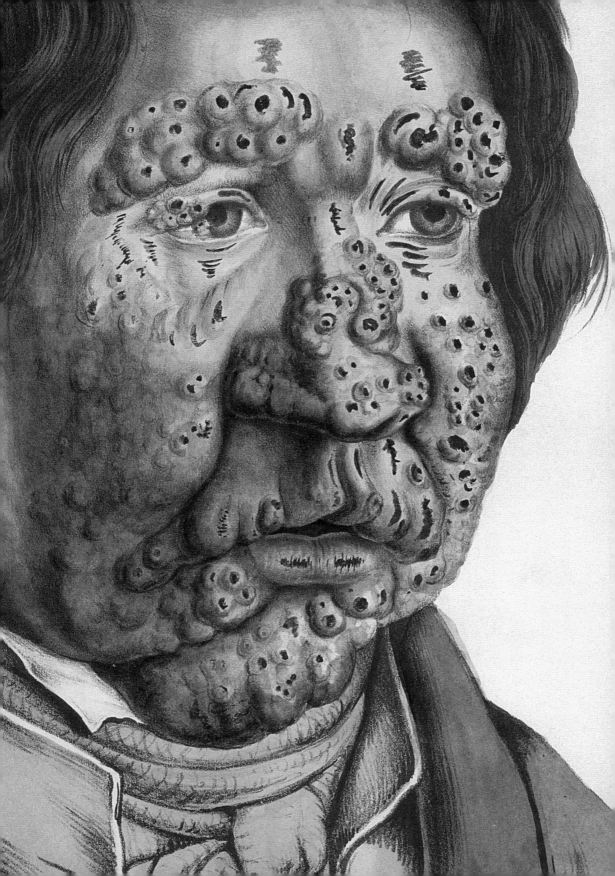

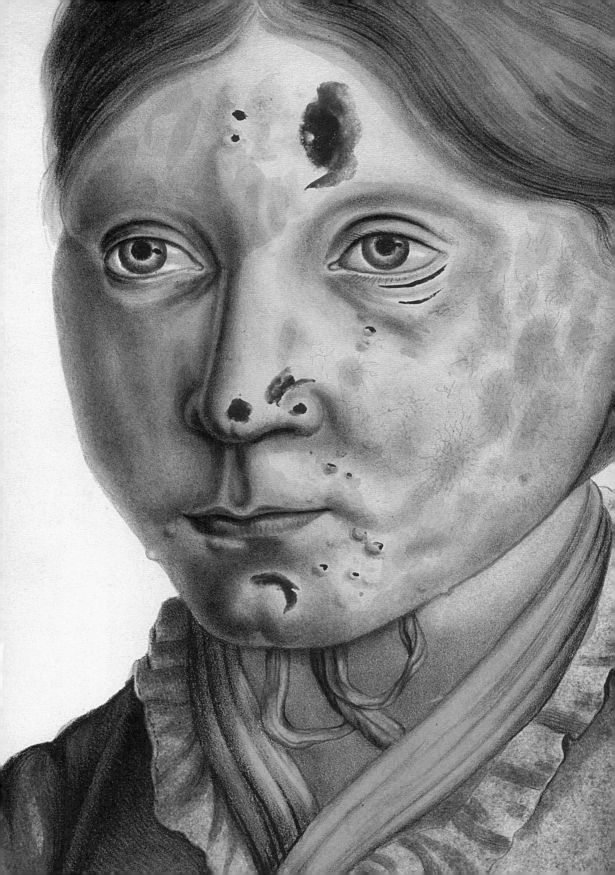

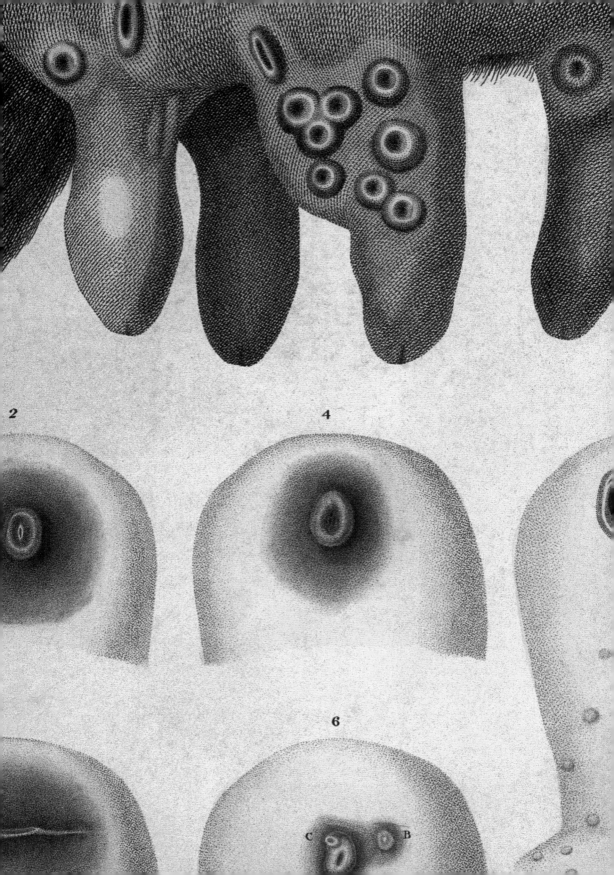

SMALLPOX

SMALLPOX

BLISTERED BY ACT OF PARLIAMENT

Riding between house-calls in the villages of Gloucestershire, the handsome physician spent a great deal of his time gazing at the smooth faces and hands of milkmaids. Proverbially beautiful, these young women seemed never to suffer the disfigurement of smallpox. As he paused to talk and flirt, the physician noted that milkmaids who caught their trade disease, cowpox – a transient contagion which manifested as small sores on the hands – thought themselves safe from the greater threat of smallpox.

This, at any rate, is one version of how the English doctor Edward Jenner – certainly a dandy and a ladies' man – came up with the idea of vaccination. Jenner's work in the late 1790s meant that, almost uniquely among the diseases discussed here, nineteenth-century physicians could counter smallpox with a specific and effective preventative measure. But vaccination was also deeply controversial, and the history of smallpox in nineteenth-century Europe was dominated by debates over the meaning and morality of state intervention in the lives of citizens.

Jenner's insight – that a milder form of smallpox might stop sufferers contracting the more serious illness – was not at all new. Variolation, in which dried smallpox scabs were ground up and pressed into small cuts in the skin, had been practised in the Middle East and Asia for centuries. The technique was not without its risks, not least causing a full-blown case of smallpox, but in most cases it seemed to confer some protection. In the late 1710s Lady Mary Wortley Montagu, epistolary sparring partner of Alexander Pope and the wife of the British ambassador to Constantinople, encountered variolation. Montagu had survived smallpox a few years earlier, at the expense of her famous beauty, and she immediately had her children variolated.

When she returned to England in 1718 Montagu set about promoting variolation. Her contacts at court brought the technique to the attention of the royal family and, after public tests on condemned prisoners and orphans, several of the royal grandchildren were variolated successfully. Though never commonplace, and with ongoing fears over its safety and morality, variolation was practised across Europe, typically by itinerant inoculators rather than physicians. For some the technique embodied the rational humanitarianism of the Enlightenment, and Voltaire praised variolation as a signpost to what enlightened medicine might hope to achieve.

Jenner himself had been variolated as a boy, and in May 1796 he carried out a hazardous test of his cowpox hypothesis. Taking pus from sores on the hand of Sarah Nelmes, a local milkmaid, he pushed it into a cut in the skin of James Phipps, the eight-year-old son of his gardener. Phipps developed cowpox, but recovered within a week. He showed no further signs of illness, even when Jenner variolated him several times. Borrowing the Latin for 'cow', Jenner named his technique vaccination.

Through the late eighteenth century Jenner's observations on cowpox had been anticipated by at least five others. What made Jenner into 'the father of vaccination' was his savvy and highly successful campaign for the technique, conducted in print and in Parliament, and supported by cutting-edge medical illustrations. Jenner's *An Inquiry into the Causes and Effects of the Variolae Vaccinae* (1798) included detailed etchings of cowpox pustules at different stages, drawn by the artist Edward Pearce and engraved by William Cuff and William Skelton. And when Captain Charles Gold of the Royal Artillery made a series of studies of smallpox in 1801, Jenner had copies of thirty images made in watercolour and included them in a petition to Parliament, after which he received an initial payment of ten thousand pounds for his work.

Jenner's vaccination was adopted all over Europe, crossing the battle-lines of the Napoleonic wars, and also taken to European colonies in the tropics. One problem facing vaccinators was that, to be effective, cowpox pus had to be taken fresh from sores, during the week or so in which they appeared. The Balmis expedition of 1803–06, which took the older technique of variolation to Spanish colonies in South America and Southeast Asia solved this problem by carrying twenty-two unvaccinated orphan boys. As one recovered, the next was inoculated from his sores. Vaccination in British India, introduced by the East India Company in 1802, was far more controversial. Variolation was for many Indians a religious ritual, practised by the devotees of Sitala, the pox-goddess, and bodily contact with matter ultimately derived from cows was deeply repugnant to cultural and religious sensibilities.

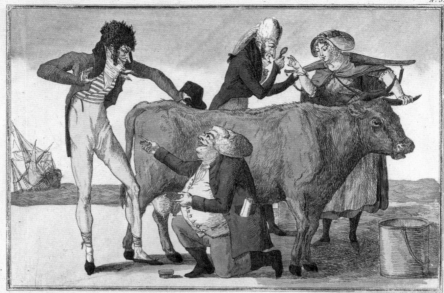

L'ORIGINE DE LA VACCINE.

A Paris chez Depeuille, Rue des Mathurins Sorbonne aux deux Pilastres d'Or.

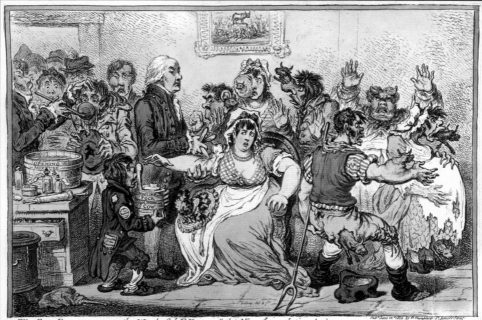

The Cow-Pock — or — the Wonderful Effects of the New Inoculation! — Vide...the Publications of ÿ Anti-Vaccine Society.

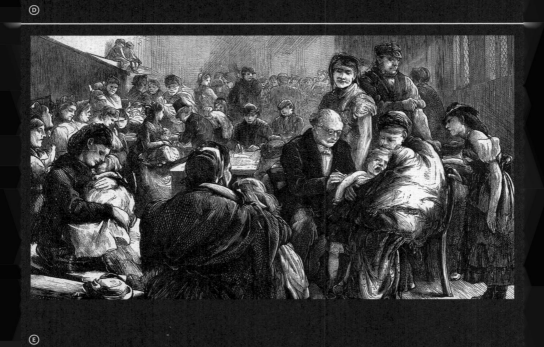

British sensibilities, too, were not unmoved by vaccination and its blurring of the boundary between human and animal. In *The Cow-Pock* (1802), his satire on Jenner, James Gillray played on public fears by showing cows bursting out of legs, noses and even the mouths of the vaccinated Ⓓ. Some landlords and employers took up vaccination for their tenants or workers, but the prevailing political ideology of *laissez-faire* discouraged any proposals for a state programme of vaccination. In the 1830s and 1840s, however, this political climate began to change, as state and medical intervention (in the form of the New Poor Law and public health reforms) became more common but no less contentious. The Compulsory Vaccination Act of 1853 made vaccination obligatory for all children born in England and Wales, and later Acts established a legal framework for punishing those who refused.

Societies like the Anti-Compulsory Vaccination League, established in 1874, and journals like the *Vaccination Enquirer*, founded in 1880, led the opposition, and most opposition to compulsory vaccination came from the self-educated, self-consciously respectable working class. Some saw it as a direct challenge to personal liberty: John Gibbs, a leading anti-vaccination campaigner, asked angrily whether Britons were now to be 'leeched, bled, blistered, burned, douched, frozen, pilled, potioned, lotioned, salivated by Act of Parliament?' Parents worried, not unreasonably, that vaccination might spread other diseases. And while those with money could pay for private vaccination from a physician, others had to enter the Poor Law system, giving vaccination some overtones of the workhouse Ⓔ. Jenner was derided as a money-grabber and a quack, and in 1862 his statue, originally placed on the fourth plinth in Trafalgar Square, was moved to a more discreet site in Kensington Gardens.

At the beginning of the twentieth century both the incidence of smallpox in Europe and the intensity of anti-vaccination campaigns were declining. By this time bacteriologists were coming to realize that some infectious diseases might be caused by agents too small to be observed with a light microscope (the viruses responsible for smallpox and cowpox were not observed until after the invention of the electron microscope in 1931). The only infectious disease that nineteenth-century medicine could prevent with any certainty was also a disease that nineteenth-century bacteriology was not equipped to decipher.

Ⓐ A French satire on English physicians: this caricature, published around 1800, shows a physician and a farmer extracting pus from cowpox sores on the teats of a cow, while a second, dandyish physician examines the hand of a beautiful milkmaid. The sinking ship in the background may refer to English (or French) losses in the Napoleonic Wars. Ⓑ Variolation before Jenner: an eighteenth-century European variolator, made of ivory and boxwood. Ⓒ Vaccination after Jenner: a mid-nineteenth-century French set of six vaccination lancets. Ⓓ Bestial anxieties: James Gillray's 1802 caricature of what might happen to those who visited Jenner's Smallpox and Inoculation Hospital at St Pancras. Ⓔ Vaccination as mass medicine: Edwin Buckman's 1871 engraving, published in *The Graphic*, shows a physician vaccinating crowds of poor children in a dispensary in the East End of London. Ⓕ & Ⓖ Infecting to prevent: these engravings, from John Ring's *Treatise on the Cowpox*, published in 1803, show the development of cowpox vesicles over about three weeks.

The Vaccine Vesicle

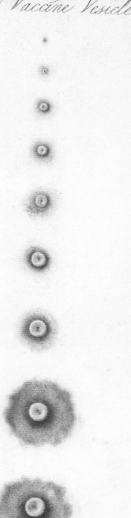

Burke Sc.

Pub. for Rings Treatise on the Cowpox. Jan.ʸ 1, 1803.

The Vaccine Vesicle

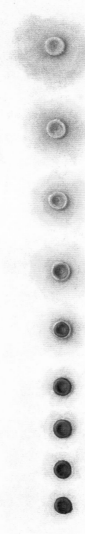

Burke Sc.

Pub. for Rings Treatise on the Cowpox. Jan.ʸ 1, 1803.

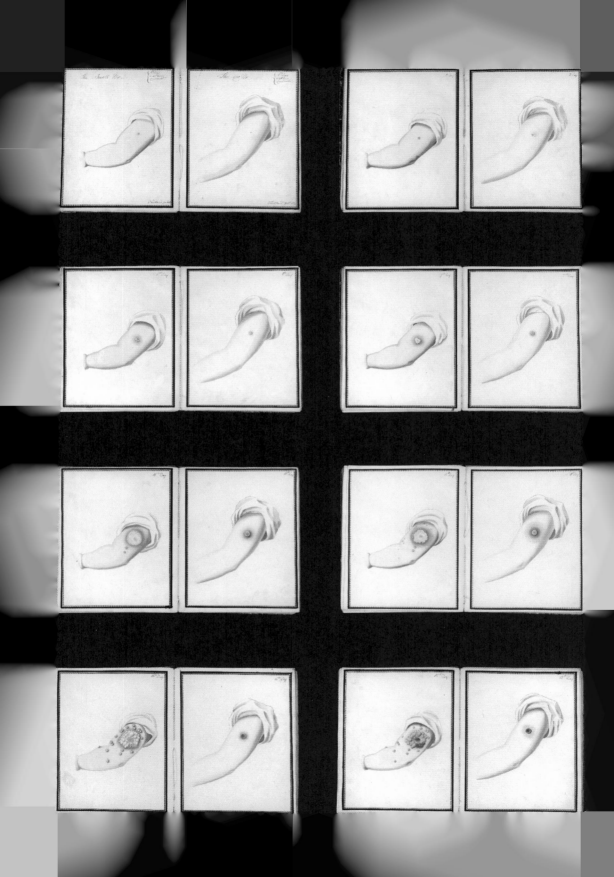

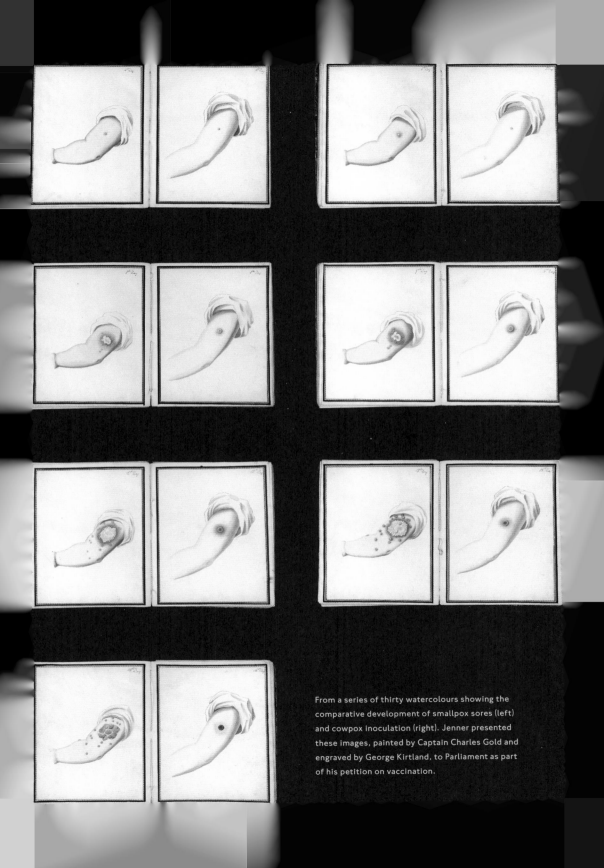

From a series of thirty watercolours showing the comparative development of smallpox sores (left) and cowpox inoculation (right). Jenner presented these images, painted by Captain Charles Gold and engraved by George Kirtland, to Parliament as part of his petition on vaccination.

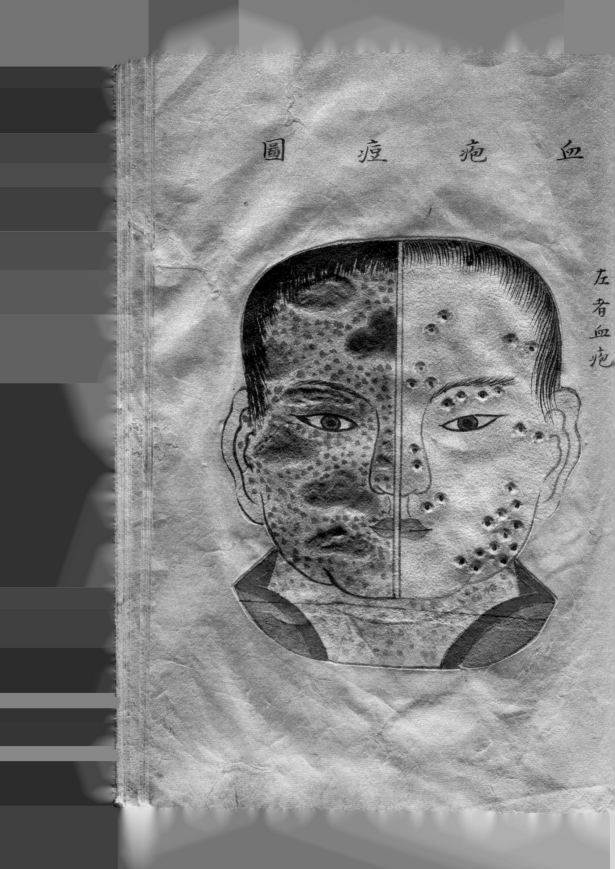

血疱痘圖

左者血疱

蛇皮痘圖

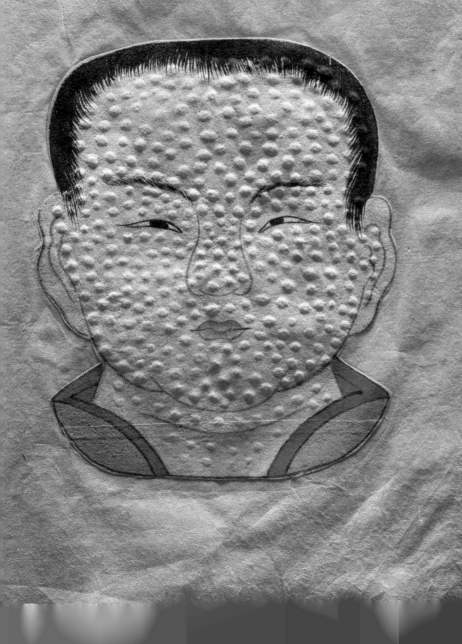

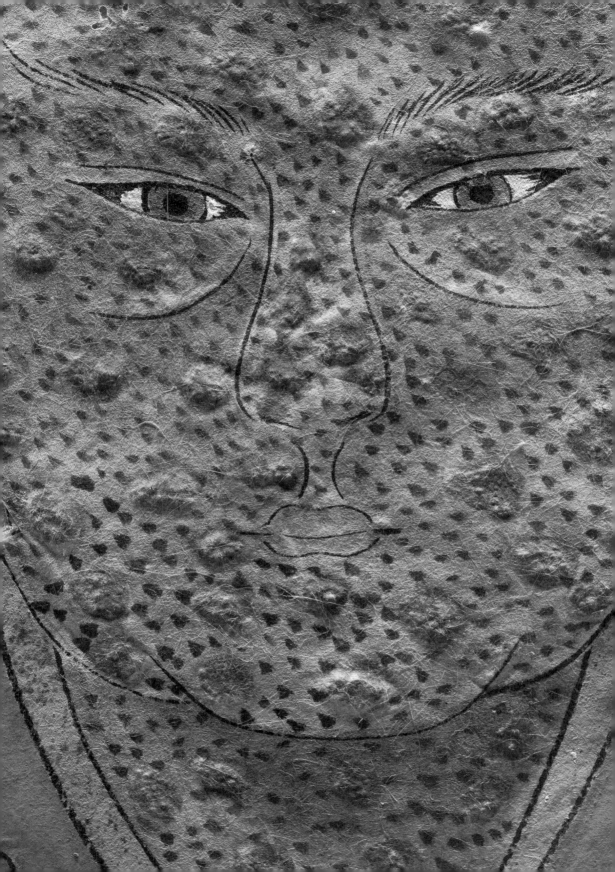

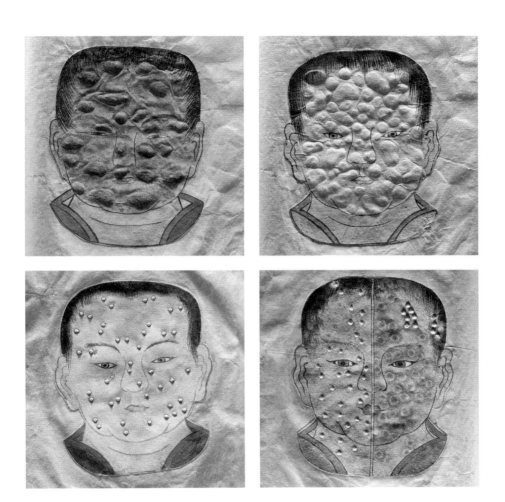

PREVIOUS, OPPOSITE, ABOVE AND OVERLEAF | Hand-drawn and textured pages from a rare, possibly unique, Japanese treatise on smallpox – *The Essentials of Smallpox* (*Tōshin seiyō* 痘疹 精要), written in the late seventeenth or early eighteenth century by the Japanese doctor Kanda Gensen (神田玄泉, alternatively 玄仙), and edited and supplemented by Enokimoto Genshō (榎本玄昌). These remarkable illustrations – the only images in this book not recognizably part of the Western tradition of anatomical and pathological illustration – offer a very different way of depicting disease, one that invokes touch as much as sight.

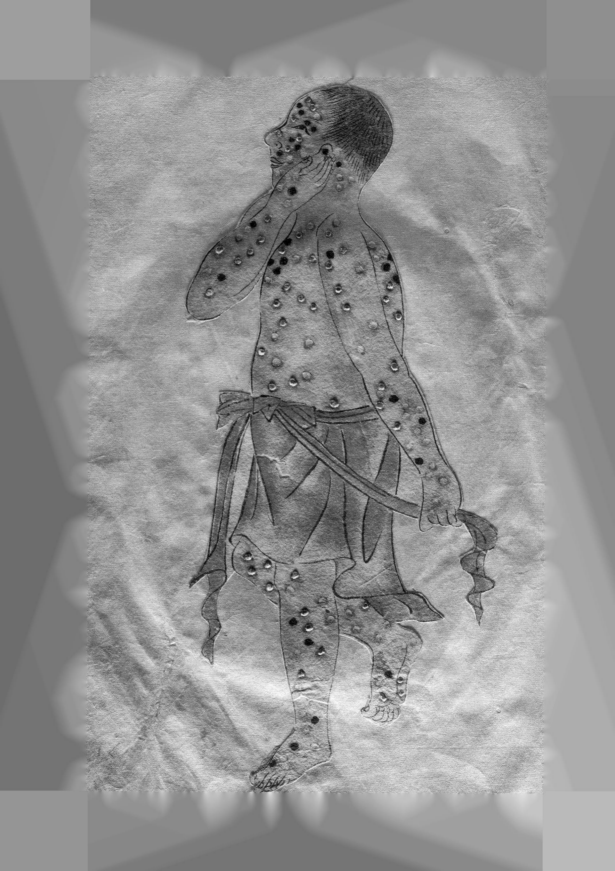

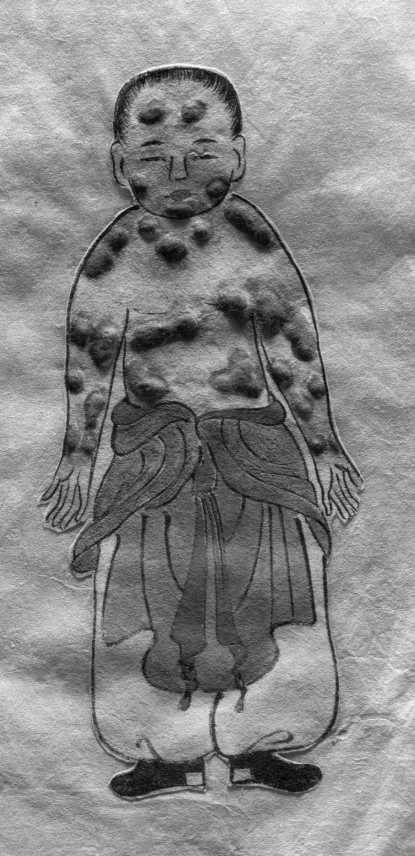

九
焦
痘
圖

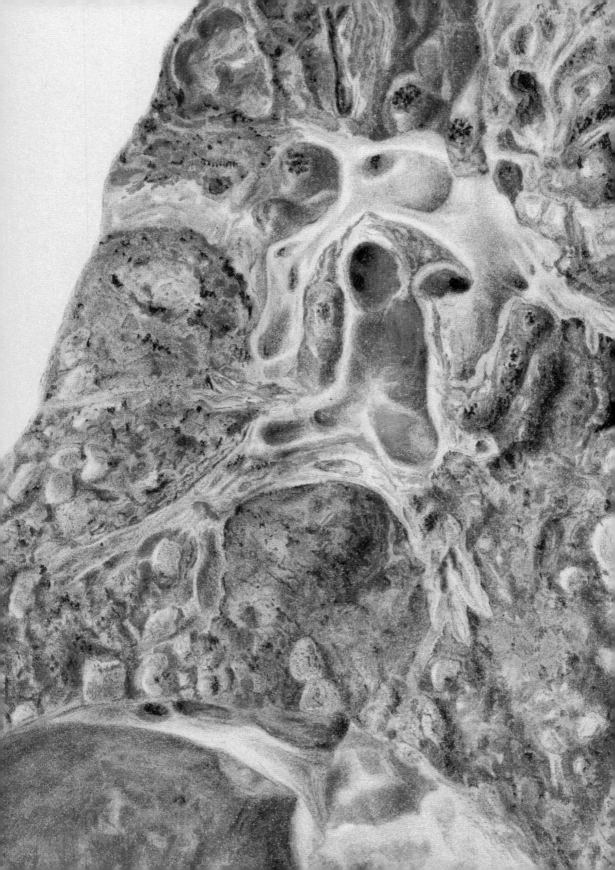

TUBERCULOSIS

TUBERCULOSIS

THE WHITE DEATH

No disease better illustrates the difficulties of nineteenth-century medical practice than tuberculosis. Arguments over heredity, nutrition, environment and contagion all came together within the potent cultural frame of a condition that killed one in five Europeans. Rather than claiming thousands in swift, savage epidemics it took its victims slowly, racking their bodies and exhausting their minds. Even as doctors and surgeons extended their claims to authority in Western culture, tuberculosis was a reminder that expanding medical knowledge did not instantly transform the profession's ability to cure. It invoked an older idea of medicine's function: chronic care over years or even decades for invalids who would not, for the most part, recover.

Older names for the disease – consumption and phthisis (from a Greek word meaning to waste away) – reflect the way in which it seemed to destroy the body from within. This was, above all, a constitutional condition *par excellence*, one that seemed to sap strength and energy until life was exhausted. And it seemed to be passed from parents to children, destroying entire families over a generation or two. For most physicians consumption was best understood as the result of a 'consumptive diathesis', an inherited predisposition brought to florid sickness by poor living conditions, a bad diet or overwork.

In 1819 the French physician René Laennec turned his clinical gaze, honed in the Paris hospitals, towards consumption. Laennec argued that a disparate set of diseases were the result of the same kind of lesion in different tissues: scrofula in the lymph nodes of the neck, consumption in the lungs, Pott's disease in the spine. Twenty years later the German doctor J. L. Schönlein named these lesions tubercles (from the Latin for a hillock), and the disease they engendered tuberculosis. Many physicians, applying the principles of pathological anatomy, noted apparent resemblances between tuberculosis and cancer. Both diseases tended to spread through the body from a single primary lesion, and tubercles killed in the same way as tumours, invading, compressing or eroding healthy tissues.

By the middle of the nineteenth century Western doctors were using Laennec's stethoscope to diagnose their patients with tuberculosis, but their prognoses remained bleak ⑧. Almost half of those diagnosed would die in their early twenties, and mortality was higher among women, perhaps due to the physiological strain of pregnancy, perhaps because bread-winning men tended to be given the best of whatever food was available. The disease spread like mist through the overcrowded, under-nourished industrial cities, but it also gained a morbid cultural reputation as the archetypal disease of artists, aesthetes and Romantics.

Consumption seemed to capture the popular notion of Romanticism: an excess of passion, burning away inside the body, purified the creative soul with suffering. It is thought to have killed John Keats, Elizabeth Barrett Browning, Henry David Thoreau, Frédéric Chopin, Jules Laforgue and the six Brontë siblings, and consumptive characters appear in nineteenth-century art and literature from Alexandre Dumas fils's *La Dame aux camélias* (1848), which inspired Giuseppe Verdi's *La Traviata* (1853), to Giacomo Puccini's *La Bohème* (1896), itself based on Henri Murger's *Scenes of Bohemian Life* (1848). Some even affected a fashionably consumptive appearance, whitening their faces with powder and mimicking emaciation with corsets.

Consumption's cultural influence can also be seen in the way that people aspired to die. The nineteenth century's ideal of the 'Good Death' reflected the kind of slow, painless death that might result when – as Allan Kellehear has pointed out – chronic tuberculosis was ameliorated with heavy doses of opium ①. The dying person experienced a gradual decline, with plenty of time to settle his or her affairs, make peace with God and take leave of family. They became paler, thinner, perhaps more beautiful, slowly taking on the characteristics of the next world as they moved towards it. As with all cultural archetypes aspiration rarely reflected quotidian reality, but this kind of 'Good Death' was enacted throughout Victorian art and literature, from Tennyson's *Idylls of the King* to any number of Dickensian deathbed scenes. In a world where sudden death might be lurking around the next corner, one might earnestly hope to meet this kind of end, rather than the swift, ugly and degrading horror of cholera.

On 24 March 1882 the German bacteriologist Robert Koch announced to the Berlin Physiological Society that he had identified the bacterium that caused tuberculosis. Koch's ideas were taken up quickly across Europe and the United States, and by the end of the century most doctors accepted that tuberculosis was fundamentally an infectious disease. But older ideas continued to inform debates over the condition, most over some potentially hereditary component. Some, drawing on the notion of a consumptive diathesis, endorsed a 'seed and soil' hypothesis in which bacteria would infect only those with weak constitutions or an inherited metabolic weakness. And though Koch's work established a consensus on the cause of tuberculosis, his treatment – tuberculin, a glycerine extract of the bacterium, announced in 1890 – was quickly shown to be ineffective.

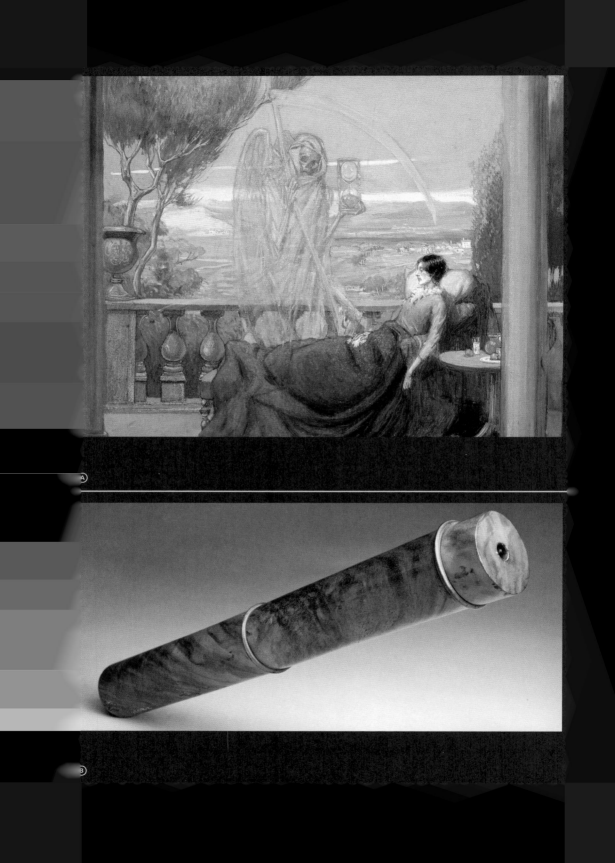

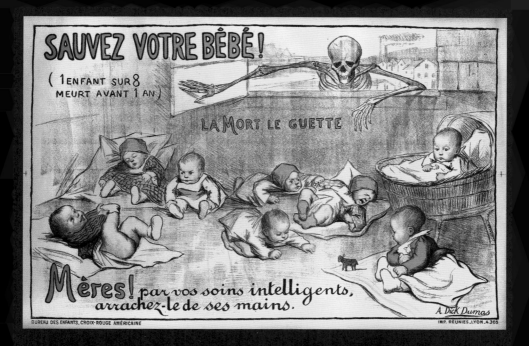

SAUVEZ VOTRE BÉBÉ!

(1 ENFANT SUR 8 MEURT AVANT 1 AN)

LA MORT LE GUETTE

Mères! par vos soins intelligents, arrachez-le de ses mains.

A. Dick Dumas

BUREAU DES ENFANTS, CROIX-ROUGE AMÉRICAINE

IMP. RÉUNIES, LYON, 4.305

©

MEDICATED BALSAMIC
CHEST PROTECTOR.
"A Friend in Need!"

S. MAW, SON & THOMPSON,
10, 11, & 12, ALDERSGATE STREET, LONDON, E.C.

Ⓓ

GEGEN DIE TUBERKULOSE!
Ausstellung
vom 27. April–18. Mai im Gewerbemuseum Spalenvorst.
Eintritt frei täglich 10–12,½–5,8–10, Sonntag 10½–12½, 2–5 Uhr.
Führungen durch Ärzte!
Im Bernoullianum 4 öffentliche Vorträge.

I. Freitag 2. Mai Herr Prof. EGGER
Der Kampf gegen die Tuberkulose.
II. Freitag 9. Mai Herr Prof. DE QUERVAIN
Die Pflichten der Gegenwart gegenüber
den chirurg. Tuberkulosen.

III. Freitag 16. Mai Herr Prof. WIELAND
Die Tuberkulose beim Kinde.
IV. Sonntag 18. Mai Herr Dr. NIENHAUS
Die Sanatoriumsbehandlung der
Lungentuberkulose.

Ⓔ

From the 1860s German physicians had begun to send their better-off consumptive patients to sanatoria, well-appointed private hospitals, usually set in the bracing air of mountains, pine forests or coastal islands. Through the late nineteenth and early twentieth centuries sanatoria – some state-funded, most private – appeared in rural regions across the West. Under medical orders to rest and regain their strength, patients could eat well, sleep deeply, sunbathe, swim and take restorative walks. Rest could even be induced surgically by collapsing an infected lung. After Koch's work sanatoria gained the additional benefit of isolating infected patients, and their inhabitants were encouraged to inhale the vapours of creosote or carbolic acid in an effort to kill off bacteria. Friedrich Jessen's sanatorium in Davos, Switzerland, provided a setting for the twentieth century's greatest work of consumptive literature – Thomas Mann's *The Magic Mountain* (1924). But the long-term results of sanatorium care were not much better than staying at home, and poorer patients in the last stages of the disease might expect nothing more comfortable than an isolation ward in a workhouse hospital.

Though the incidence of tuberculosis began to decline in the late nineteenth century (most likely a consequence of improving nutrition and living conditions among the urban poor), the stigma attached to the diagnosis still encouraged doctors and patients to conceal it, and statistics showed that the disease was still closely tied to poverty. The parallel decline of Britain's industrial and military pre-eminence amplified fears over the future of the British Empire and, perhaps, the physical and intellectual deterioration of her native stock. At the beginning of the twentieth century, as Germany and the United States emerged as world powers, some British commentators began to wonder: would their empire, and eventually the entire West, suffer a kind of collective consumption, a slow decline into endless night?

[1] Allan Kellehear, *A Social History of Dying*, Cambridge University Press, 2007.

Ⓐ The white death: in this late nineteenth- or early twentieth-century watercolour by Richard Tennant Cooper, tuberculosis – personified as a skeletal angel of death, clutching the traditional attributes of a scythe and hourglass – appears before a sickly, bedridden young woman, as she rests on a balcony overlooking a beautiful landscape. Ⓑ Listening to the lungs: this polished three-part wooden stethoscope is of the kind invented in 1816 by the French physician René Laennec. Dr Paul Gachet, most famous for treating the painter Vincent van Gogh in the weeks before his suicide, owned this example. Ⓒ Childhood mortality: this coloured lithograph, made by the artist Alice Dick Dumas and distributed by the American Red Cross in France, highlights the threat posed to the health of young children by dirty industrial townscapes – here embodied in the skeletal figure of Death. Ⓓ Desperate remedies: a 'Medicated Balsamic Chest Protector', marketed in London in the late nineteenth century as a way of preventing tuberculosis infection. Ⓔ In a poster for a 1913 exhibition at the Science Museum, Basel, tuberculosis is personified as the writhing, petrifying head of the Medusa. Ⓕ In this 1905 poster, raising funds for a children's sanatorium outside Zurich, a girl with tuberculosis beckons her fellow-sufferers into the healthful air of the pine forest. Perhaps snakes, as in the previous image, here curled around the tree trunks, are seen to embody some particular aspect of the disease.

OPPOSITE | A dissection of a tubercular lung. From the accompanying notes:
'The lower part is solidified by greyish, tubercular infiltration, the central portion
contains a large abscess and the superior part a patulous one surrounded by incipient
gangrene. The central abscess is traversed by a branch of the pulmonary artery
and the pleura is much thickened because of inflammation.' | ABOVE | Dissections
of tubercular lungs and brains. | OVERLEAF LEFT | Some of the effects of
tuberculosis in the kidneys. | OVERLEAF RIGHT | Tuberculosis in the brain.

119.

a

b

c

220.

a

b

c

d

221.

g

f

c

e

d

b

a

224.

a

223.

a

b

222.

a

b

c

226.

a

229.

228.

227.

225.

a

From Nature & finished
on Stone by Dr Hope

From Nature & revised
on Stone by Dr Hope.

A. Ducôte's Lithog, 70, St Martin's Lane

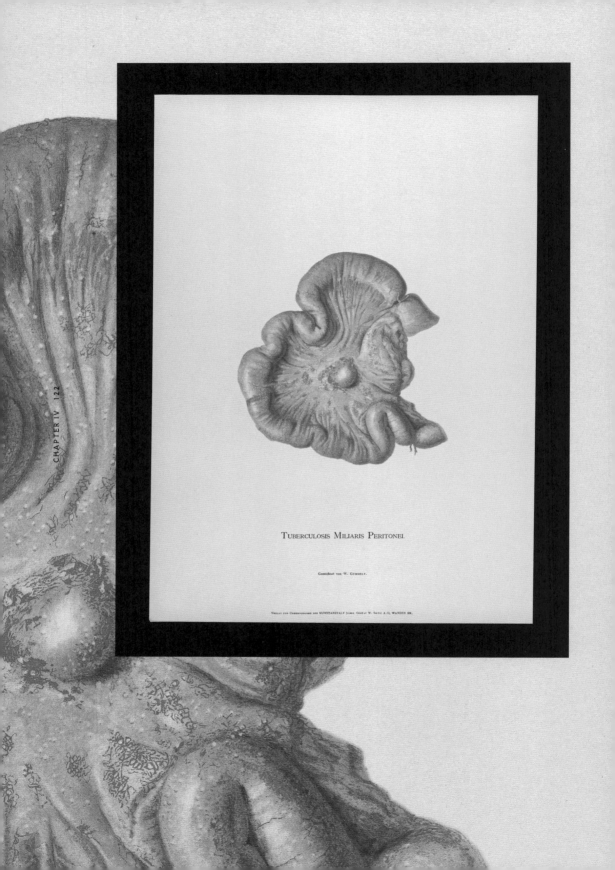

TUBERCULOSIS MILIARIS PERITONEI

Gezeichnet von W. Gummelt.

Verlag der Chromographie der KUNSTANSTALT (vorm. Gustav W. Seitz) A.-G. WANDSBEK.

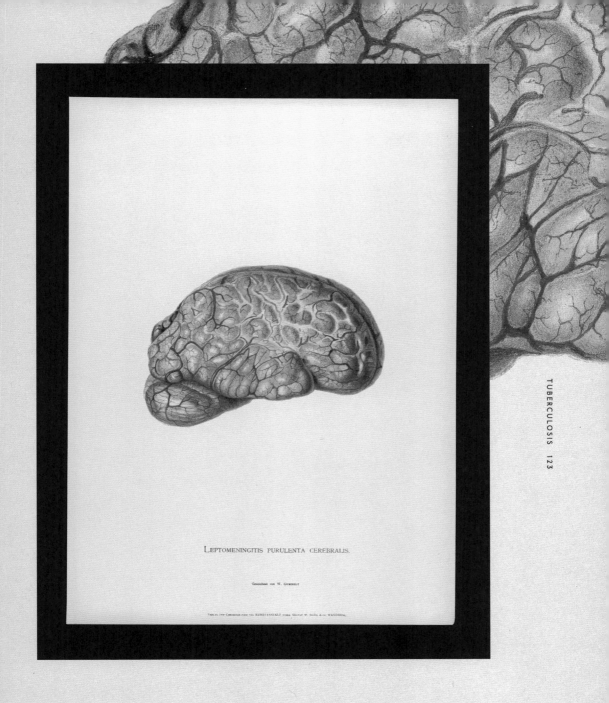

LEPTOMENINGITIS PURULENTA CEREBRALIS.

Gezeichnet von W. Gummelt

Verlag und Chromographie von KUNSTANSTALT (vorm. Gustav W. Seitz) A.-G. WANDSBEK.

OPPOSITE | Miliary tuberculosis affecting the peritoneum and intestines. | ABOVE
Tubercular leptomeningitis – a purulent infection of the membranes enclosing the brain.
OVERLEAF | Dissections showing the appearance and effects of pulmonary tuberculosis.

Fig.1.

Fig.2.

Drawn from Nature
⅄ on Stone by A. Rider.

Printed by
Childs & Inman.

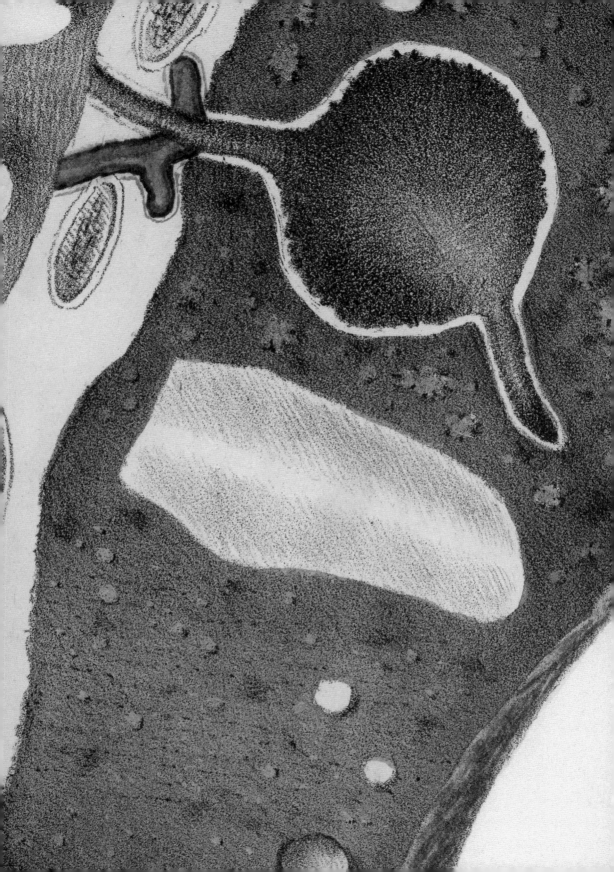

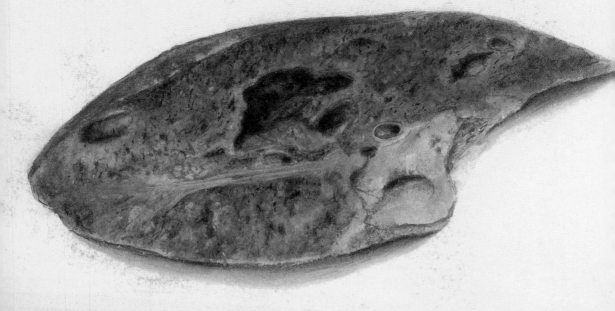

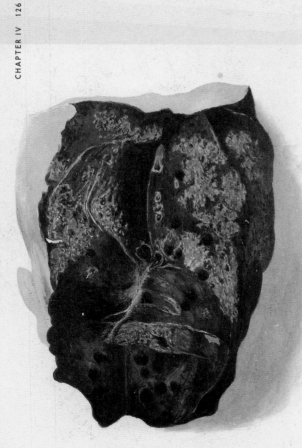

ABOVE | A dissection of a lung taken from a patient who died from pulmonary tuberculosis. The large cavities are tubercles – the 'walled-off' nodules characteristic of the disease. | LEFT | A dissection of a tubercular lung, showing diffuse and spotted apoplexy. The patient reportedly coughed up blood in the last stages of the illness. OPPOSITE | Top: A dissection showing miliary (disseminated) tuberculosis in a child's lung. Bottom left: Dissection of the spleen of a boy who had tubercles in his lungs, liver and other organs. It shows abundant diffuse tubercular deposits. Bottom right: A piece of lung tissue with a tubercular cavity.

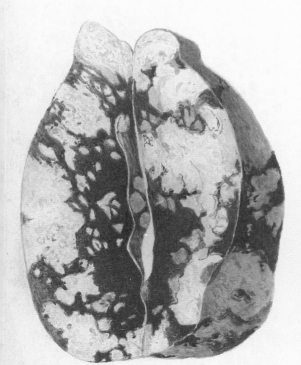

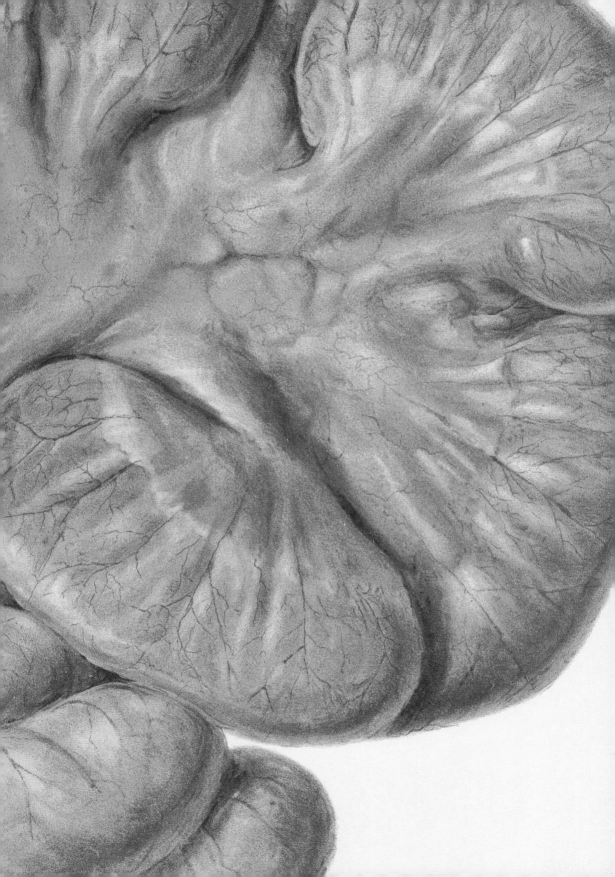

CHOLERA

CHOLERA

A FREE TRADE IN DISEASE

The history of cholera in the nineteenth century is inescapably global. Around 130,000 people died of the disease in Britain, with equally large numbers in most other Western nations, but it killed more than twenty million in India. From 1817 European governments watched with growing horror as cholera left its historical heartland in Bengal and began, slowly but inexorably, to move west. An editorial in the *Quarterly Review* called it:

'ONE OF THE MOST TERRIBLE PESTILENCES WHICH HAVE EVER DEVASTATED THE EARTH.... IF THIS MALADY SHOULD REALLY TAKE ROOT AND SPREAD IN THESE ISLANDS, IT IS IMPOSSIBLE TO CALCULATE THE HORROR EVEN OF ITS PROBABLE FINANCIAL RESULTS ALONE.'

Cholera was enormously significant in mid-nineteenth century politics and culture. In Britain it provoked a revolution in public health, political ideology and the treatment of the poor. It became a running theme in *The Times*, *The Lancet*, the novels of Charles Dickens and the scribblings of many less distinguished hacks and pamphleteers. And it gave its name to an age: historians still refer to the middle third of the nineteenth century as 'the cholera years'.

Demographically, however, cholera's impact on Europe was less clear-cut. It was epidemic, not endemic like tuberculosis, and Britain suffered only four epidemics over four decades (1831–32, 1848–49, 1853–54 and 1866). Over the nineteenth century cholera killed far fewer people than tuberculosis or the diseases of childhood. Even at the height of the 1831–32 epidemic it was never more than the third most common cause of death. Compare this with the Black Death, which returned dozens of times over three centuries, and in its first visitation carried off perhaps a third of Europe's population. So what lay behind the peculiar fear of 'Asiatic cholera'?

First, the name. 'Asiatic cholera' reflected the perceived origin of the disease, but it also expressed disquiet about the underside of imperialism. For most large Western nations the nineteenth century was an age of endless movement, of wars, migrations, exploration and trade. One vision of utopia was built on the free movement of people and commodities, and this seemed impossible without a parallel free trade in diseases. 'Asiatic cholera' appeared as a disease of filthy, uncivilized savages – whether in the slums of Soho or the bustees of Calcutta – that threatened to overwhelm the civilized heart of imperial government.

Epidemics of 'Asiatic cholera' came swiftly and without mercy, intense and seemingly indiscriminate, killing the fit and the strong alongside infants, the aged and the weak. Those who began to display the symptoms of cholera faced roughly a one in two chance of dying in their own watery faeces, within a day or even half a day of infection. Contemporary medicine could do nothing beyond the standard nostrums of brandy, opium, bleeding and purging, and many hospitals sensibly, if cynically, refused to admit infected patients.

From the perspective of government, cholera could be observed in novel and not always reassuring ways. In the late 1830s the British General Register Office began to collect and publish national data on births and deaths. For many, this perspective on the disease merely confirmed its near-supernatural capacity to spread and to kill. But most of all cholera seemed to threaten the established social and political order. Nineteenth-century European governments feared revolution on French lines, and cholera only amplified this trepidation in an era that also witnessed famines, economic depressions and the rise of working-class political movements like Chartism.

Cholera challenged the authority and accountability of a liberal state like Britain, and pointed an accusing finger at the moral squalor of those who (depending upon the observer's political persuasion) let themselves and their families live in filth, or paid their workers so little that they had no choice but to live in filth. In Charles Kingsley's novel *Two Years Ago* (1857) one character confesses the meaning of cholera:

'I HAVE BEEN A VERY DIRTY, NASTY FELLOW. I HAVE LIVED CONTENTED IN EVIL SMELLS, TILL I CARE FOR THEM NO MORE THAN MY PIG DOES.... I HAVE PROBABLY BEEN MORE OR LESS THE CAUSE OF HALF MY OWN ILLNESSES, AND OF THREE-FOURTHS OF THE ILLNESSES OF MY CHILDREN.'

Paradoxically, given all this, cholera was in one sense not at all new, and European doctors had been diagnosing their patients with the disease for centuries. In the Hippocratic world-view, those whose bodies were dominated by hot, dry yellow bile – *choler* – had a choleric temperament, fiery and easily angered. Yellow bile was the predominant humour of summer, adulthood and warm climates, and 'a cholera' was not necessarily a disease. It might be a kind of natural purging, the body ridding itself of excess yellow bile as the seasons turned, or in the passage from adulthood to old age. Only when this purging became excessive was it considered pathological, and given a name: *cholera morbus*, literally 'bile sickness'.

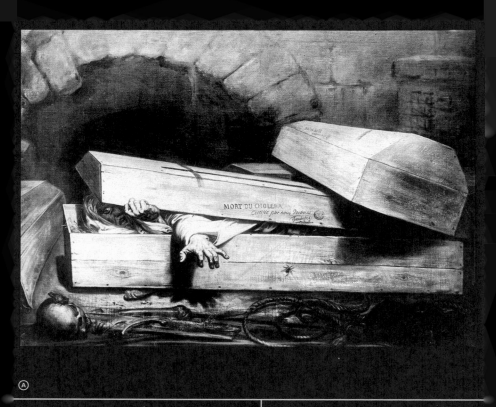

MORT DU CHOLERA
Certifié par nous Docteurs
Barnbetti

Now you rascal where
are you going to

Beware
of the
Bull

Board
of
Health

I am going back again

The
Wooden
WALLS
of
OLD
ENGLAND

REFORM BILL

JOHN BULL CATCHING THE CHOLERA

London Pubd by Mudgeons Cloth Fair

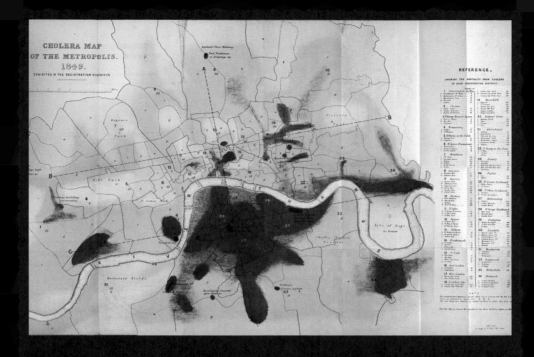

CHOLERA MAP OF THE METROPOLIS. 1849.

EXHIBITED IN THE REGISTRATION DISTRICTS.

REFERENCE,

SHEWING THE MORTALITY FROM CHOLERA IN EACH REGISTRATION DISTRICT.

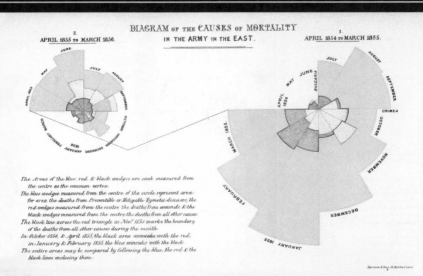

DIAGRAM OF THE CAUSES OF MORTALITY IN THE ARMY IN THE EAST.

2.
APRIL 1855 TO MARCH 1856.

1.
APRIL 1854 TO MARCH 1855.

The Areas of the blue, red, & black wedges are each measured from the centre as the common vertex.

The blue wedges measured from the centre of the circle represent area for area the deaths from Preventible or Mitigable Zymotic diseases, the red wedges measured from the centre the deaths from wounds & the black wedges measured from the centre the deaths from all other causes.

The black line across the red triangle in Nov. 1854 marks the boundary of the deaths from all other causes during the month.

In October 1854, & April 1855, the black area coincides with the red, in January & February 1855 the blue coincides with the black.

The entire areas may be compared by following the blue, the red, & the black lines enclosing them.

By the early nineteenth century the most popular explanation for cholera was miasmatic theory. In this interpretation, 'filth diseases' like cholera and typhoid were a product of the appalling conditions of urban life. Rotting sewage, refuse, graveyards and even living human bodies gave off poisonous vapours, miasmas. This theory underpinned the revolution in public health and government provoked by lawyer Edwin Chadwick's *Report on the Sanitary Condition of the Labouring Population of Great Britain* (1842). Chadwick rejected the moral and political Malthusianism of the 1834 New Poor Law, which had established a national system of workhouses. Instead he advocated a programme of public health reform; cleaning up the industrial cities would, he reasoned, remove sickness and poverty.

What seems to be the most empirical explanation for cholera – a germ theory of infectious disease – appeared at the time to be a blur of hypothesis, speculation and wishful thinking. Could this continent-crossing disease be the result of tiny, possibly animate specks of matter? If these contagious particles could be found everywhere, how did anyone escape death? Until the laboratory bacteriology of Robert Koch and Louis Pasteur became widely accepted a generation later, there were no standardized techniques for classifying, isolating and studying microscopic life. It was largely a matter of microscopists comparing drawings of what they had seen through their lenses; not surprisingly, they rarely agreed.

In the second edition of *On the Mode of Communication of Cholera* (1855) the general practitioner and anaesthetist John Snow used innovative epidemiological studies of a cholera outbreak in Soho in 1854 to demonstrate the connection between cholera and contaminated water Ⓖ. But Snow's work was largely ignored and had little influence on the course of nineteenth-century medicine and public health. When the German bacteriologist Robert Koch announced the identification of *Vibrio cholera* in 1883 – the single most important step in establishing a germ theory of cholera – his paper did not mention Snow.

From a modern perspective, the problem of cholera was an epidemiological and pathological puzzle, to be solved with shoe leather, statistics and flashes of insight. But it was also the problem of free trade and living in industrial cities; of maintaining imperial control and global military and naval strength; of the origin and nature of poverty; of the proper role of medicine in government and public life. It is ironic, and revealing, that many of these problems were solved not by physicians wielding microscopes and germ theories, but by lawyers, administrators and engineers who believed that cholera blew on the wind.

Ⓐ In this 1854 engraving by Anton Joseph Wiertz, a man wakes up in a crypt, having been mistakenly buried as a cholera victim. Ⓑ This lithograph by Gabriele Castagnola shows the collection of cholera victims for burial in the 1835 Palermo epidemic. Ⓒ This coloured lithograph, showing John Bull defending Britain against the invasion of cholera, personified as an Indian immigrant, also satirizes resistance to the Great Reform Bill of 1832. Ⓓ This map shows the incidence of cholera in London in 1848–49. Note the high incidence in the southern districts, which took their drinking water straight from the polluted Thames – an observation that did not elude John Snow. Ⓔ Florence Nightingale's innovative polar area diagrams in *Notes on Matters Affecting the Health, Efficiency, and Hospital Administration of the British Army* (1858), showing that, during the Crimean War, the British Army lost far more men to cholera and infectious diseases than to wounds. Ⓕ Cholera raged through mid-nineteenth-century London's crowded, insanitary industrial slums, as depicted in this woodcut from the fifth report of the National Philanthropic Association (1850). Ⓖ John Snow's *On the Mode of Communication of Cholera* (1855, 2nd ed.) mapped all the deaths from cholera from one epidemic in Soho, showing that they clustered around a communal water-pump.

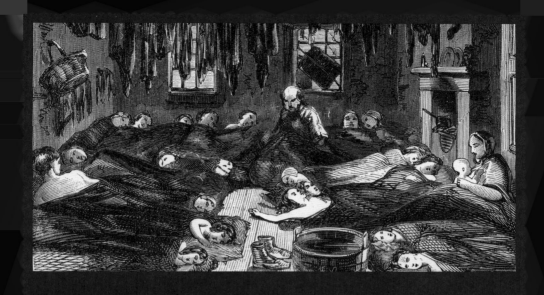

F

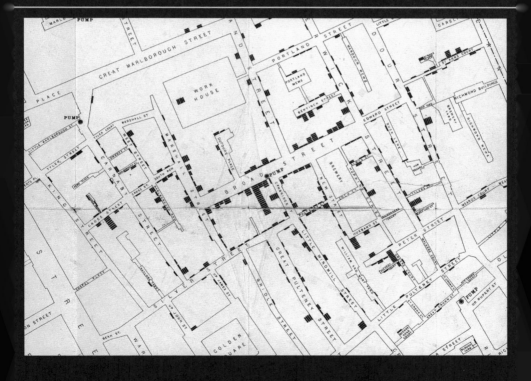

G

Giovane Viennese di 23. Anni

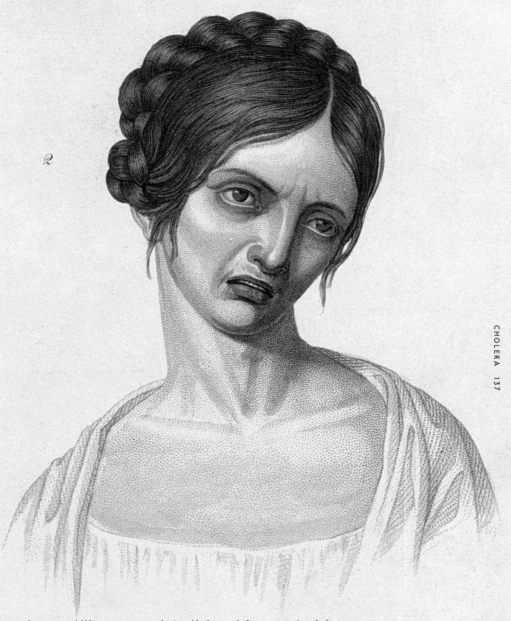

2

A twenty-three-year-old Viennese woman, depicted before and after contracting cholera in the first European epidemic in 1831. According to the original caption, the second image shows her only an hour after contracting the disease, and she died four hours later.

La med.ᵃ un'ora appreſso l'invasione del Cholera, e quattr'ore prima della morte

OPPOSITE | The effects of dehydration caused by cholera on various tissues. | ABOVE | Microscopic sections showing the effects of cholera dehydration on kidney and intestinal tissues.

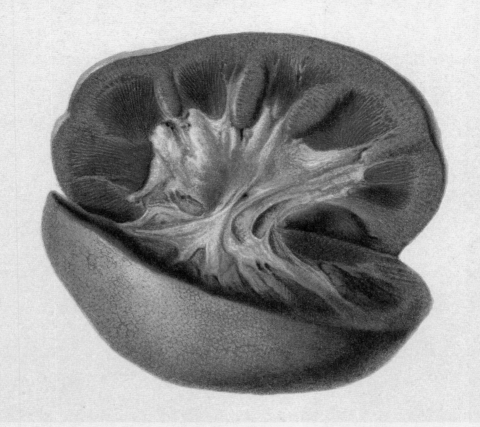

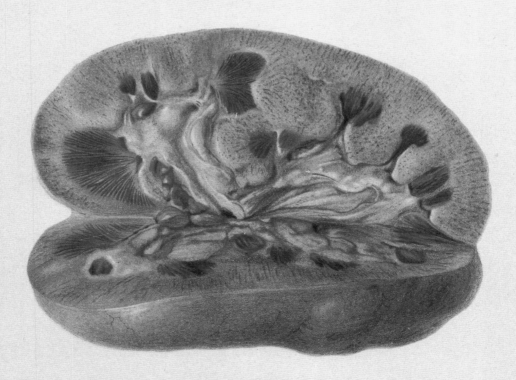

F 9.—

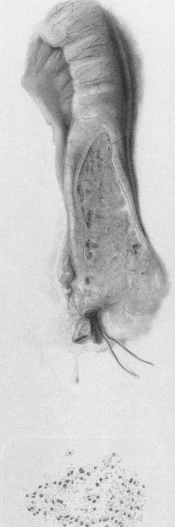

ILEUM CUM CONTENTIS. — BACILLI KOCHII CUM EPITHELIIS EX CONTENTIS.

(CHOLERA ASIATICA.)

Gezeichnet von W. GUMMELT.

VERLAG UND CHROMOGRAPHIE DER KUNSTANSTALT (VORM. GUSTAV W. SEITZ) A.-G., WANDSBEK.

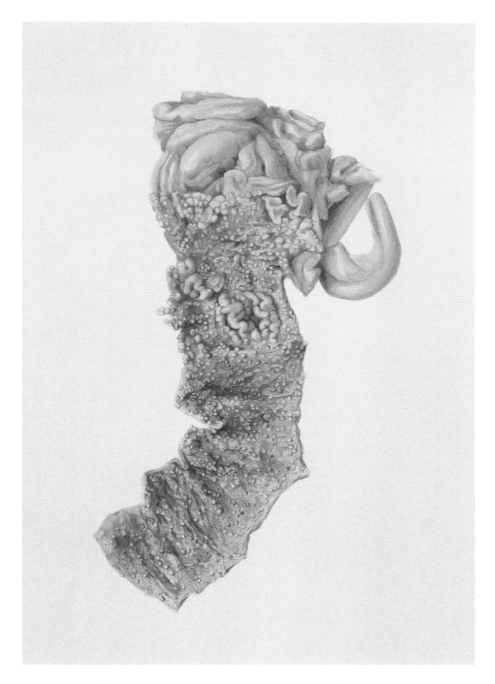

PREVIOUS LEFT | Dissection of an infarcted kidney from a cholera patient. | PREVIOUS RIGHT
A section of intestine removed, along with its contents, at autopsy from a patient who died of cholera.
OPPOSITE | Dissection showing the appearance of a section of intestine from a patient who died
of cholera. | ABOVE | Dissection showing the lining of the intestine in a cholera patient.

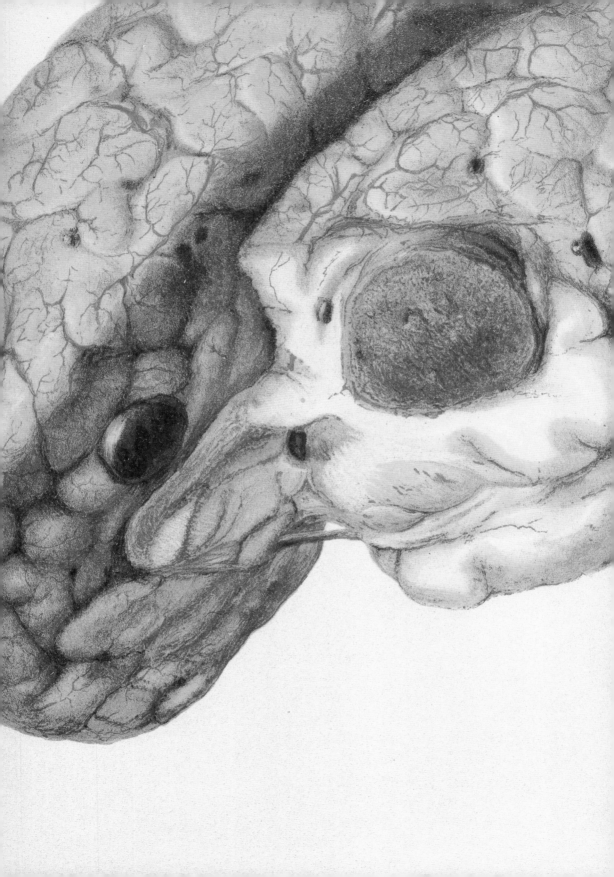

CANCER

CANCER

THE CLAWS OF THE CRAB

As nineteenth-century doctors entered public health and politics, so they began to talk about the body in new ways, as a busy city or a well-ordered nation-state. In this metaphor cancer was an insidiously political disease, a kind of insurrection in which the body politic revolted against itself, calling up forces of disorder and destruction lying dormant in everyday life. Keeping order – the maintenance of a proper balance in patients' bodies, minds and lives – had always been one of medicine's chief roles. In an age of apparently uncontrollable growth, with industrial cities metastasizing across the landscape and radical forms of political dissent emerging in working-class consciousness, cancer evoked the difficulties facing politics and medicine.

In the Classical tradition cancer was a severe kind of imbalance, an excess of cold, bitter black bile. One of the Hippocratics also gave a name to this condition, by comparing the branching veins within tumours (or possibly their spreading extremities) to the legs and claws of a crab – *karkinos* in Greek, in Latin *cancer*. As early modern anatomists and physicians rethought Classical constructions of the body, they came to understand the disease as a consequence of excessive or wrongly-directed inflammation, the result of injury or chronic pain.

Under the revolutionary regime of Paris medicine, cancer, at least in its solid forms, became a kind of archetypical disease. It produced specific, material lesions in tissues, which the skilful practitioner could discern in life through physical examination and observe after death on the autopsy table. Xavier Bichat argued that cancer was fundamentally a disease of tissue repair, the consequence of a physiological process going wrong. Through the nineteenth century this focus narrowed even further, as the clinical gaze was directed through microscopes in German

laboratories, and as cells supplanted tissues as the fundamental fabric of the body.

In *Microscopic Investigations on the Accordance in the Structure and Growth of Plants and Animals* (1839) the German microscopist Theodor Schwann put forward a unified cell theory of life. Through his research Schwann became fascinated by the development of embryos: how could a single fertilized ovum generate so many different adult tissues, from bones to brains? Rudolf Virchow, another German physician who developed Schwann's work into a theory of cell pathology, wondered if tumours might grow from undifferentiated embryonic cells found in many kinds of connective tissue. William Waldeyer, working in Bonn, thought Virchow was on the right lines, but argued that cancers originated in the fast-growing epithelial cells lining the lungs, gut and many other organs.

By the mid-nineteenth century a growing medical consensus held that cancer was essentially a disease of cell division. Microscopical work, combined with Virchow's theory of cell pathology, could be used to classify tumours by the cell type from which they originated: lipomas from fat cells, myomas from muscle cells, chondromas from cartilage cells and so on. Researchers also began to draw a distinction between benign and malignant cancers, by the speed of cell reproduction and the integrity of tumours, and to observe other kinds of non-solid cancers. Several clinicians described diseases in which white blood cells proliferated uncontrollably, and in 1856 Virchow named these cancers 'leukaemias'.

Within this consensus, however, arguments continued over the nature of cancer, its cause and – especially

– the means by which it spread around the body. Autopsies on those who had died from malignant tumours revealed a scattering of smaller and apparently identical growths in other parts of the body. But was this physical colonization by cancerous cells, or did tumours engender cancer in other tissues by secreting some kind of poison or seed, a 'dyscrasia' or *seminium morbi*? And could the resemblance between tuberculosis and some cancers be taken to mean that a common underlying disease process was at work?

Similar to tuberculosis, cancer seemed impossible to pin down to a single specific cause. Physicians in the eighteenth century had connected some types of tumour to particular factors – nasal cancers with snuff-taking, scrotal cancers in chimney-sweeps with exposure to soot – and by the end of the nineteenth century studies of industrial workers revealed the carcinogenic properties of chemicals like aniline and phosphorus. Most cancers, however, were not so easily explained, and statistical studies showed the incidence of the disease increasing steadily through the century.

This seemingly inexorable rise was one factor behind the dramatic growth of cancer hospitals. In the secular landscape of Europe after the Reformation, cancer (along with venereal disease) was one of the first conditions to be treated in specialist institutions. The brewer Samuel Whitbread endowed the first specialist cancer ward at Middlesex Hospital in London in 1792, and in 1802 a group of London clinicians established the first association devoted to the disease – the Society for Investigating the Nature and Cure of Cancer. More influential was William Marsden's London Cancer Hospital, established as a dispensary in 1851 and opened to in-patients in 1862. Marsden, a surgeon

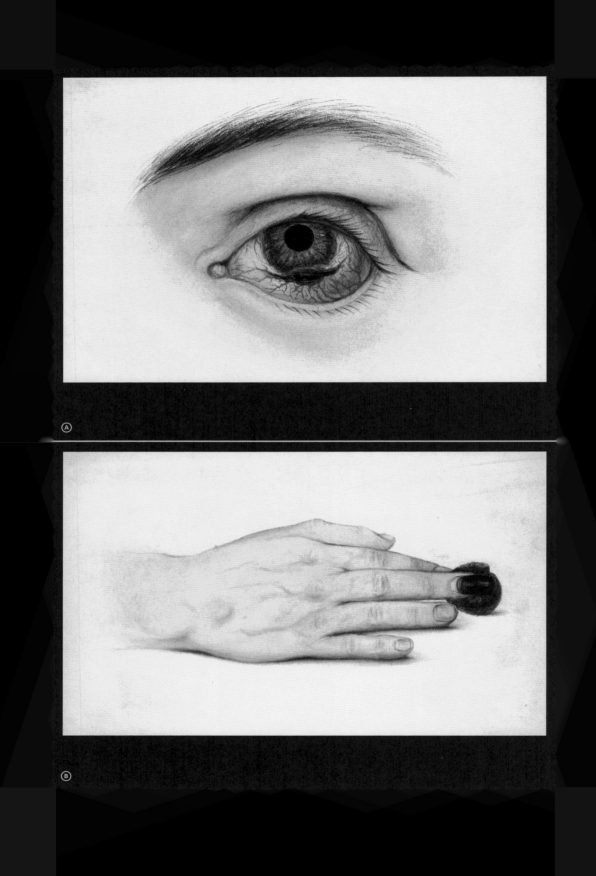

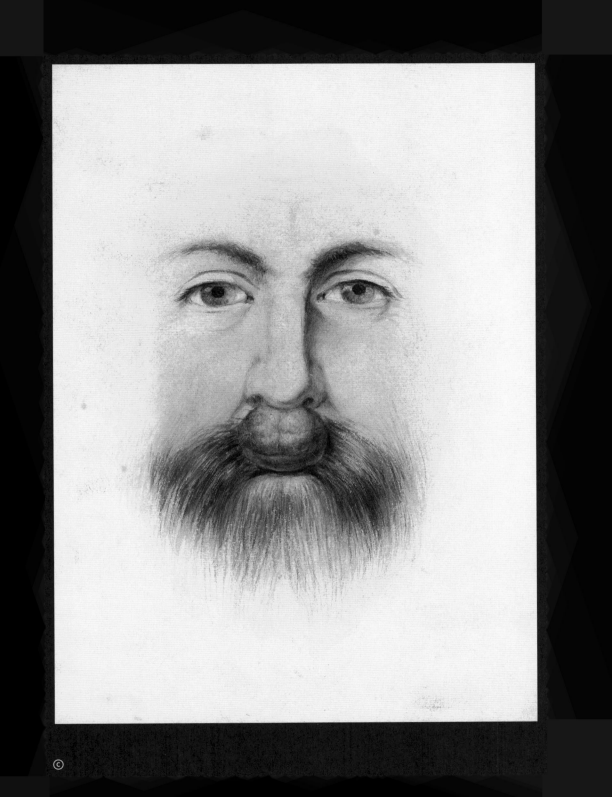

who had opened London's first free hospital in 1828, was moved to act by the death of his wife from cancer, and over the next generation most industrial cities in Europe and the United States acquired a specialist cancer hospital.

By the end of the century surgeons working in these hospitals were carrying out radically invasive operations, intended to excise every fragment of tumour. Cervical or ovarian cancer was met with total hysterectomy; stomach cancer with total gastrectomy, and breast cancer with removal of the whole breast and parts of the chest wall. Surgery had been the principal response to cancer for several centuries, at least for large benign tumours that could be addressed without opening the chest or abdomen. Even after the advent of anaesthesia, surgical intervention was widely feared, not only for the prospect of death on the operating table, but also for the prospect of surviving to face life with extensive surgical mutilation. And success rates remained low: the Austrian surgeon Theodor Billroth estimated that fewer than five per cent of his breast cancer patients would live three years or more.

Their achievements in identifying the causes of other diseases encouraged clinicians and scientists to search for less drastic and more effective treatments. Radiation seemed particularly promising, and on the eve of World War I, radium institutes were a common feature of large city hospitals. X-ray machines and radium therapy could halt and even reverse the growth of tumours, though doctors learned quickly that radiation had punishing side-effects, including hair loss and burns, and could itself initiate cancers.

Most importantly, medicine's encounters with cancer revivified ancient, almost philosophical arguments over what it meant to cure a disease. In the Hippocratic tradition a cure was the restoration of balance to a disturbed constitution. Under germ theory, however, medicine was reconceived as a battle between the doctor and the disease, with the cure as a final victory in which germs or tumours were driven decisively from the patient's body. The authority of scientific medicine was built – and to a great extent still is – on the promise that it would develop this kind of cure for all diseases. In the case of cancer, researchers were, over the twentieth century, able to produce increasingly sophisticated accounts of the disease process, to extend life through radiotherapy and chemotherapy, and to make increasingly accurate estimates of what time might remain. But for many kinds of cancer they were generally unable to offer a definitive 'cure' in the sense derived from germ theory. As in so many fields of medicine, the rigours of long-term management and day-to-day care have supplanted the language and tactics of the clinical battlefield.

Ⓐ The left eye of a woman, showing the growth of a melanotic sarcoma through the conjunctiva and sclera along the lower border of the cornea. Ⓑ A hand with a melanotic sarcoma of the middle finger. From the accompanying notes: *'The finger was amputated but the patient died ten months after the operation with a return of the disease in the axillary glands.'* Ⓒ The face of a man, showing a recurrent epitheliomatous tumour of the upper lip. According to the accompanying notes, an earlier and similar growth had been removed five years previously. Ⓓ It is highly unusual for the names of the patients in these images to have been recorded, but this fine 1829 watercolour drawing shows one Mr Gledell suffering from a 'rodent ulcer' – now known as a basal cell carcinoma. It is part of a series depicting 'gentlefolk of Leeds with grievous illnesses'.

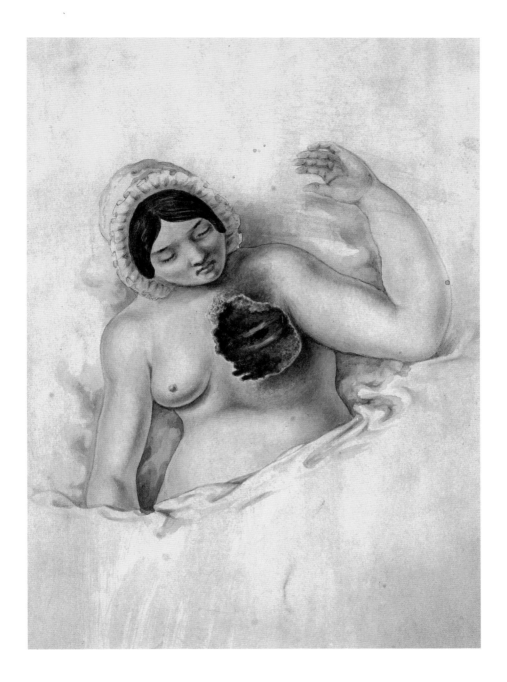

OPPOSITE | A woman suffering from breast cancer. | ABOVE | Breast tissue that
has necrosed and ulcerated, leaving a woman's chest muscles and ribcage exposed.

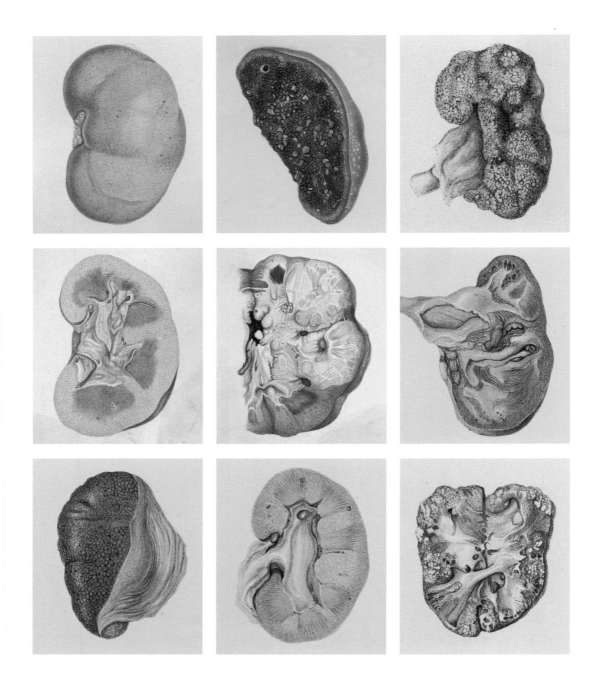

ABOVE | Various kinds of cancers affecting the kidneys. | OPPOSITE | Various forms of carcinoma in different organs. | OVERLEAF LEFT | Metastatic growths in various tissues. OVERLEAF RIGHT | Primary and metastatic growths in the intestines, lung and other tissues.

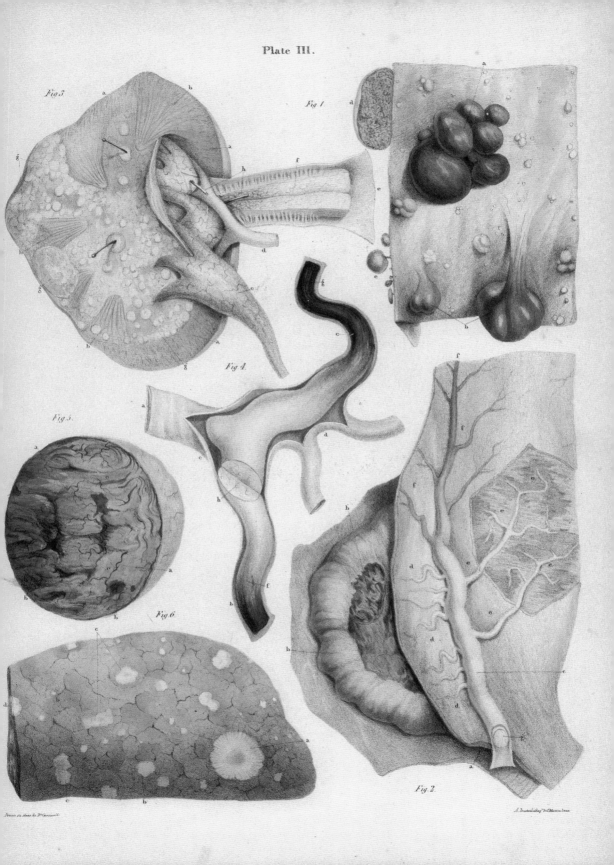

Plate III.

Plate I.

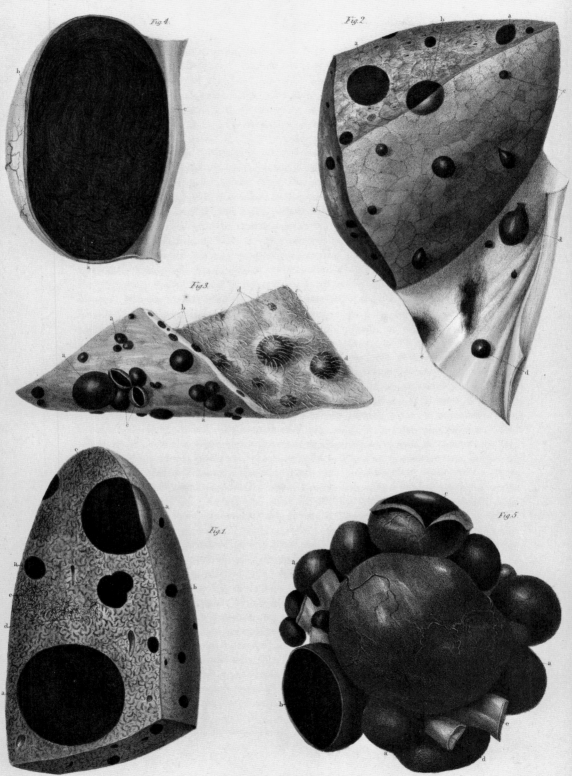

Plate III.
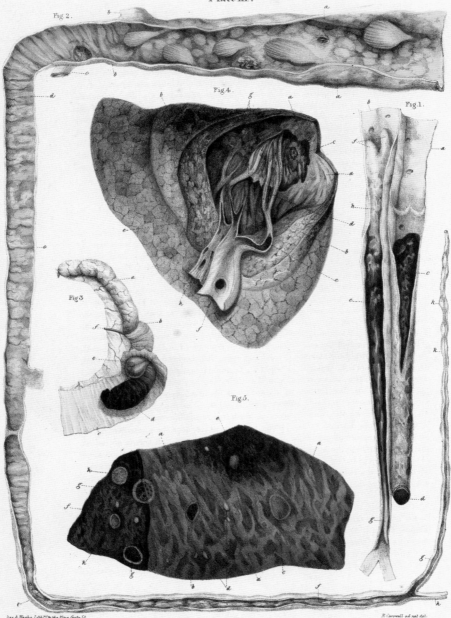

Day & Haghe Lith.rs to the King, Gate St.

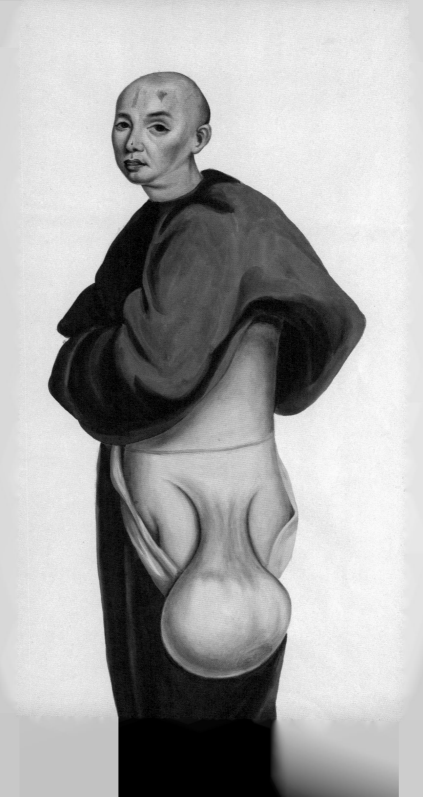

In 1835 the American physician Peter Parker opened a hospital in the Chinese city of Canton. For five years he commissioned gouache paintings from the painter Lam Qua, depicting patients at the hospital.

OPPOSITE | A man with a large pendent hip tumour. | BELOW A man with a large pendent face tumour. | OVERLEAF LEFT | Top left: Spherical neck tumour. Top right: Forehead tumours. Bottom left: Tumour covering the eye. Bottom right: A tumour on the left trunk. OVERLEAF RIGHT | Top left: A tumour below and behind the right ear. Top right: A pendent neck tumour. Bottom left: A tumour on the left arm. Bottom right: Pendent tumours on the left side of the face.

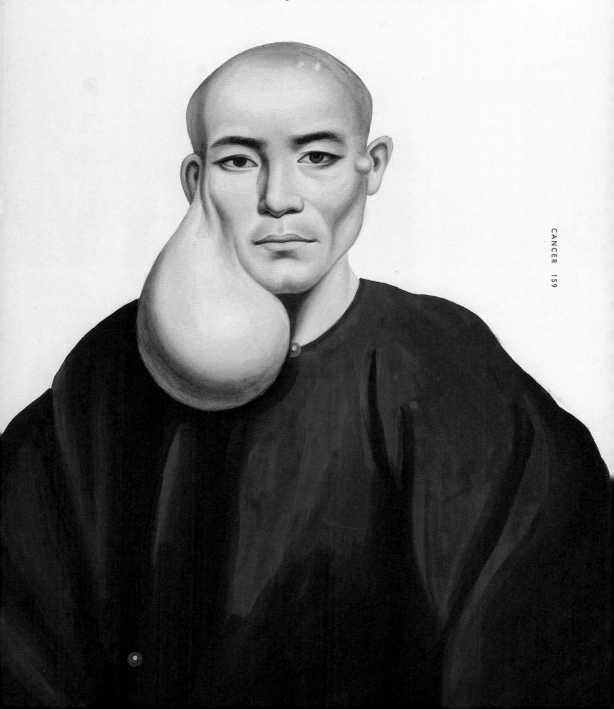

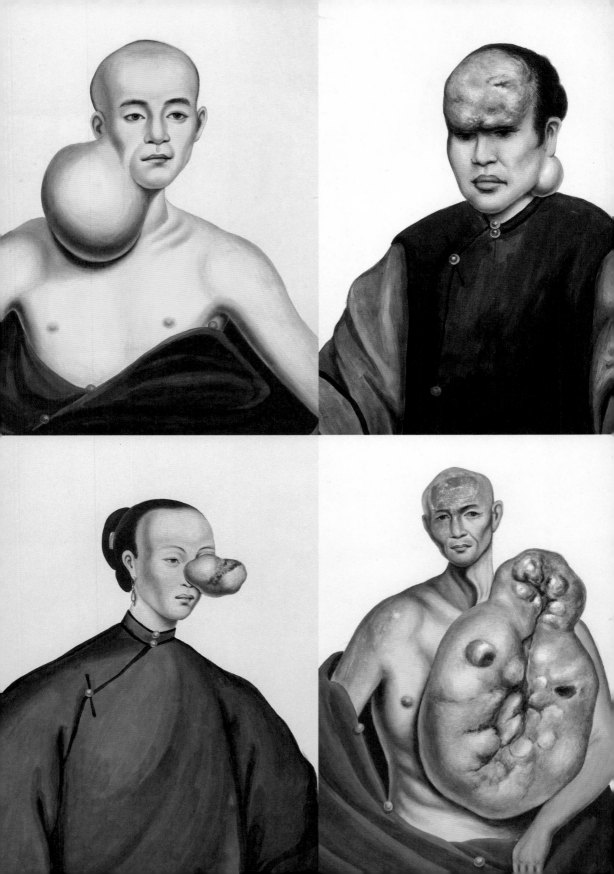

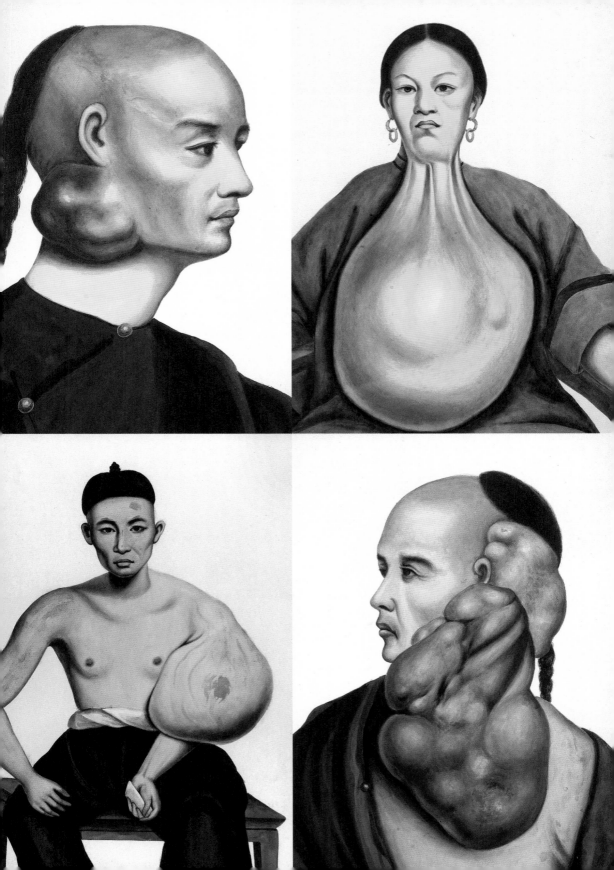

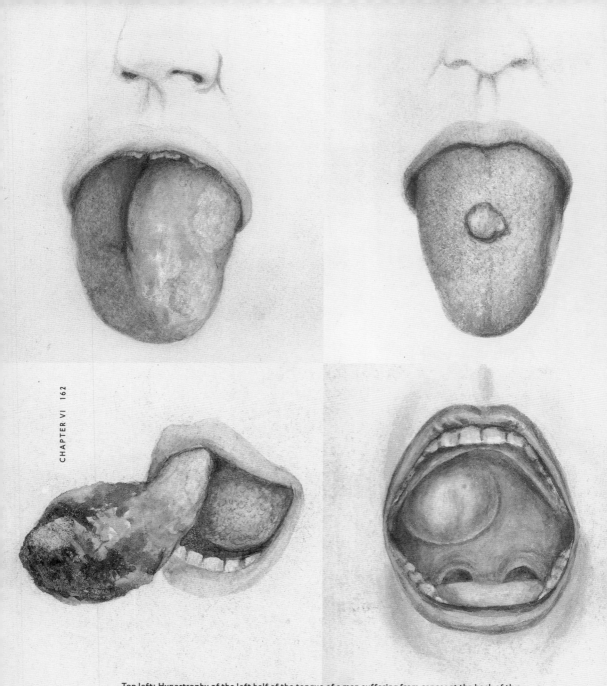

Top left: Hypertrophy of the left half of the tongue of a man suffering from cancer at the back of the organ. According to the notes, the hypertrophy was due to inflammation and to the pressure on the vessels exercised by the cancer. Top right: A tumour growing from the palate of a twenty-four-year-old woman. According to the accompanying notes, the growth was initially thought to be a cartilaginous tumour, but after removal found to be a fibro-adenoma. Bottom left: A soft, round-celled sarcomatous tumour springing from the angle of the mouth and inside the cheek of a young child. Bottom right: The tongue of a child, aged three and a half years, showing a small recurrent papillary growth.

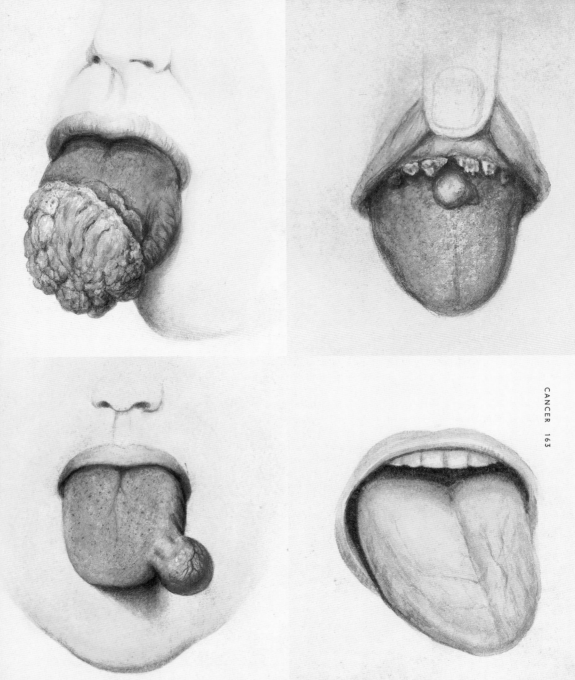

Top left: An advanced cancer of the tongue. Top right: Another view of the tumour shown on the facing page, top right. Bottom left: A congenital pedunculated tumour that grew from the anterior portion of the left lateral margin of the tongue. According to the accompanying notes, microscopical examination of the tumour after its removal showed that it was a soft fibroma – not, in modern terms, considered a form of cancer. Bottom right: Watercolour drawing showing hemiatrophy and hemiplegia of the left side of the tongue of a man, aged fifty, caused by a malignant tumour situated deeply in the neck (left side). The sense of taste was not affected on either side, nor was there any other paralysis.

HEART

DISEASE

Within the Western medical tradition, fundamental ideas about the heart and its function in the body – as a muscular pump – did not change radically between William Harvey's proof of the circulation of the blood in 1628 and the 'new cardiology' of the late nineteenth century Ⓐ. But diagnostic tools like the stethoscope and the electrocardiogram (ECG) changed the ways in which medicine could observe this metaphorically potent organ, both in health and in disease. Laboratory physiology and microscopy generated new ideas about the blood, its role in transportation, healing and immunity, and ended a two-thousand-year-old tradition of therapeutic bleeding. And in defining the end of life as the cessation of the heartbeat, Western cultures acknowledged medicine as an arbiter of life and death.

Building on Harvey's work, eighteenth-century dissectors began to elucidate the ways in which physical changes could alter the heart's function. The French anatomist Raymond Vieussens, and his Roman contemporary Giovanni Maria Lancisi, examined the great valves of the heart, showing that stenosis – narrowing of the valves – was found in the swollen bodies of those who died from dropsy. At the end of the century the Scottish-born, London-based physician Matthew Baillie linked thickening and growths on the heart valves with some types of rheumatism, and the leading Parisian cardiologist Jean-Nicolas Corvisart began to draw out the mechanism of heart failure, arguing that impairment of the heart's function led to dropsy and fluid in the lungs. Other clinicians took a more traditional line, concentrating on symptoms rather than on underlying pathological changes. In a lecture to the Royal College of Physicians in 1768 the English physician William

Heberden used symptomatology alone to distinguish angina pectoris from other kinds of thoracic pain. Heberden observed that angina came on only after exercise, and that 'males are most liable to this disease, especially such as have past their fiftieth year'.

For the Viennese physician Leopold Auenbrugger, however, visible symptoms and invisible lesions could be linked by the use of percussion. By tapping on the chests of his patients (an idea said have been inspired by watching his father test the levels of wine barrels in the cellar of his hotel) Auenbrugger found he could work out the size of the heart and the presence of fluid in the chest. His Latin treatise on percussion – *Inventum Novum Ex Percussione Thoracis Humani Ut Signo Abstrusos Interni Pectoris Morbos Detegendi* (1761) – was little-read until Corvisart's French translation in 1808. Percussion chimed with the tenets of Paris medicine, and in 1818 the Paris-trained physician René Laennec, a student of Corvisart, developed the stethoscope. Laennec initially used his device, something like a wooden flute, for studying lung diseases, but quickly realized that it could also be used to listen to the beating heart.

Auscultation – deciphering the elements and locations of sounds within the body – was a difficult skill and took time to learn, but in the right hands it could be extremely effective. Laennec's British disciple, James Hope, wrote textbooks on auscultation, and in 1831 published *A Treatise on the Diseases of the Heart and Great Vessels*. In this massive work Hope drew together a century of anatomical and pathological work on the heart with his findings from auscultation. He showed that, for example, the distinctive heart murmurs of rheumatic fever were caused by the valve damage observed by Baillie a generation earlier

(and later shown to be the result of bacterial infection). Even the pulse, that ancient marker of constitutional balance, could be reinterpreted in this light. William Stokes and Robert Adams, two Irish clinicians, connected sudden fainting fits – now known as Stokes-Adams syndrome – with a fall in cardiac output and a correspondingly sluggish pulse.

From the middle of the nineteenth century, laboratory sciences, particularly physiology, began to supplant the dissecting rooms of Paris medicine as the cutting edge of clinical research. Physiology, with its emphasis on function, encouraged physicians and scientists to look beyond structural lesions in the tissues of the heart and to think again about the capacities of the heart as a pump. Laboratory technologies could also be used to study cardiac action, and many of these were based on the German Carl Ludwig's kymograph – a rotating drum, covered with paper and marked by a moving pen, which had become the distinctive tool of late-nineteenth-century physiology ⓓ. In France the pioneer photographer and scientist Étienne-Jules Marey modified a kymograph to record the pulsations of arteries, and the Scottish physiologist James Mackenzie developed the polygraph – a continuously moving strip of paper on which several pens could trace different cardiac, arterial or venous variables. Like Laennec's stethoscope, Mackenzie's polygraph created another way to visualize irregularities in the pulse, and to access the living heart in action.

Ironically, the technical sophistication of this work was a bar to its acceptance by many leading practitioners. Elite European clinicians, who a century before had rejected hands-on examination of their patients as useless and socially unacceptable, now saw

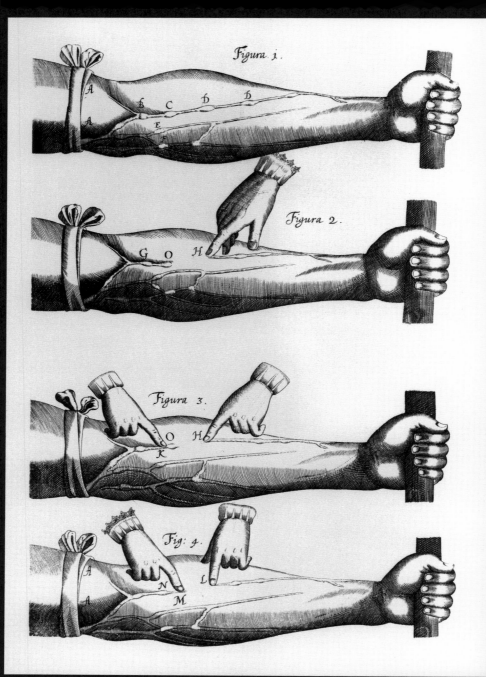

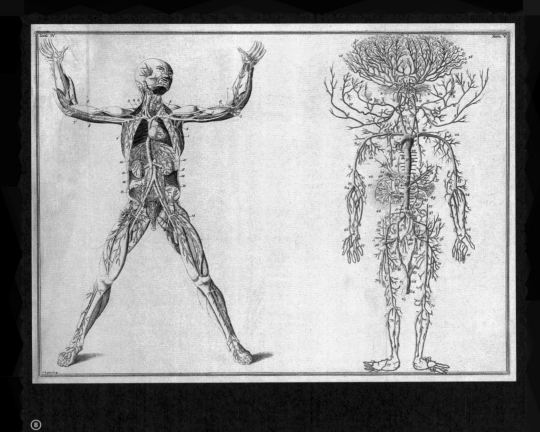

laboratory equipment like the polygraph as a threat to their highly-prized skills in physical diagnosis, honed in the clinic and the morgue. Drawing on an older, humanistic conception of 'the art of medicine', they argued that these technologies, along with the fragmentation of general medicine and surgery into specialities and the growth of state regulation and funding, threatened to turn practitioners into narrow-minded mechanics, subservient to machines and lacking a wider appreciation of the human condition. Willem Einthoven's ECG, developed in Germany in 1902, recorded electrochemical impulses in the nerves of the heart, and was taken up by a few European physiologists (most successfully by Thomas Lewis in London) as a tool of laboratory-based research. In the United States, however, it was applied with enthusiasm to diagnosis: in 1918–19 the Chicago physicians James Herrick and Fred Smith used the ECG to diagnose coronary artery disease in ways that were not possible with the naked senses alone.

At the end of the nineteenth century, surgeons, too, were beginning to turn their attention to the heart. For centuries the major task of surgery had been heroic excision; surgeons sought to cut out what needed to be cut out, as quickly as possible and without killing the patient. The advent of anaesthesia and antisepsis in the mid-nineteenth century led to what Roy Porter called 'surgery's heroic, even knife-happy age', as this older notion of surgery could be applied to more and more parts of the body (particularly the internal organs) [1]. In the 1890s European surgeons began for the first time to mend wounds to the heart, but it took a generation or more to get used to the possibility of repairing or replacing (rather than merely removing) damaged tissue. Heart surgery – one of the most notable successes of the twentieth century – required a delicacy alike of technique and outlook, one that most surgeons at the beginning of the century did not, for the most part, possess.

[1] Roy Porter, *The Greatest Benefit to Mankind: A Medical History of Humanity from Antiquity to the Present*, HarperCollins, 1997, p. 611.

(A) Remaking the heart: these engravings from William Harvey's *De Motu Cordis* (1628) formed a central part of Harvey's demonstration that the blood circulates and that the heart is a pump. (B) Following Harvey's work, eighteenth-century anatomists mapped the arterial and venous systems in fine detail, as in these tables of the veins (left) and arteries (right), from the physician Robert James's *Medicinal Dictionary* (1745). (C) Leopold Auenbrugger's technique of percussion enabled physicians to determine the size of the heart in a living patient by tapping the chest wall and listening to the sound. This nineteenth-century English percussor has a finely-carved ivory pleximeter for measuring the distance between taps. (D) At the end of the nineteenth century, experimental physiologists devised new techniques, such as this clockwork kymograph, for recording and studying the action of the heart. (E) The development of open-heart surgery in the twentieth century depended on, among many other things, a fine-level knowledge of the structure and function of the living heart, as embodied in these illustrations from Robert Carswell's *Pathological Anatomy*, published in 1838.

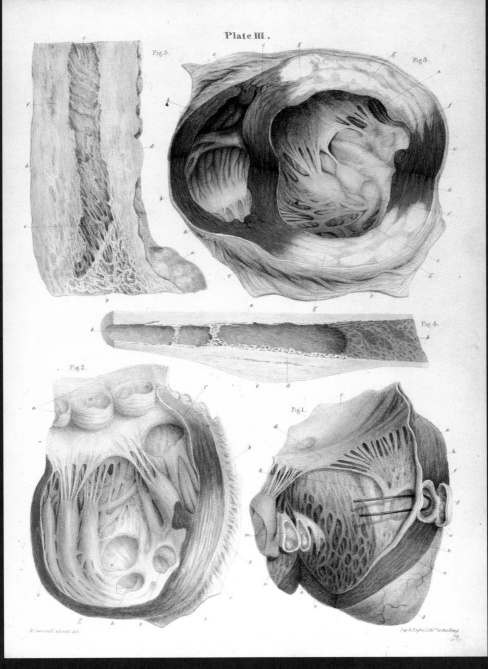

Plate III.

Fig. 5.

Fig. 3.

Fig. 4.

Fig. 2.

Fig. 1.

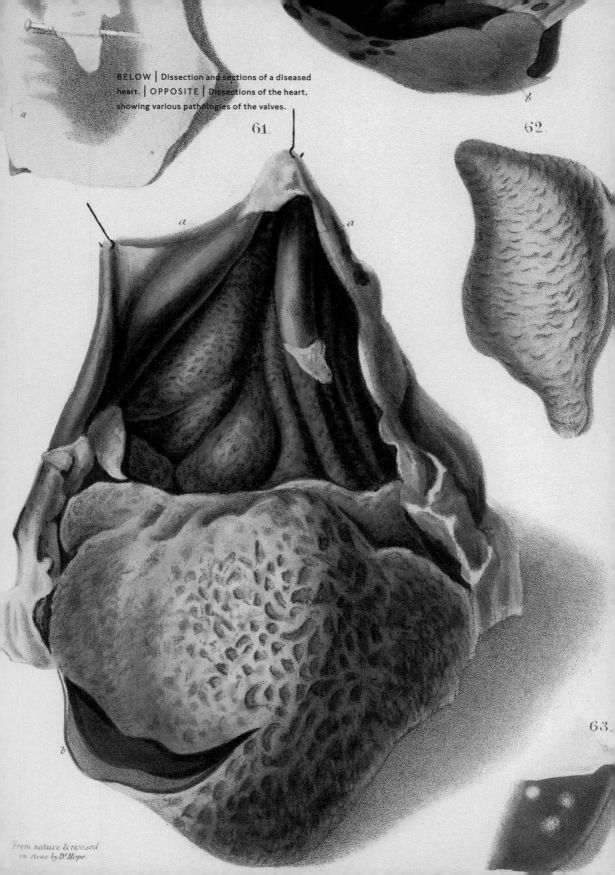

BELOW | Dissection and sections of a diseased
heart. | OPPOSITE | Dissections of the heart,
showing various pathologies of the valves.

a

61.

a

a

62.

b

63.

From nature & revised
on stone by Dʳ Hope.

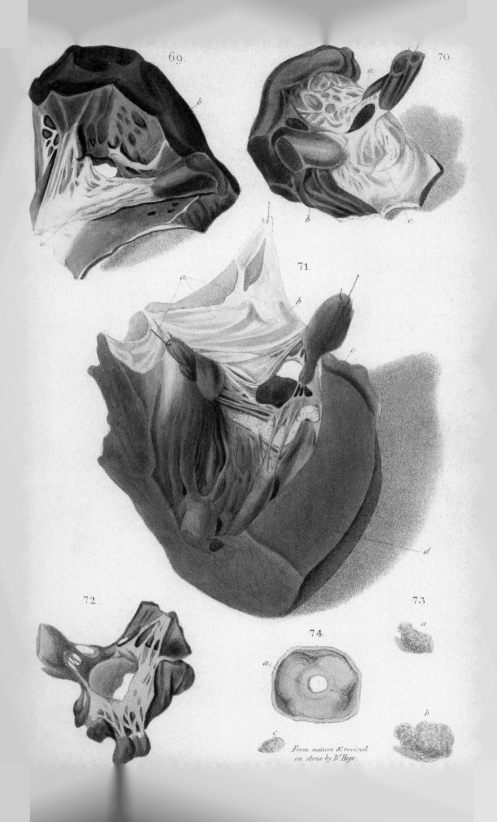

From nature & revised on stone by Dr Hope.

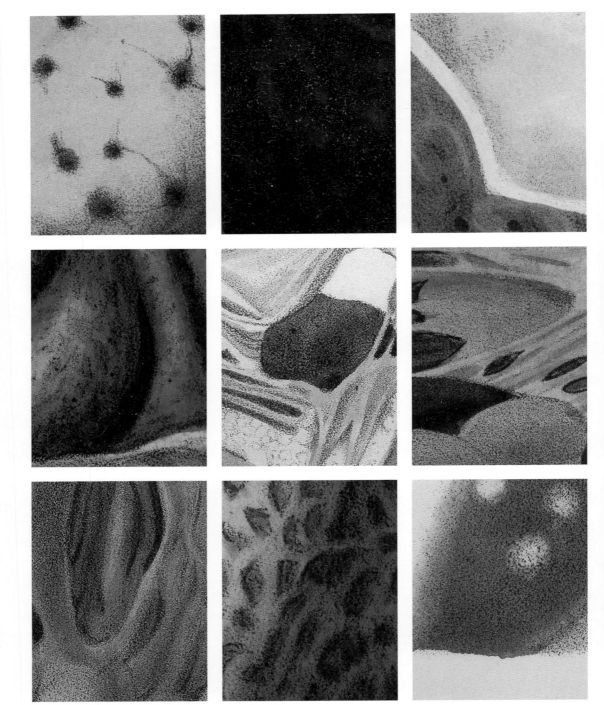

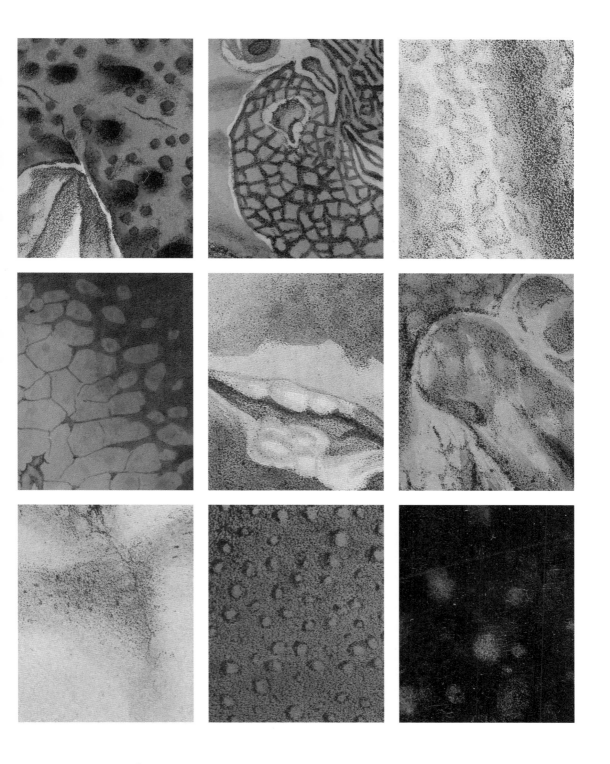

OPPOSITE, ABOVE | Close-up views of various kinds of pathology affecting the tissues of the heart.

T.Godart Del.

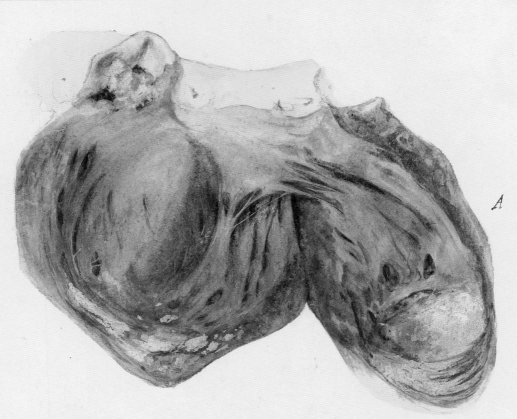

A

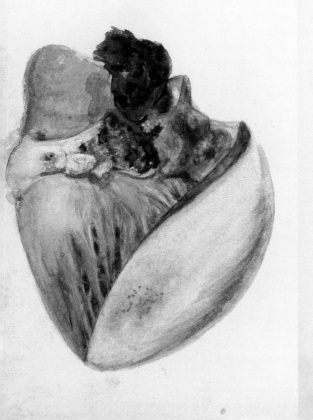
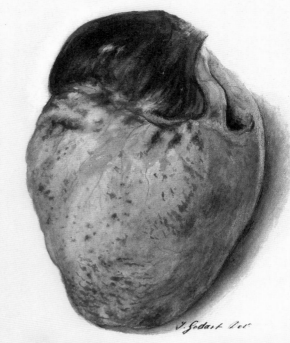

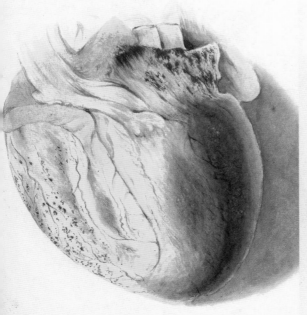
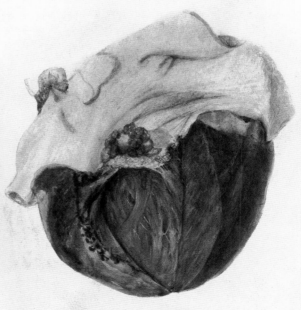

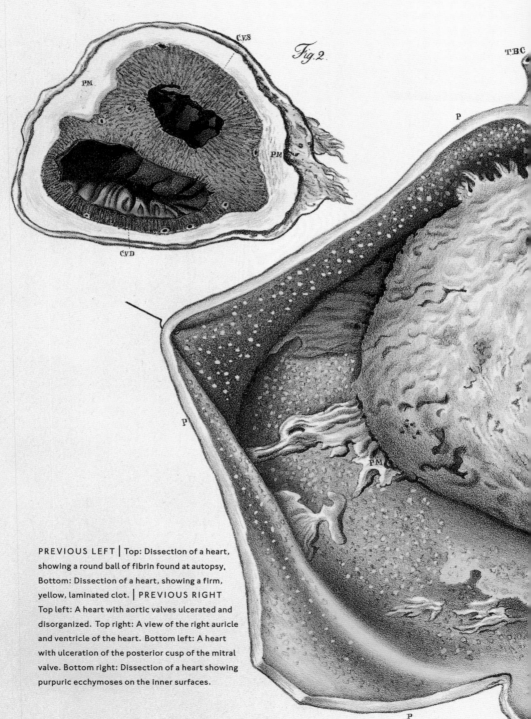

G. Muzzi.

Fig.2.

Li. Batelli e Son

PREVIOUS LEFT | Top: Dissection of a heart, showing a round ball of fibrin found at autopsy. Bottom: Dissection of a heart, showing a firm, yellow, laminated clot. | PREVIOUS RIGHT Top left: A heart with aortic valves ulcerated and disorganized. Top right: A view of the right auricle and ventricle of the heart. Bottom left: A heart with ulceration of the posterior cusp of the mitral valve. Bottom right: Dissection of a heart showing purpuric ecchymoses on the inner surfaces.

A dissection and section of the heart,
showing pericarditis, an inflammation
of the membrane enclosing the heart.

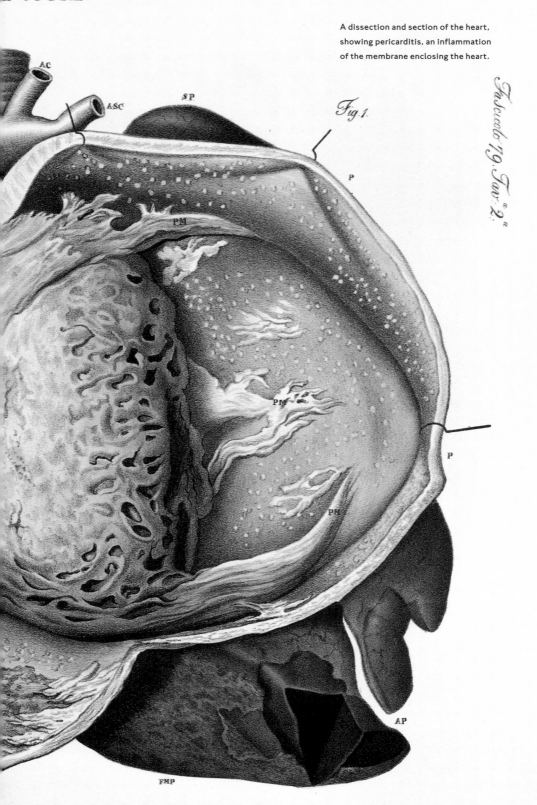

AC

ASC

SP

Fig.1.

P

PM

PM

P

PN

AP

FMP

Fascicolo 19. Tav. 2ª

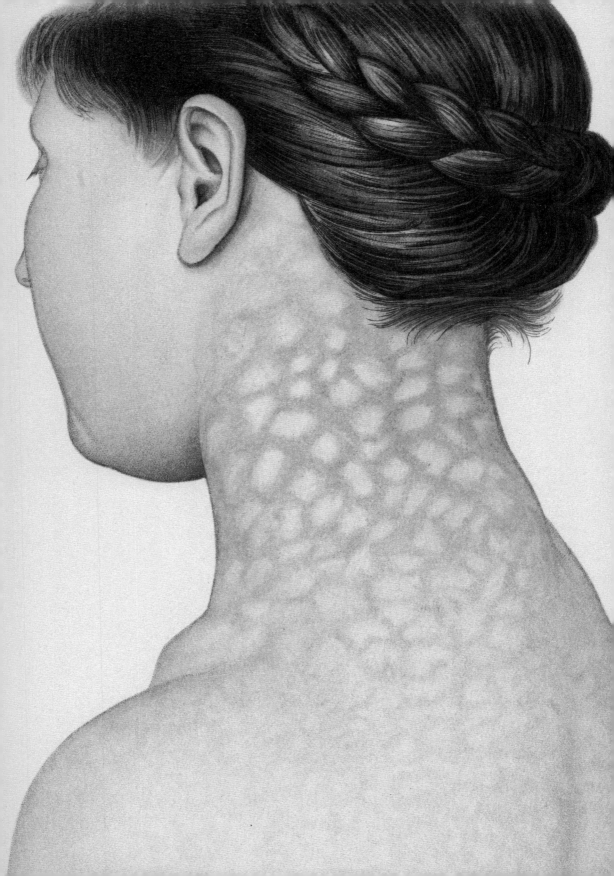

VENEREAL

DISEASES

VENEREAL DISEASES

A LIFETIME WITH MERCURY

Difficult as it can be to find a nineteenth-century artist who did not suffer a bout of tuberculosis, it is almost impossible to find one who was not diagnosed, during their life or after death, with syphilis. A. W. N. Pugin, Robert Schumann, Ludwig van Beethoven, Franz Schubert, Charles Baudelaire, Gustave Flaubert, Guy de Maupassant, William Burges, Vincent van Gogh, Friedrich Nietzsche, Leo Tolstoy, Henri de Toulouse-Lautrec, Fyodor Dostoevsky, Edgar Allan Poe, Jules de Goncourt and Arthur Rimbaud (and the list might be extended almost infinitely) have all been claimed as victims. Recent estimates suggest that around fifteen to twenty percent of Europe's population was infected, and its influence has been traced in almost every aspect of life.

For early modern physicians syphilis was 'the great imitator', a disease that mystified with the sheer range of its symptoms and the length of time it might take to show itself. A small sore near the site of infection – a chancre – would disappear quickly, but over years or even decades the victim might suffer painful rashes, agonizing bone-aches, heart problems, fever, hair loss, the destruction of soft tissues and bone, particularly around the face and larynx, the growth of large benign swellings known as gummas, difficulty in walking, dementia and death.

Syphilis was first recorded in Europe in the mid-1490s, and the coincidence with Columbus's first voyage to the New World led contemporary physicians (along with more recent archaeologists and historians) to conclude that his sailors had brought the disease back with them. In his epic poem *Syphilis, sive Morbus Gallicus* (1530) Girolamo Fracastoro, a Veronese physician and scholar, told the story of Syphilus [*sic*], a shepherd who had insulted the sun god and was stricken with a foul sickness. For Fracastoro the New World had brought the disease, but it also supplied the cure. Syphilus made amends and was shown how to cure himself with mercury and guaiacum, an extract of the South American palo santo tree:

'WITH THESE INGREDIENTS MIX'D, YOU MUST NOT FEAR
YOUR SUFFERING LIMBS AND BODY TO BESMEAR,
NOR LET THE FOULNESS OF THE COURSE DISPLEASE,
OBSCENE INDEED, BUT LESS THAN THE DISEASE.

THE MASS OF HUMOURS NOW DISSOLVED WITHIN,
TO PURGE THEMSELVES BY SPITTLE SHALL BEGIN,
TILL YOU WITH WONDER AT YOUR FEET SHALL SEE
A TIDE OF FILTH, AND BLESS THE REMEDY.'

Within a century guaiacum was falling out of favour, but mercury had become the standard European therapeutic for syphilis. Administered by surgeons, who until the nineteenth century took responsibility for treating venereal diseases, mercury could be taken orally, injected into the urethra with a syringe, or made into an unguent and rubbed onto the skin. As Fracastoro noted, the cure could be as fearsome as the disease, and by provoking uncontrollable salivation (along with ulcers, loose teeth, fragile bones and nerve damage) mercury was seen to rid the body of filth or excess humours.

A lifetime with mercury was not the only possible consequence of a night with Venus. From the middle of the eighteenth century, physicians and surgeons argued over whether syphilis and gonorrhoea – a white discharge from the genitals – were two different diseases, or two expressions of the same disease. In 1767 John Hunter claimed to have proved, on the basis of an experiment in which he inoculated himself with gonorrhoea, that they were identical; he seems unwittingly to have used a needle also contaminated with syphilis. In 1837 the French-American physician Philippe Ricord repeated the experiment, not on himself but on seventeen prisoners in Parisian jails, demonstrating that gonorrhoea was a separate disease and not a symptom of syphilis.

In the mid-nineteenth century Ricord and his student, the dermatologist Jean-Alfred Fournier, began to disentangle this web of pathologies. Ricord described three stages of syphilis: primary and secondary took place within weeks or months of infection, but tertiary syphilis might take a decade or more to develop, after a long period of latency. Fournier, meanwhile, showed that two apparently psychiatric

disorders – general paresis of the insane, a severe form of dementia, and *tabes dorsalis*, a creeping form of blindness and paralysis – were symptoms of tertiary syphilis. These conditions have been blamed for the astonishing growth of lunatic asylums in the nineteenth century, and the euphoric hallucinations associated with general paresis of the insane are sometimes cited as a major influence on the collective imagination of the period. Was there, as the critic and filmmaker Jonathan Meades teasingly suggested, a 'syphilitic school' of British architecture, refracting the revived Christian piety of the mid-nineteenth-century Oxford Movement through the pathological prism of neurosyphilis to create the psychedelic swirls, obsessive detailing and soaring spires of Gothic Revival churches and houses [1]?

For Fournier, as for so many of his colleagues, syphilis was far more than just a medical problem. Through his Société Française de Prophylaxie Sanitaire et Morale he called for an international campaign against this scourge of civilized society, the cause of physical, mental and moral degeneration. Historically, European societies had responded to public concerns over syphilis and other venereal diseases by concentrating on those seen to be responsible for their spread – prostitutes. The London Lock Hospital, founded in 1747, took as its constituency 'females suffering from disorders contracted by a vicious course of life', while the Magdalen Hospital, established in Whitechapel a few years later, tempered treatment with religious imprecation and hard manual labour.

By the mid-nineteenth century this principle was enshrined in the bureaucratic apparatus of European states. According to this view, men were inherently more sexually active than

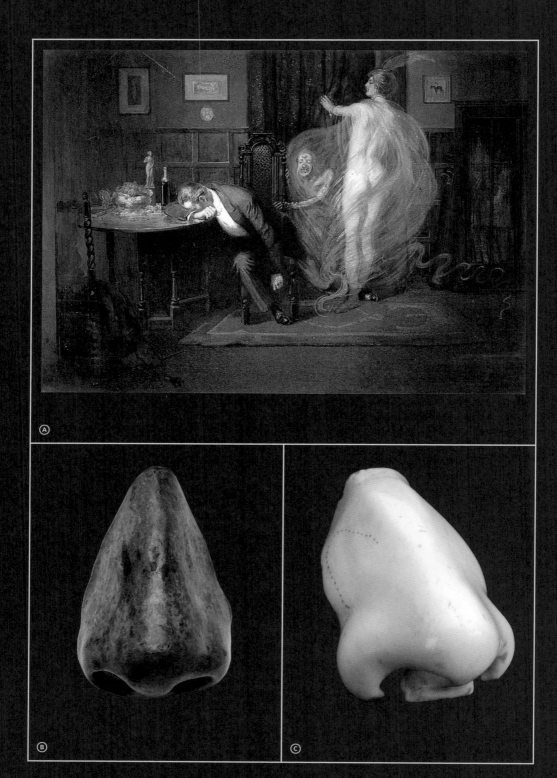

(respectable) women, and it was natural, though regrettable, that they might seek gratification outside the marriage bed. In order to protect the health and purity of the bourgeois family, the fallen women who served male needs should be inspected and, if necessary, forcibly treated. An outcry over the high incidence of venereal disease among soldiers and sailors in the Crimean War led the British government to pass a series of Contagious Diseases Acts in the second half of the 1860s. Under this legislation, police officers could arrest and examine any woman found within a certain distance of barracks in ports or army towns. If any marks of venereal disease were detected, she could be incarcerated in a lock hospital for up to a year. The Acts generated enormous opposition among the public and the medical profession. Over a long and rancorous campaign the leading feminist Josephine Butler criticized a double standard that tacitly tolerated prostitution, but which placed all the blame for venereal disease on prostitutes themselves.

Butler's powerful protest led to the repeal of the Contagious Diseases Acts in 1886, and in the first decade of the twentieth century scientists working in German laboratories gained fresh purchase on 'the great imitator'. In 1905, the dermatologist Erich Hoffmann and the zoologist Fritz Richard Schaudinn identified a bacterium, *Treponema pallidum*, as the causative agent of syphilis, and in the next year the bacteriologist August von Wassermann developed a diagnostic test for infection. In 1909 the physician Paul Ehrlich (who the previous year had received a Nobel Prize for his work on immunology) announced the discovery of a pharmaceutical treatment for syphilis. Salvarsan, an arsenic compound, was highly toxic but effective, and the first specific chemical therapeutic to be developed in the laboratory.

At the beginning of the twentieth century the study and treatment of venereal diseases was gradually becoming a respectable (if still highly discreet) part of mainstream medicine. But its stigma was so great that a doctor might advise a young man infected with syphilis to take a mercury treatment and wait for up to four years before sleeping with his wife, but would not warn the wife or her family. In his play *Ghosts* (1882) Henrik Ibsen drew out the ways in which syphilis could undermine trust within a marriage, subverting the bourgeois values of discipline, restraint and cleanliness. Venereal diseases still carried malign overtones of decadence and degeneration.

[1] Jonathan Meades, *Victoria Died in 1901 and Is Still Alive Today*, BBC2, 2001.

Ⓐ Male artists of the European fin de siècle could rarely resist the urge to portray syphilis as a voluptuous, alluring and deadly woman, as in this 1912 gouache by Richard Tennant Cooper. Note the wizened figure, showing the facial disfigurement characteristic of tertiary syphilis, lurking within the woman's veil. Ⓑ & Ⓒ Losing by a nose: these eighteenth-century prostheses, one in metal, one in ivory, were intended to conceal the destruction of facial tissues in tertiary syphilis. Ⓓ In this watercolour Richard Tennant Cooper offers another gendered vision of syphilis as a provocative, voluptuous woman, this time lying on a bed and accompanied by a cloaked skeleton, as a naked man leaves her bedchamber, trudging to join a throng of the diseased and dying. Ⓔ Yet another beautiful and blowsy woman embodying the threat of syphilis: this example, from a poster advertising a 'radical and absolute' cure for syphilis in a Barcelona sanatorium around 1900, offers a flower in one hand while concealing a black viper behind her back.

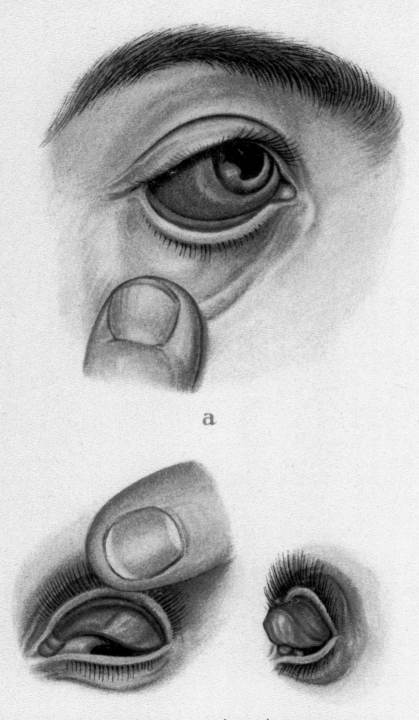

a

OPPOSITE | Syphilitic sclerosis of the mouth in a male patient. | ABOVE | Three images of condylomatous iritis, a form of inflammation thought to be characteristic of syphilis. | OVERLEAF LEFT | Syphilitic infiltration of the submucosa in the mouth and tongue of a male patient. | OVERLEAF RIGHT | Inflamed erosions, known as diphtheritic papules, in the mouth of a male patient.

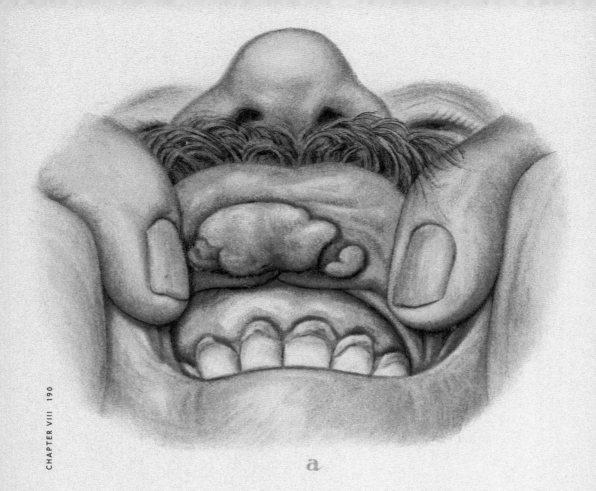

a

b

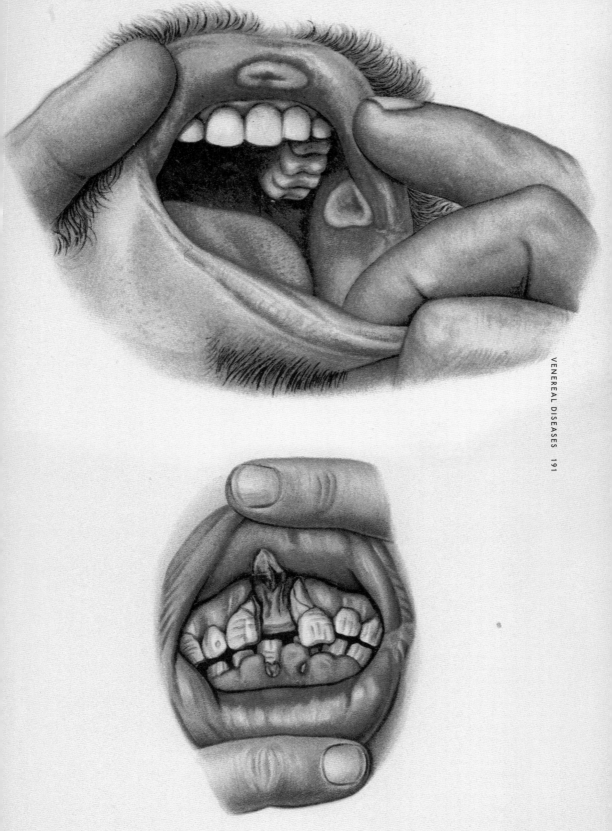

b

SYPHILIDA.(ROSEOLA, RUPIA)

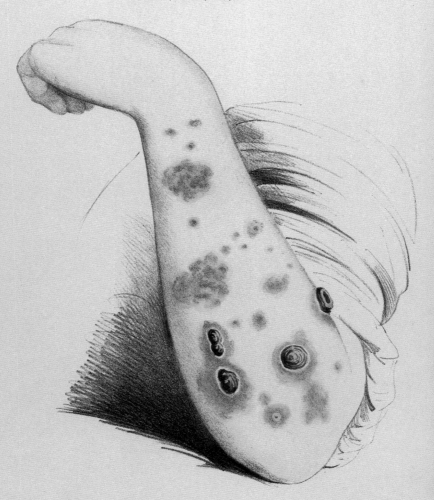

S. Solly ad nat del

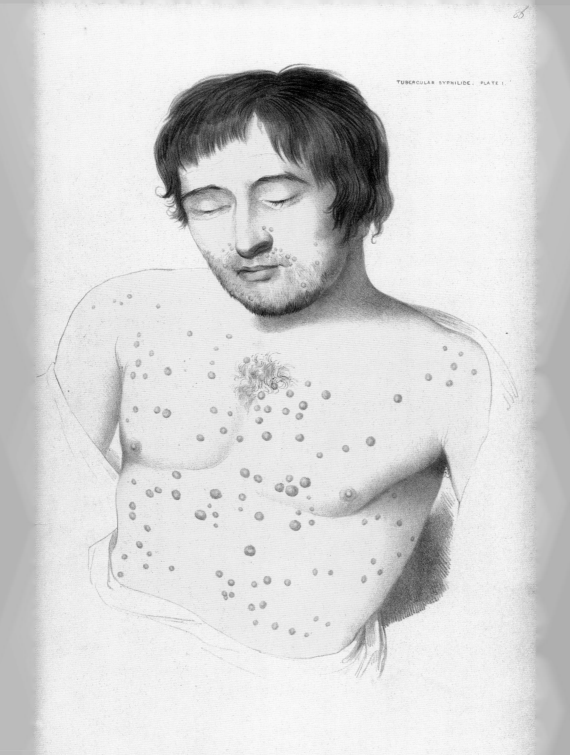

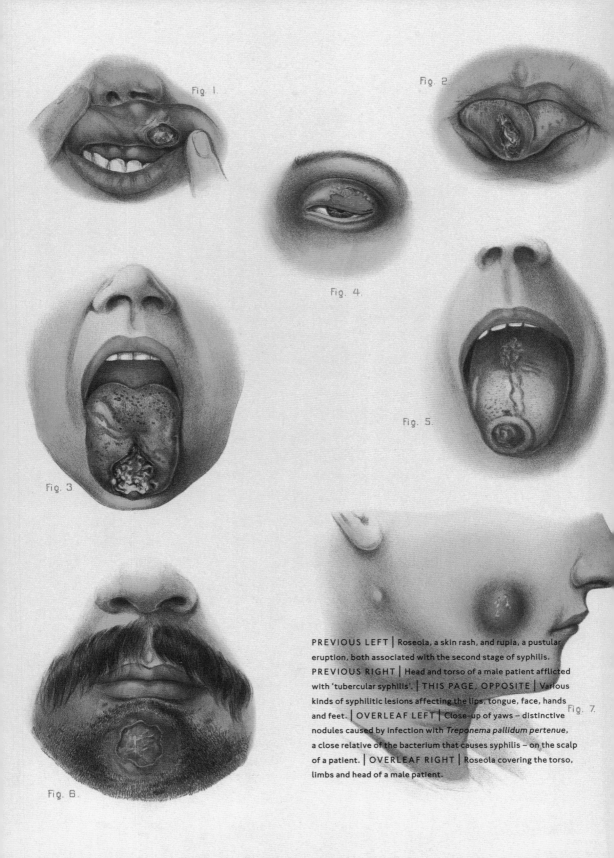

Fig. 1.

Fig. 2.

Fig. 4.

Fig. 3.

Fig. 5.

Fig. 6.

Fig. 7.

PREVIOUS LEFT | Roseola, a skin rash, and rupia, a pustular eruption, both associated with the second stage of syphilis. PREVIOUS RIGHT | Head and torso of a male patient afflicted with 'tubercular syphilis'. | THIS PAGE, OPPOSITE | Various kinds of syphilitic lesions affecting the lips, tongue, face, hands and feet. | OVERLEAF LEFT | Close-up of yaws – distinctive nodules caused by infection with *Treponema pallidum pertenue*, a close relative of the bacterium that causes syphilis – on the scalp of a patient. | OVERLEAF RIGHT | Roseola covering the torso, limbs and head of a male patient.

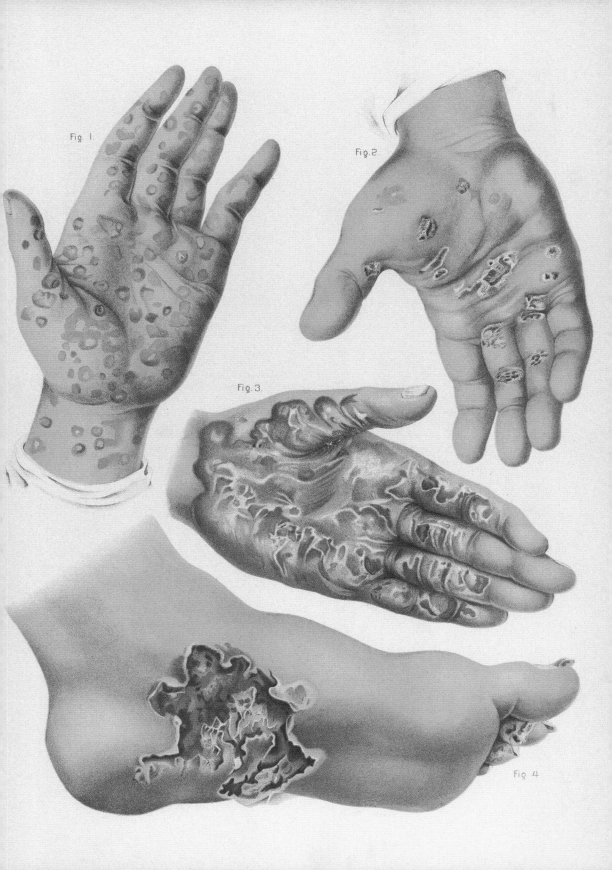

Fig. 1.

Fig. 2.

Fig. 3.

Fig 4

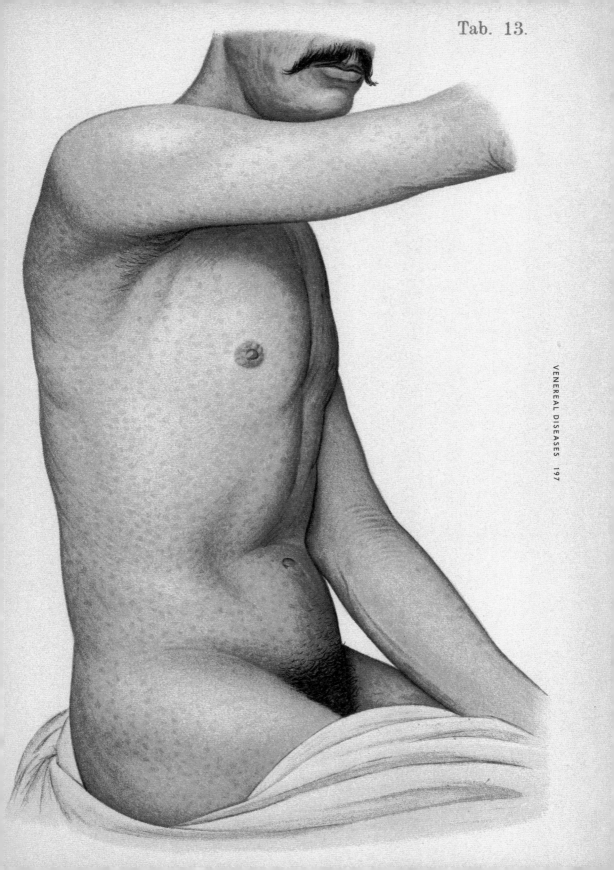

Tab. 13.

No. 5 Example
of pustule crustaceous
syphilid

Portfolio No. 1
6

Ulcer situated over
the left parietal bone

Christopher D. Alton
del.

Fig. I.

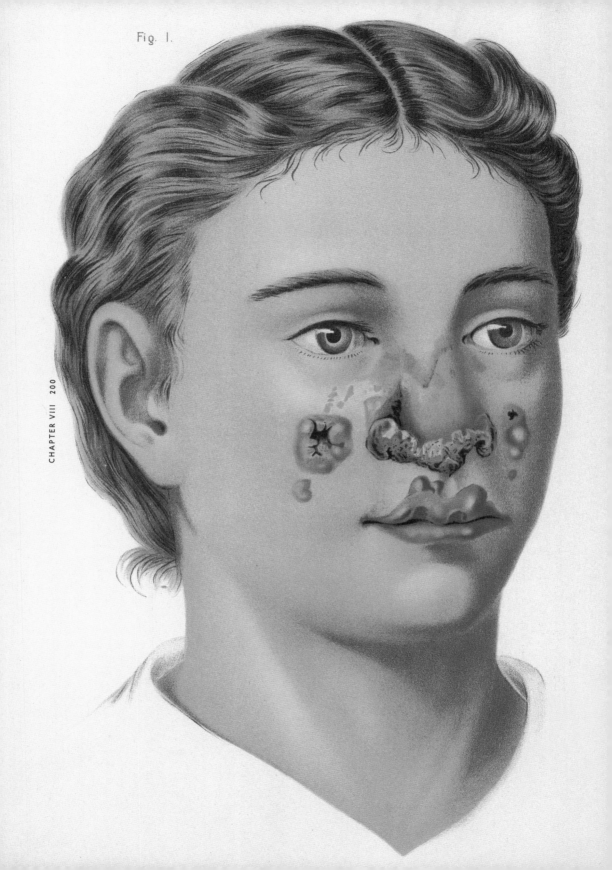

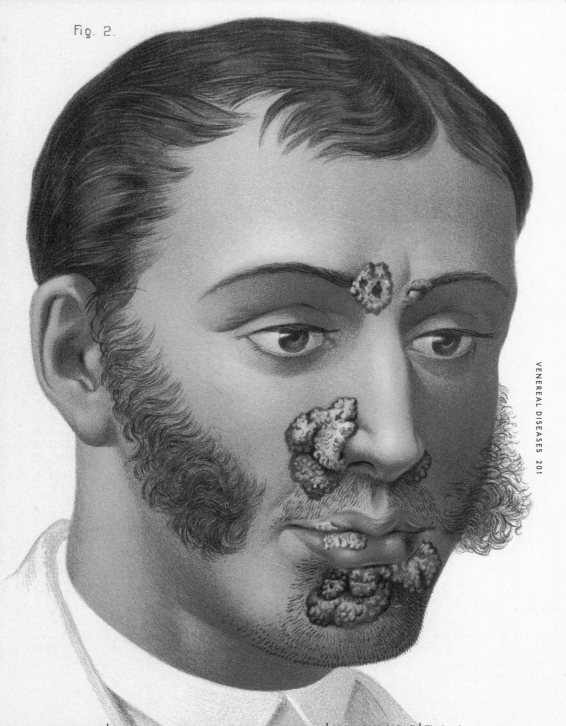

Fig. 2.

PREVIOUS LEFT | Close-up of syphilitic ulceration of an internal organ. | PREVIOUS RIGHT | The head of a male patient suffering from tertiary syphilis, showing severe rupia and erosion of the nose, cheeks, chin and forehead. | OPPOSITE, ABOVE | The faces of a female and male showing the bone and soft tissue erosions characteristic of tertiary syphilis. | OVERLEAF | Four views of syphilitic sclerosis and ulceration of the cervix.

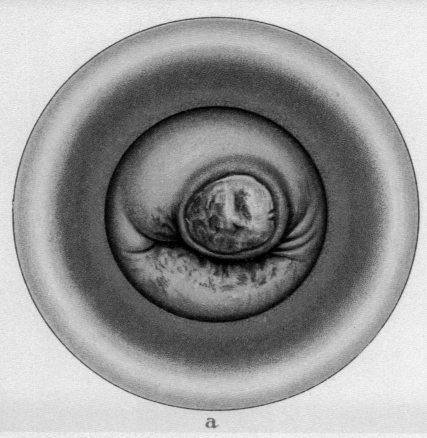

a

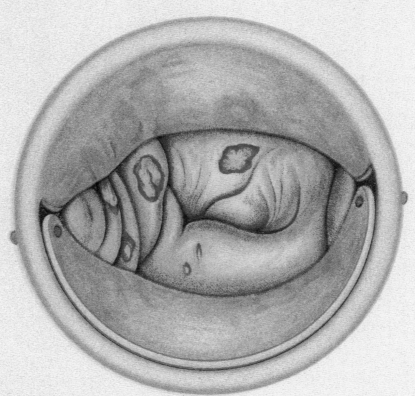

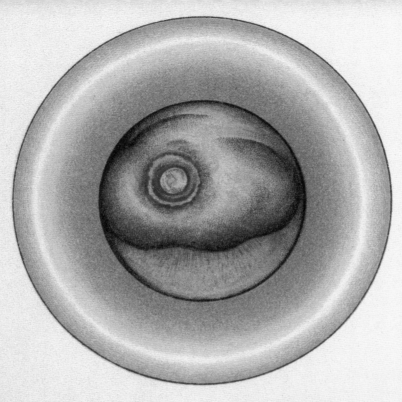

b

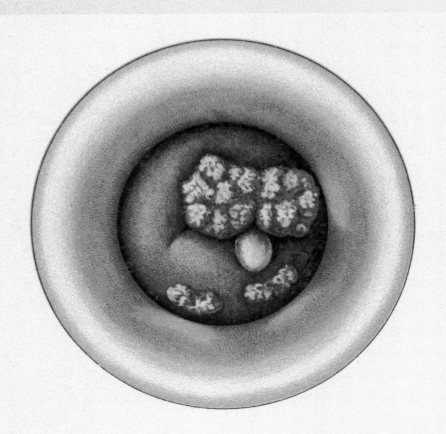

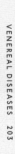

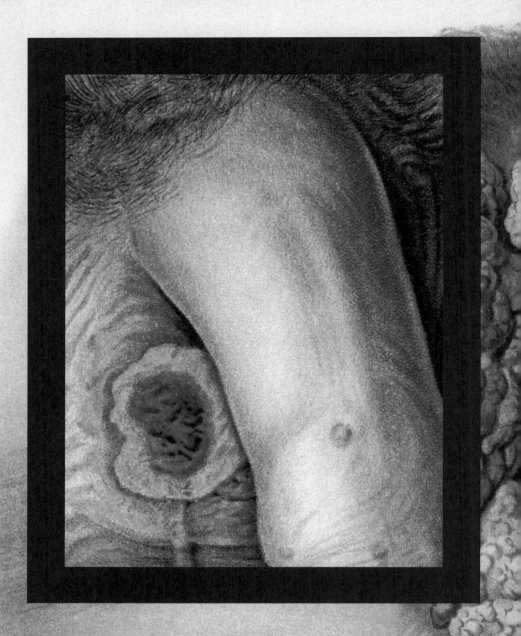

ABOVE | Close-up showing syphilitic ulceration of the scrotum. | OPPOSITE | Close-up showing syphilitic ulceration of the labia majora. | BACKGROUND | Severe syphilitic ulceration of the genitals in a female patient. | OVERLEAF LEFT | Syphilitic inflammation of perineum and anus in male patient. OVERLEAF RIGHT | Syphilitic ulceration of the genitals in a male patient and a female patient.

Tab. 67.

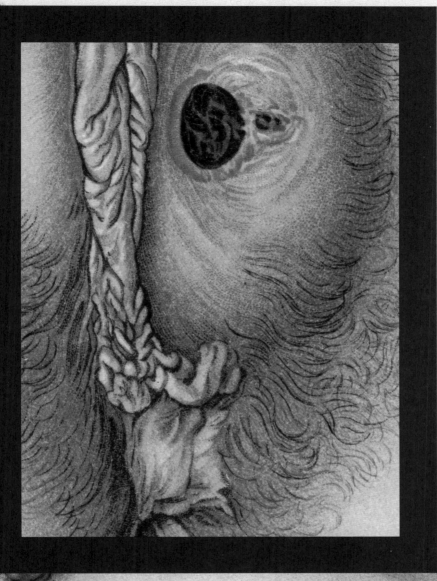

Tab. 63.

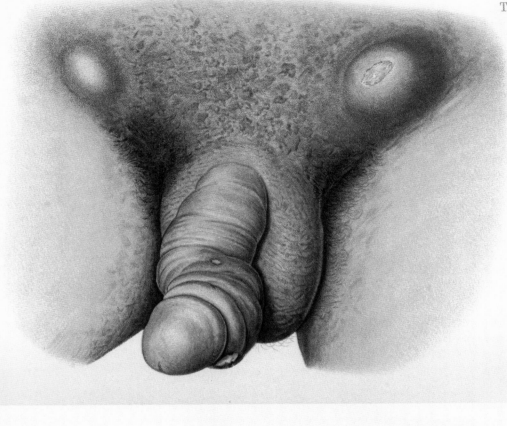

Tab. 4.

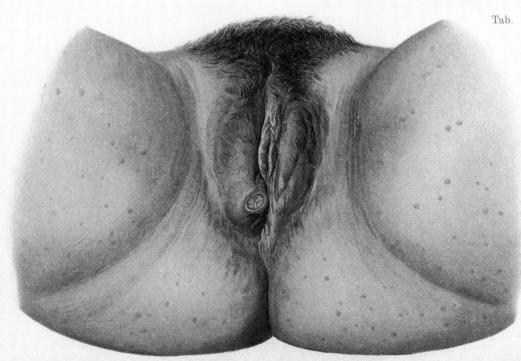

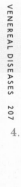

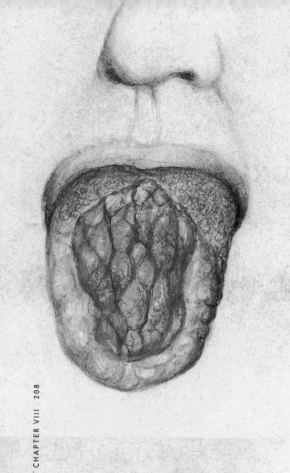

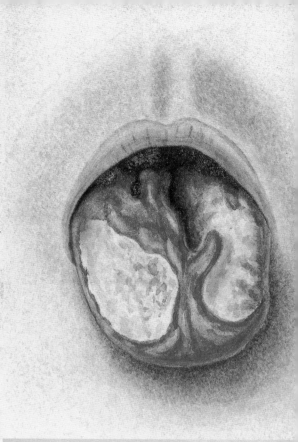

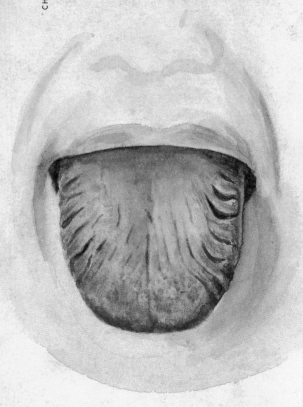

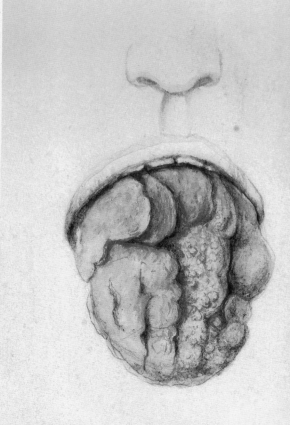

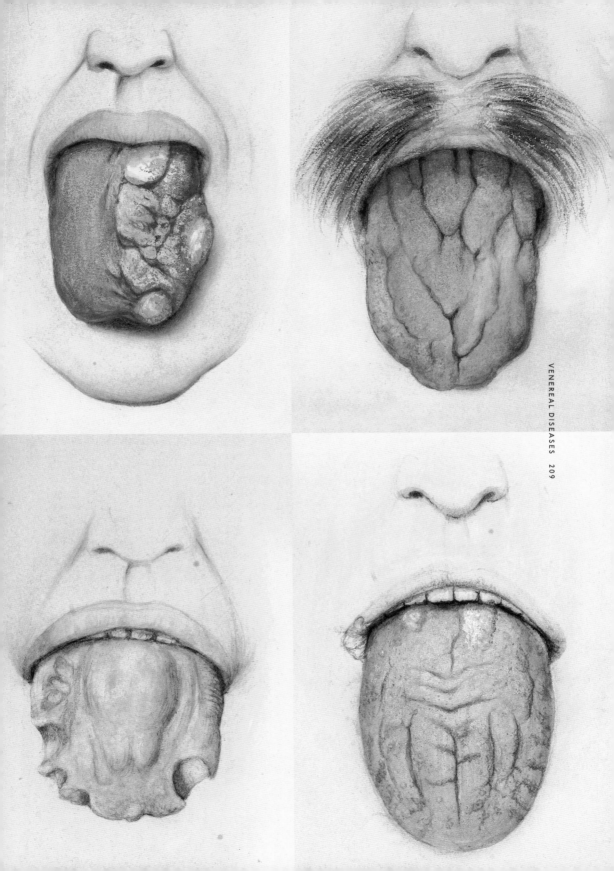

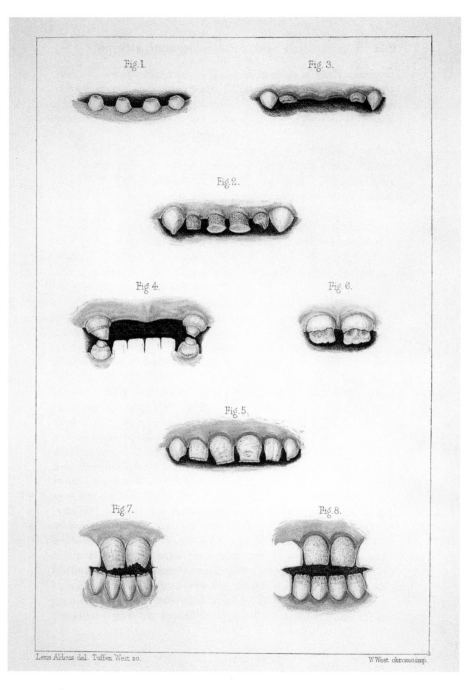

Fig. 1.

Fig. 3.

Fig. 2.

Fig 4.

Fig. 6.

Fig. 5.

Fig 7.

Fig. 8.

Lens Aldous del. Tuffen West sc.

W.West chromo.imp.

PREVIOUS | Tongues of patients suffering tertiary or congenital syphilis. | ABOVE | Syphilitic malformations of the permanent teeth. | OPPOSITE | The head, shoulders and hands of a male infant suffering from hereditary syphilis, skin wrinkled, with keratitis, and covered in pustules.

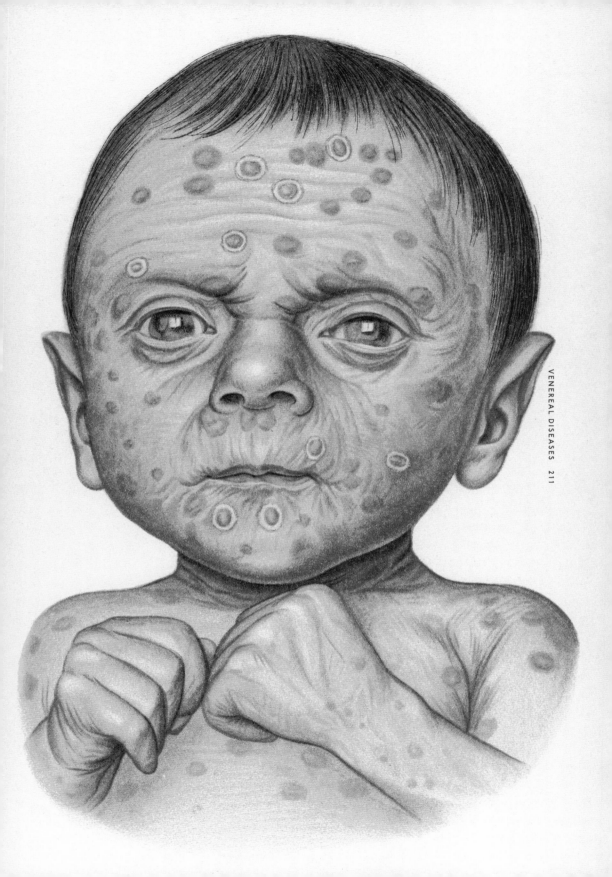

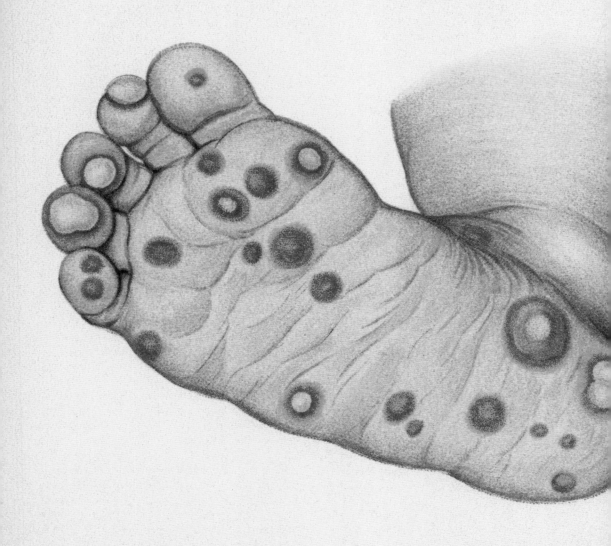

Feet of an infant suffering from hereditary syphilis,
showing the skin covered in pustules.

Tab. 59.

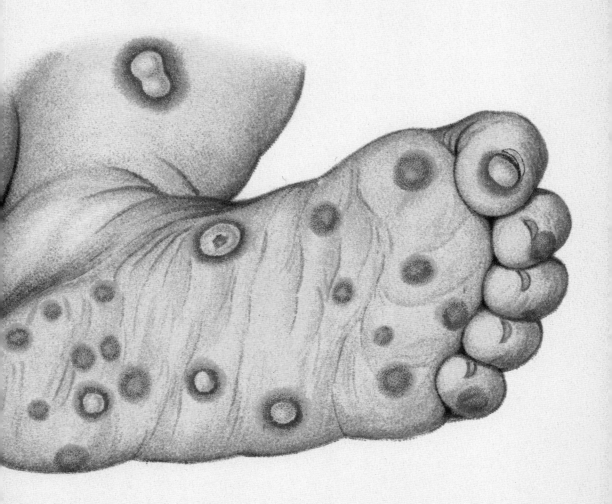

29.

30.

68.

31.

62.

vac.

67.

vac.

PARASITES

PARASITES

COLONIZERS COLONIZED

Parasites, like death and taxes, are inescapable. We all play host, all the time, to a remarkable range of life – most of it microscopic, and harmless if not beneficial – and throughout human history we have been sadly familiar with the attentions of larger and more alarming creatures, from fleas and ticks to lice, worms and bedbugs. In the nineteenth century these macro-parasites became one stimulus for germ theories of disease, suggesting, by analogy, that disease might be caused not by constitutional imbalances or tissue lesions but by invasions of living organisms in the form of germs, fungi and many kinds of micro-parasite. In most cases, however, merely discovering a causative organism was far from sufficient for the full understanding of a disease. How was it spread? What was its life cycle, and at what point did it become dangerous? Where were the natural reservoirs? And what kinds of microscopic life were capable of causing human diseases?

Those who acquired the clinical gaze of Paris medicine found, occasionally, that tissue lesions might not be all they

seemed. In 1835 James Paget – then a medical student at St Bartholomew's Hospital in London, later a leading English surgeon – noted what appeared to be spicules of bone in the flesh of a corpse he dissected. Under a microscope these spicules turned out to be the calcified capsules of small worms. Paget presented a paper on his discovery to the Zoological Society of London, and the comparative anatomist Richard Owen named the worms *Trichinella*. A decade later Joseph Leidy, a professor of anatomy in Philadelphia, observed *Trichinella* in samples of raw pig meat, and in 1860 the German pathologist Friedrich Albert von Zenker worked out the life cycle of the worms and the pathogenesis of trichinosis, the disease they caused in humans Ⓐ.

As they began to make microscopical work part of their practice, European physicians reported many similar discoveries: hookworms by the Italian physician Angelo Dubini in 1843; *Schistosoma hematobium*, the trematode causing sleeping sickness, by the German Theodor Bilharz in 1862; and *Giardia lamblia*, the protozoan

responsible for giardiasis, by the Czech physician Vilém Dušan Lambl in 1859. A decade later the Russian microscopist Nikolai Mikhailovich Melnikov described the role of dog fleas in spreading some species of tapeworm – the earliest report of a macro-parasite serving as a vector for micro-parasites, and an idea that would become central to the understanding of many of the most lethal tropical diseases.

During the late nineteenth and early twentieth centuries tropical medicine emerged as a distinct clinical speciality, combining the apparatus of imperial government and the techniques of the laboratory with a concern for the ecology of parasitic diseases like malaria and sleeping sickness. Westerners knew from experience that imperial control could be maintained only with healthy and well-disciplined soldiers, sailors and merchants. They also understood – as slave-owners had for centuries – that the economic value of tropical plantations was entirely dependent upon the health of the workforce. Tropical medicine was not merely a new avenue for clinical curiosity and global humanitarianism, but a response to the urgent medical and political problems raised by the growing European presence in the tropical colonies.

In 1866 a young Scottish doctor, Patrick Manson, followed his older brother into the Chinese Imperial Maritime Customs and was posted to the South China Sea. He spent more than a decade as medical officer to customs posts in Taiwan and Amoy, and through his work for a charity hospital he encountered patients suffering from elephantiasis, a disease in which the legs and scrotum became grotesquely swollen. Manson knew that elephantiasis was associated with the presence of microscopic worms – *Filiaria* – in the blood, and he became convinced that *Filiaria* must be spread by the bite of a blood-sucking insect. He examined the stomach contents of mosquitoes after they fed on elephantiasis patients, discovering that the worms were not only present but also seemed to be thriving.

Manson never completed his work on the life cycle of *Filiaria*, and in 1889 he retired to Scotland, but in the early 1890s he was forced back into practice by a currency crash that wiped out his Chinese pension. He began to concentrate on the treatment of tropical diseases, and in 1897 was appointed Chief Medical Officer to the Colonial Office. A year later he published *Tropical Diseases*, one of the first textbooks on the subject, and a manifesto for his ecological approach to tropical medicine, combining bacteriology and pathology with the perspectives of entomology and natural history. Manson used his official post to campaign for the creation of a school of tropical medicine, and in 1899 this was established at the Albert Dock Seamen's Hospital, among the docks of east London. Early tropical medicine was truly 'Mansonian medicine', and its greatest vindication came with the decipherment of the most emblematic of tropical disease – malaria.

Malaria had not always been a disease of the tropics. For centuries it had been an occupational hazard for the inhabitants of low-lying European estuaries and fens. Eighteenth-century physicians had understood the disease as one of a class of relapsing fevers, brought on by exposure to putrid miasmas – an idea reflected in its Italian name, *mala aria*, 'bad air'. In the late nineteenth century a number of Western microscopists had identified suspect organisms in the blood of malaria patients, but there was no consensus

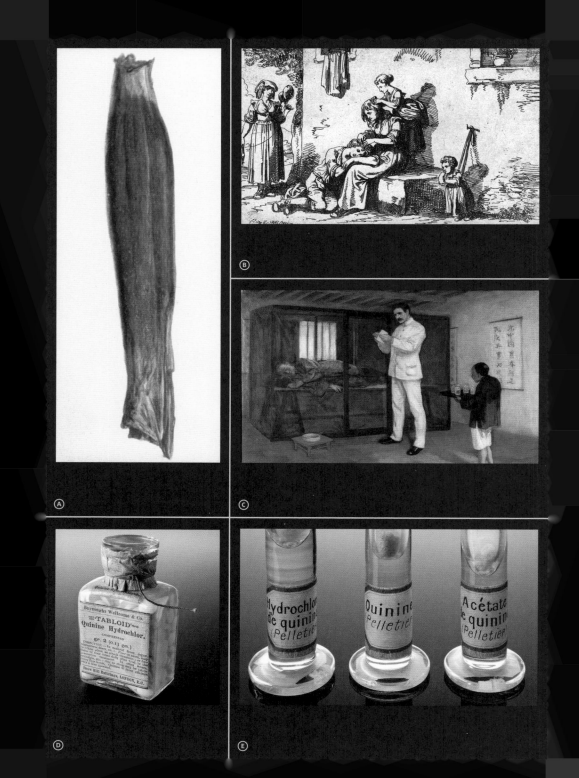

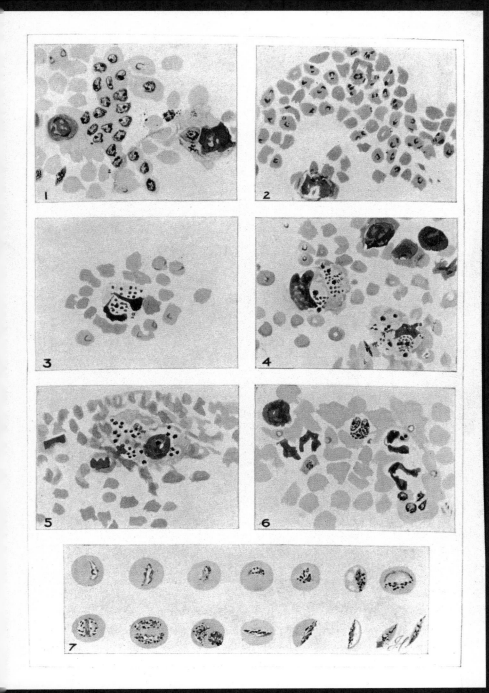

as to its identity, and the life cycle and transmission of this putative parasite were still unknown. In 1894 Ronald Ross, a young doctor working in the Indian Medical Service, met Manson in London. His work on elephantiasis had led Manson to make what he called his 'Grand Induction', that malaria was spread by the bites of mosquitoes. Manson taught Ross his own techniques for observing microscopic parasites and for studying vector insects in their own habitats, and when Ross returned to India he served as Ross's agent, obtaining research funding and working to get Ross's papers published in reputable journals.

On 20 August 1897 – 'Mosquito Day', he noted in his diary – Ross worked out the last details of the transmission of malaria by *Anopheles* mosquitoes. He sat down and wrote an epic poem on the subject, and then began drafting a paper for Manson. Early in the following year Ross's work was published in several London journals, to widespread acclaim. An Italian team, working in the Pontine Marshes to the south of Rome, published almost identical work in the same year. Ross, however, had Manson and the might of the British Empire behind his work; he was given sole credit, and in 1902 received only the second Nobel Prize for Physiology or Medicine.

Ⓐ Lesions as parasites: this 1897 chromolithograph by Wilhelm Gummelt shows a dissected biceps muscle infected with trichinosis. Ⓑ For most of human history, parasites both large and small have been part of everyday life. This 1816 etching by the Italian artist Bartolomeo Pinelli shows a young girl picking fleas from the head of a woman, who in turn picks fleas from the head of a boy who rests on her knee. Ⓒ Tropical medicine as Mansonian medicine: this 1912 painting by Ernest Board shows Patrick Manson in heroic-humanitarian form, carrying out a trial on the transmission of elephantiasis. Ⓓ & Ⓔ From the seventeenth century on, cinchona bark from Peru was used to treat malarial fever. In 1820 two French chemists, Joseph Bienaimé Caventou and Pierre-Joseph Pelletier, identified quinine as the active ingredient of cinchona bark, and by the early twentieth century Burroughs Wellcome was marketing standardized quinine tablets around the world. Ⓕ Unpicking malaria: these microscopic illustrations, from a 1908 *Lancet* case report, show the different stages of malaria infection in human blood samples. Ⓖ For centuries a less severe form of malaria was endemic in low-lying and estuarial regions of Europe. This species of mosquito, now classified as *Anopheles atroparvus*, was capable of spreading *Plasmodium vivax*, the organism responsible for this 'ague'.

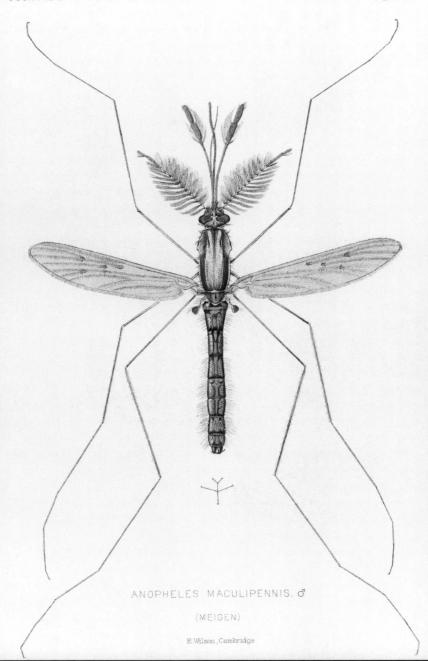

ANOPHELES MACULIPENNIS. ♂

(MEIGEN)

E.Wilson., Cambridge

PLAGUE.

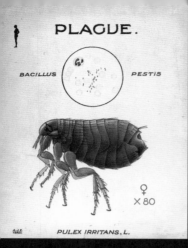

BACILLUS PESTIS

♀ X 80

PULEX IRRITANS, L.

AFRICAN FLOOR MAGGOT.

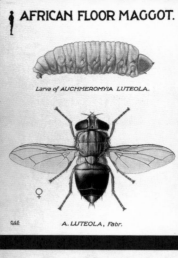

Larva of AUCHMEROMYIA LUTEOLA.

♀

A. LUTEOLA, Fabr.

MYIASIS.

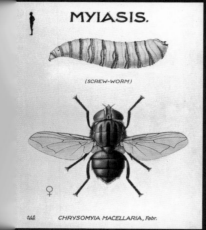

(SCREW-WORM)

♀

CHRYSOMYIA MACELLARIA, Fabr.

MYIASIS.

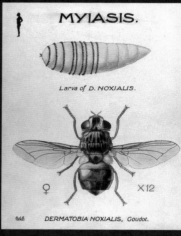

Larva of D. NOXIALIS.

♀ X 12

DERMATOBIA NOXIALIS, Goudot.

MYIASIS.

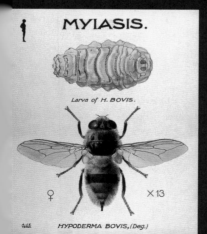

Larva of H. BOVIS.

♀ X 13

HYPODERMA BOVIS, (Deg.)

MYIASIS.

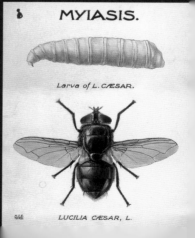

Larva of L. CÆSAR.

♀

LUCILIA CÆSAR, L.

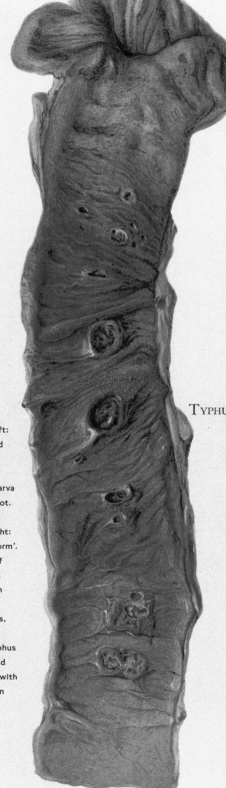

TYPHUS ABDOMINALIS. ULCERA DEPURATA.

Gezeichnet von W. GUMMELT.

OPPOSITE | Magnified views of parasites and vectors. Top left: A female flea, *Pulex irritans*, and the bacterium responsible for bubonic plague, now known as *Yersinia pestis*. Top right: The larva and fly of the Congo floor maggot. Middle left: The larva and fly of a species of blow fly. Middle right: The larva and fly of the 'beef worm'. Bottom left: The larva and fly of the ox warble-fly. Bottom right: The larva and fly of the common greenbottle. | RIGHT | As the similarity of the names suggests, nineteenth-century physicians had difficulty distinguishing typhus (spread by body lice) and typhoid (spread by water contaminated with infected faeces). This dissection of a section of intestine shows ulcerations caused by typhoid, not typhus.

VERLAG UND CHROMOGRAPHIE DER KUNSTANSTALT (VORM. GUSTAV W. SEITZ) A. G. WANDSBEK.

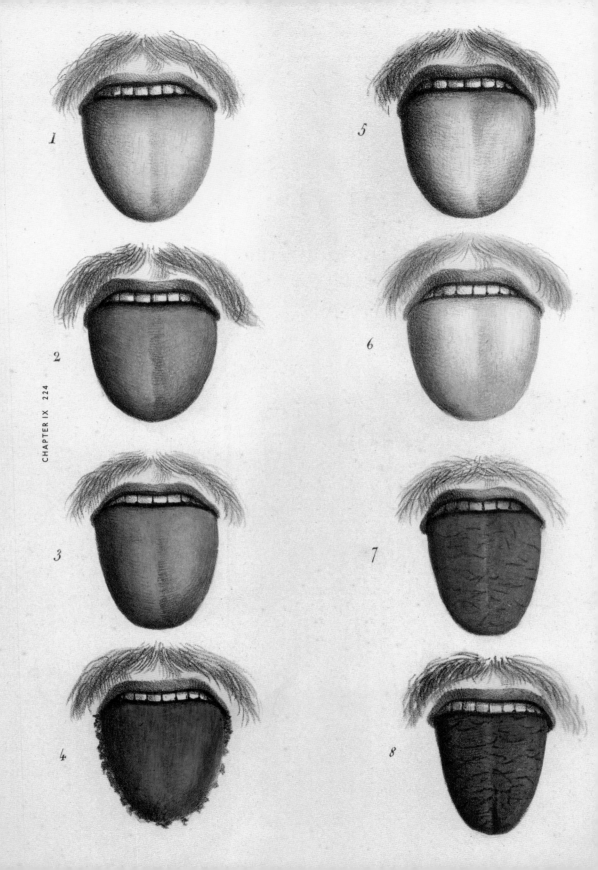

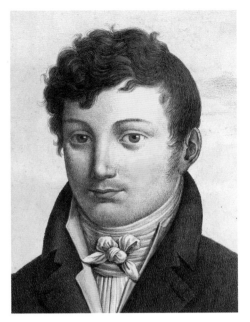
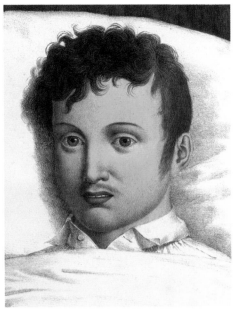
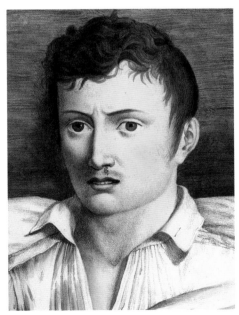
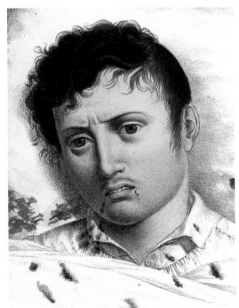

OPPOSITE | The tongues of eight male patients, showing different presentations of yellow fever.

ABOVE | Four views of a young male patient, showing the stages in the development of yellow fever.

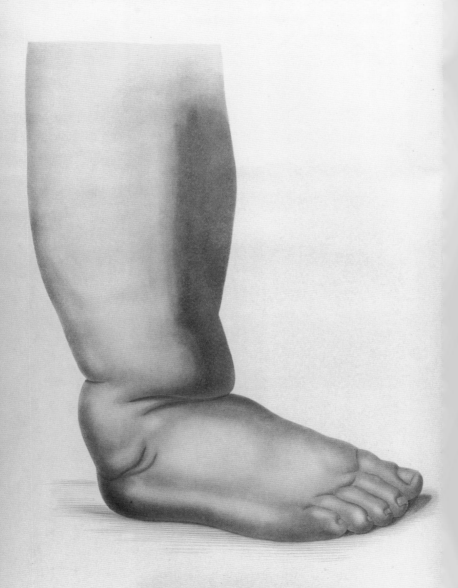

Éléphantiasis des Arabes.

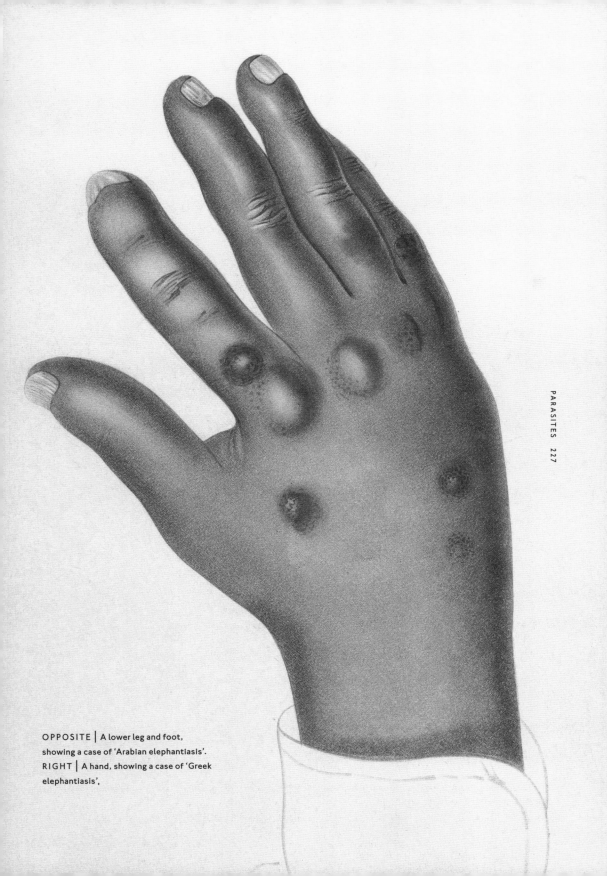

OPPOSITE | A lower leg and foot,
showing a case of 'Arabian elephantiasis'.
RIGHT | A hand, showing a case of 'Greek
elephantiasis'.

21.

24b'

24ª

ep.int.

28.

22.

23.

a

24.c

27.

26.

25.

THESE PAGES | Microscopic illustrations showing various stages in the life cycle of the malaria parasite. | OVERLEAF LEFT | Ringworm is now known to be caused by a fungal infection, but nineteenth-century physicians argued over its parasitical nature. A severe ringworm infection of the inside of the right wrist. | OVERLEAF RIGHT Two views of a boy showing stages in an extensive ringworm infection of the scalp.

31.

32.

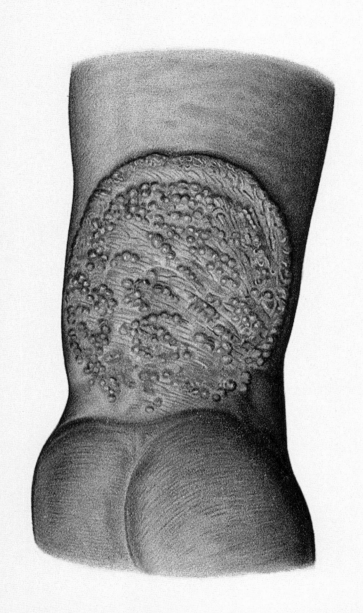

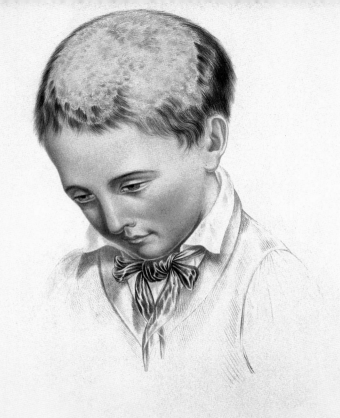

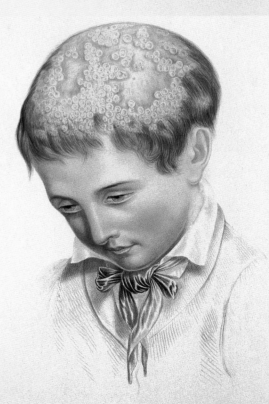

MALATTIE DELLE ARTICOLAZIONI

(Gotta)

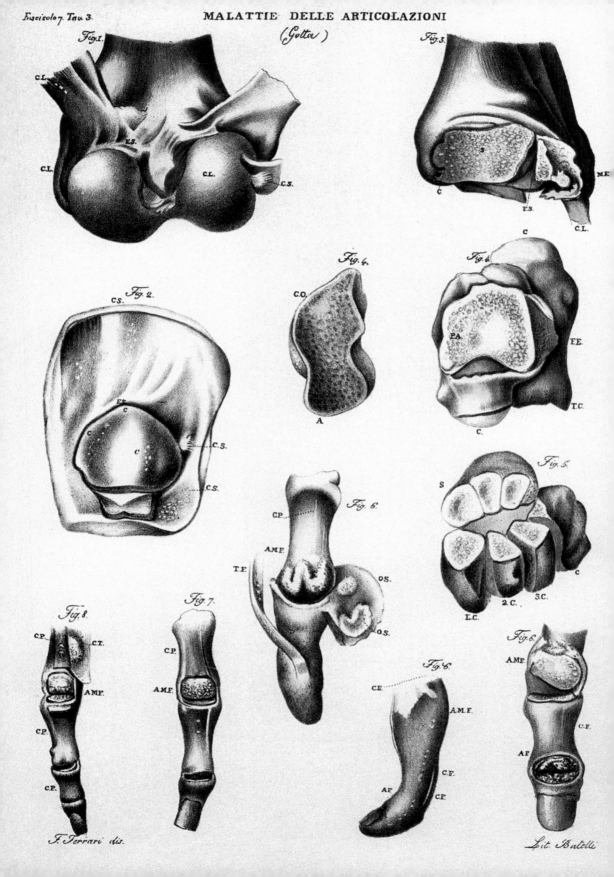

F. Ferrari dis.

Lit. Batelli

GOUT

GOUT

FASHIONABLE AGONY

Like so many of the diseases discussed in this book, gout had a double face. Though it caused agonising pain, it was also seen to indicate a certain degree of civilization, luxury, ease, even sensibility. Just as John Keats rejoiced when he saw spots of tuberculotic blood in his handkerchief, so an early modern merchant might feel a certain pride when he suffered his first bout of gout; it was a sign that he had made it. Gout was, in the words of Roy Porter and George Rousseau, a patrician malady, one of a number of 'non-infectious, non-lethal ailments' that might afflict the comfortable (and typically male) consumers of claret and port at different points in their lives [1].

Typically gout struck a joint in the big toe or thumb, but under the Hippocratic tradition it was seen as a mutable condition, one that might move around the body and cause head-aches, heart palpitations or worse. The diarist and civil servant Samuel Pepys, the greatest chronicler of London life under King Charles II, suffered exquisite pains from his gouty bladder stone, but he feared surgery so much that he spent two years trying every other remedy he could find. Turpentine pills and lucky rabbits' feet did him no good, however, and in March 1658 he called Thomas Hollier, a surgeon from St Bartholomew's Hospital, to rid him of his stone.

Hollier gave Pepys a bottle of brandy to drink – partly to numb the pain, and partly to make him insensible and tractable. He tied Pepys to a table, naked and face-up, and inserted a long metal rod through his penis and into his bladder, to 'sound' and locate the stone. He then made a deep incision into the bladder, and used a pair of pliers to remove the stone. This procedure could take as long as half an hour. The wound was dressed and Pepys was put to bed, with orders to stay as still as he could for seven weeks while the incision healed. The stone was, he later wrote in his diary, the size of a real tennis ball, and he had it cleaned up and mounted in gold as a paperweight.

Gout was to the Enlightenment what melancholy was to the High Renaissance, or stomach ulcers were to the 1950s. When he was not examining a Hogarth print or conversing in a coffee house, a stereotypical man of the middling sort might have been consulting his doctor about an episode of the gout. Most eighteenth-century physicians took their cues on gout from the English physician George Cheyne. Cheyne saw gout as the result of blood stagnating in the extremities, and thought that it served as a kind of constitutional safety valve. The substances precipitating from the blood in the fingers and toes might have caused more serious mischief if they had settled in the major organs.

Cheyne in turn adapted many of his ideas about gout from Thomas Sydenham, the seventeenth-century 'English Hippocrates'. In his *Treatise on the Gout* (1683) Sydenham gave a vivid description of the typical gouty patient:

'THE GOUT GENERALLY ATTACKS THOSE AGED PERSONS, WHO HAVE SPENT MOST PART OF THEIR LIVES IN EASE, VOLUPTUOUSNESS, HIGH LIVING, AND TOO FREE AN USE OF WINE, AND OTHER SPIRITUOUS LIQUORS, AND AT LENGTH, BY REASON OF THE COMMON INABILITY TO MOTION IN OLD AGE, ENTIRELY LEFT OFF THOSE EXERCISED, WHICH YOUNG PERSONS COMMONLY USE.... SUCH AS ARE LIABLE TO THIS DISEASE HAVE LARGE HEADS, AND ARE GENERALLY OF A PLETHORIC, MOIST, AND LAX HABIT OF BODY, AND WITHAL OF A STRONG AND VIGOROUS CONSTITUTION, AND POSSESSED OF THE BEST STAMINA VITAE.'

Bleeding and purging could, Sydenham thought, be counterproductive, driving 'peccant humours' further into the extremities. Instead he recommended a light diet, plenty of fluid and regular doses of a digestive remedy he called bitters – distilled spirit infused with watercress, horseradish, wormwood and angelica root.

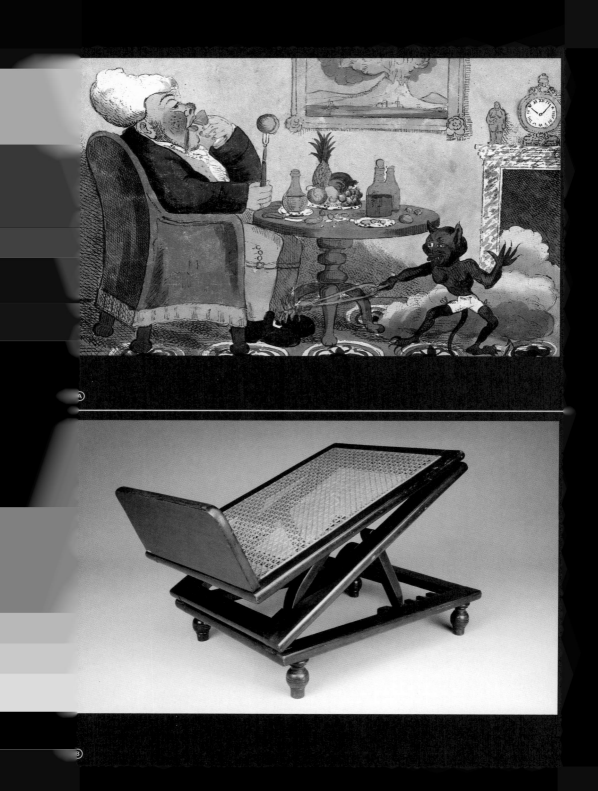

The GOUT.

Sydenham's bitters became a popular remedy for the gout – not least because they gave sufferers a defensible excuse to take nips of strong spirit during attacks – and other practitioners sought to emulate their success. In 1712 the Reverend Richard Stoughton devised a recipe for Stoughton's Elixir, which became one of the first (if not the first) medicine to receive a British royal patent. Stoughton's bitters became one of the most successful British exports to the American colonies, and following the War of Independence distillers in Boston were quick to produce a native version. In 1783 Nicholas Husson, an officer in the French army, began to sell bitters that included an extract of meadow saffron, Colchicum autumnale – one component of which, colchicine, is now known to block the metabolic pathways that cause gout.

Following Stoughton's example, another group of practitioners – quacks – took patent medicines in a more nakedly commercial direction. Travelling from town to town, quacks hawked flashy, inexpensive remedies that promised instant results. They were showmen and bricoleurs, patching together their credibility from whatever came to hand, and they could work the crowd like a hellfire preacher. Their nostrums were usually based on spirit, coloured and flavoured with vegetable dyes, spices and substances ranging from malt extract to strychnine. Dr Radcliffe's

Famous Purging Elixir, Bateman's Pectoral Drops, Daffy's Elixir, Godfrey's Cordial, Radcliffe's Royal Tincture – all had more in common with Sydenham's bitters than most physicians would have cared to admit.

Through the nineteenth century both the medical and the cultural meanings of gout were transformed. Pierre François Rayer, the dean of the Paris medical school, carried out dissections of gouty kidneys and joints, seeking to bring the disease under the clinical gaze of pathological anatomy. In 1849 the English physician Alfred Baring Garrod noted high levels of uric acid in the blood of gout sufferers, and suggested that this chemical might be crystallizing in the joints and urinary tract.

Even after Garrod's work, though, gout was still seen as fundamentally a disease of excess, of over-indulgence in rich food and drink. Following this, treatment continued to emphasize the restoration of bodily balance and the purification of the body. More and more, gout was seen not as an agonizing achievement but a mark of moral laxity, a throwback to the kind of wild eighteenth-century excess that the respectable middle classes wished to leave behind.

[1] Roy Porter & G. S. Rousseau, Gout: The Patrician Malady, Yale University Press, 2000, p. 2.

Ⓐ Eighteenth- and early nineteenth-century caricaturists took gout as a metaphor for laziness and genteel excess, as in this 1818 lithograph by George Cruikshank. Ⓑ Wooden footrests, like this English example from 1830, were used to relieve pressure on gouty joints. Ⓒ Satirists and caricaturists found many ways to represent the fearsome pain of gout. In this 1799 etching by James Gillray, a tiny black demon sinks his claws and fangs into a gouty foot. Ⓓ Gout provided a lucrative field for quacks and mountebanks: these pots contained Holloway's Ointment, one of the most popular nineteenth-century remedies. Thomas Holloway used his fortune to establish the college now known as Royal Holloway, University of London. Ⓔ Gout could cause problems in many parts of the body, and this 1893 sketch by Algernon Francis Stevens shows deposits of urate in the conjunctival membrane of a patient's eye.

Sodium urate in the Conjunctiva
Chron. Gout. (Murexide reaction
 obtained)
 Clin. de France. 1893

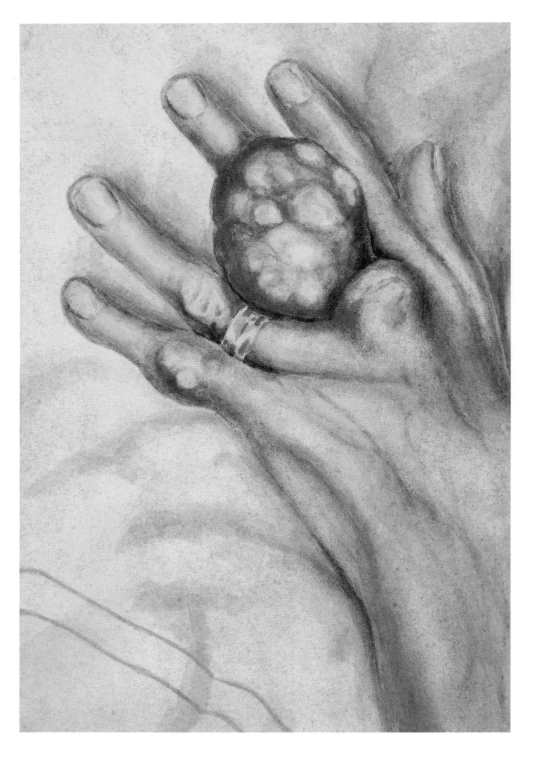

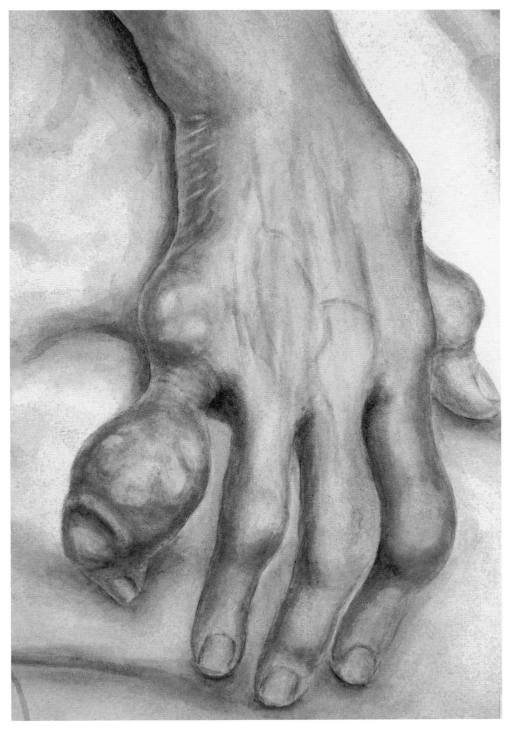

PREVIOUS LEFT | Watercolour drawing of the left hand of a sixty-three-year-old woman suffering from chronic gout. PREVIOUS RIGHT | Watercolour of the right hand, extremely disfigured by large tophi. The skin over these tophi has partly ulcerated. | THIS PAGE | Watercolour drawing of the mouth of a gouty patient, showing a prominent 'buck-tooth' central incisor of the lower jaw.

FURTHER READING

BOOKS AND ESSAYS

† Benedict Anderson, *Imagined Communities* (revised ed.), Verso, 1991

† Julie Anderson, Emm Barnes & Emma Shackleton, *The Art of Medicine: Over 2000 Years of Medicine in Our Lives*, Ilex for Wellcome Collection, 2011

† David Arnold, *Colonizing the Body: State Medicine and Epidemic Disease in Nineteenth-Century India*, University of California Press, 1993

† Richard Barnett, 'John Snow and Cholera', sickcityproject. wordpress.com/2013/03/11/ john-snow-and-cholera/, 2013

† Richard Barnett & Mike Jay, *Medical London: City of Diseases, City of Cures*, Strange Attractor Press for Wellcome Collection, 2008

† Sanjoy Bhattacharya, Mark Harrison & Michael Worboys, *Fractured States: Smallpox, Public Health and Vaccination Policy in British India 1800-1947*, Orient Longman & Sangam Books, 2005

† Joan Jacobs Brumberg, *Fasting Girls: The History of Anorexia Nervosa* (new ed.), Vintage, 2001

† Helen Bynum, *Spitting Blood: The History of Tuberculosis*, Oxford University Press, 2012

† W. F. Bynum, *Science and the Practice of Medicine in the Nineteenth Century*, Cambridge University Press, 1994

† William & Helen Bynum (eds), *Great Discoveries in Medicine*, Thames & Hudson, 2011

† W. F. Bynum & Roy Porter (eds), *Companion Encyclopedia of the History of Medicine*, 2 vols, Routledge, 1993

† W. F. Bynum et al, *The Western Medical Tradition: 1800 to 2000*, Cambridge University Press, 2006

† Havi Carel, *Illness*, Acumen, 2008

† Lawrence I. Conrad et al, *The Western Medical Tradition: 800 BC to AD 1800*, Cambridge University Press, 1995

† Roger Cooter & John Pickstone (eds), *Routledge Companion to Medicine in the Twentieth Century*, Routledge, 2003

† Alfred W. Crosby, *Ecological Imperialism: The Biological Expansion of Europe 900–1900*, Cambridge University Press, 1986

† Andrew Cunningham & Perry Williams (eds), *The Laboratory Revolution in Medicine*, Cambridge University Press, 1992

† Lorraine Daston & Peter Galison, *Objectivity*, Zone Books, 2007

† Nadja Durbach, *Spectacle of Deformity: Freak Shows and Modern British Culture*, University of California Press, 2010

† Michel Foucault, *The Birth of the Clinic: An Archaeology of Medical Perception* (trans. A. M. Sheridan Smith), Vintage, 1963

† Richard Gordon, *Eating Disorders: Anatomy of a Social Epidemic*, Blackwell, 2000

† Christopher Hamlin, *Cholera: The Biography*, Oxford University Press, 2009

† Mark Harrison, *Disease and the Modern World: 1500 to the Present Day*, Polity Press, 2004

† Daniel R. Headrick, *The Tools of Empire: Technology and European Imperialism in the Nineteenth Century*, Oxford University Press, 1981

† Kelly Hurley, *The Gothic Body: Sexuality, Materialism, and Degeneration at the Fin de Siecle*, Cambridge University Press, 2004

† Mike Jay, *Emperors of Dreams: Drugs in the Nineteenth Century*, (revised ed.), Dedalus Books, 2011

† Ludmilla Jordanova, *The Look of the Past: Visual and Material Evidence in Historical Practice*, Cambridge University Press, 2012

† Ludmilla Jordanova, *Nature Displayed: Gender, Science and Medicine 1760–1820*, Longman, 1999

† Allan Kellehear, *A Social History of Dying*, Cambridge University Press, 2007

† Martin Kemp & Marina Wallace, *Spectacular Bodies: The Art and Science of the Human Body from Leonardo to Now*, Hayward Gallery, 2000

† Kenneth Kiple (ed.), *Cambridge World History of Human Disease*, Cambridge University Press, 1993

† Julia Kristeva, *Powers of Horror: An Essay on Abjection*, Columbia University Press, 1982

† Bruno Latour, *The Pasteurisation of France*, Harvard University Press, 1988

† Christopher Lawrence, *Medicine in the Making of Modern Britain*, Routledge, 1994

† Milton J. Lewis, *Medicine and Care of the Dying: A Modern History*, Oxford University Press, 2007

† James T. Patterson, *The Dread Disease: Cancer and Modern American Culture*, Harvard University Press, 1987

† Deanna Petherbridge & Ludmilla Jordanova, *The Quick and the Dead: Artists and Anatomy*, South Bank Centre, 1997

† Daniel Pick, *Faces of Degeneration: A European Disorder, c. 1848 – c. 1918*, Cambridge University Press, 1989

† Roy Porter, *The Greatest Benefit to Mankind: A Medical History of Humanity from Antiquity to the Present*, HarperCollins, 1997

† Roy Porter & G. S. Rousseau, *Gout: The Patrician Malady*, Yale University Press, 2000

† David Punter, *The Gothic Tradition*, Longman, 1996

† Ruth Richardson, *Death, Dissection and the Destitute: The Politics of the Corpse in Pre-Victorian Britain*, Routledge & Kegan Paul, 1987

† Ruth Richardson, *The Making of Mr Gray's Anatomy: Bodies, Books, Fortune and Fame*, Oxford University Press, 2008

† Benjamin Rifkin, Michael J. Ackerman & Judy Folkenberg, *Human Anatomy: Depicting the Body from the Renaissance to Today*, Thames & Hudson, 2006

† Charlotte A. Roberts & Keith Manchester, *The Archaeology of Disease*, Cornell University Press, 2005

† Sheila M. Rothman, *Living in the Shadow of Death: Tuberculosis and the Social Experience of Illness in American History*, Basic Books, 1994

† Charles E. Rosenberg & Janet Golden (eds), *Framing Disease: Studies in Cultural History*, Rutgers University Press, 1992

† Steven Shapin, 'The Invisible Technician', *American Scientist* 77, 1989, pp. 554–563

† Elaine Showalter, *The Female Malady: Women, Madness and English Culture, 1830–1980*, Penguin, 1987

† Susan Sontag, *Illness as Metaphor*, Allen Lane, 1979

† Laurence Talairach-Vielmas, *Wilkie Collins, Medicine and the Gothic*, University of Wales Press, 2009

† Laurence Talairach-Vielmas, 'Collecting the Materials: Anatomical Practice and the Material Body in *Frankenstein*', in Claire Bazin (ed.) *Frankenstein Galvanised*, Red Rattle Books, 2013

† John L. Thornton & Carole Reeves, *Medical Book Illustration: A Short History*, Oleander Press, 1983

† James Vernon, *Hunger: A Modern History*, Belknap Press, 2007

† John Harley Warner, *Against the Spirit of System: The French Impulse in Nineteenth-Century American Medicine*, Princeton University Press, 1998

† John Harley Warner & James M. Edmonson, *Dissection: Photographs of a Rite of Passage in American Medicine: 1880–1930*, Blast Books, 2010

† Marina Warner, *Phantasmagoria: Spirit Visions, Metaphors and Media*, Oxford University Press, 2006

† Carl Watkins, *The Undiscovered Country: Journeys Amongst the Dead*, The Bodley Head, 2013

† Jeffrey Weeks, *Sex, Politics and Society: The Regulation of Sexuality Since 1800*, Longman, 1989

† Mick Worboys, *Spreading Germs: Disease Theories and Medical Practice in Britain, 1865–1900*, Cambridge University Press, 2000

WEBSITES

† Brought to Life: Exploring the History of Medicine www.sciencemuseum.org.uk/broughttolife.aspx

† Dream Anatomy www.nlm.nih.gov/dreamanatomy

† The Last Tuesday Society www.thelasttuesdaysociety.org

† London's Museums of Health and Medicine www.medicalmuseums.org

† Making Visible Embryos www.hps.cam.ac.uk/visibleembryos

† *Medical History: An International Journal for the History of Medicine and Related Sciences* journals.cambridge.org/action/displayJournal?jid=MDH

† Morbid Anatomy: Surveying the Interstices of Art and Medicine, Death and Culture morbidanatomy.blogspot.co.uk

† National Library of Medicine www.nlm.nih.gov

† Wellcome Images wellcomeimages.org

† Wellcome Trust www.wellcome.ac.uk

† The Wildgoose Memorial Library www.janewildgoose.co.uk

PLACES OF INTEREST

† Anatomy Museum at the University of Glasgow, University Avenue, Glasgow G12 8QQ, UK www.gla.ac.uk/schools/lifesciences/aboutus/themuseumofanatomy

† Barts Pathology Museum, Third floor, Robin Brook Centre, St Bartholomew's Hospital, West Smithfield, London EC1A 7BE, UK www.smd.qmul.ac.uk/about/pathologymuseum

† Berliner Medizinhistorisches Museum der Charité, Charitéplatz 1, D 10117 Berlin, Germany www.bmm-charite.de

† Deutsches Hygiene-Museum, Lingnerplatz 1, 01069 Dresden, Germany. www.dhmd.de

† Dittrick Medical History Center, Allen Memorial Medical Library, 11000 Euclid Ave, Cleveland, OH 44106-1714, USA. www.case.edu/artsci/dittrick/museum

† Florence Nightingale Museum, St Thomas's Hospital, 2 Lambeth Palace Road, London SE1 7EW, UK www.florence-nightingale.co.uk

† Hunterian Museum at the Royal College of Surgeons, 35-43 Lincoln's Inn Fields, London WC2A 3PE, UK www.rcseng.ac.uk/museums/hunterian

† Museum Boerhaave, Lange Sint Angietenstraat 10, 2312 WC Leiden, Netherlands www.museumboerhaave.nl

† Museo di Storia Naturale la Specola, Via Romana 17, 50125 Florence, Italy. www.msn.unifi.it

† Museum Vrolik, Academic Medical Center, Meibergdreef 15, J0–130, 1105 AZ Amsterdam, Netherlands. www.amc.nl/web/AMC-website/Museum-Vrolik-EN/Museum-Vrolik.htm

† Mütter Museum of the College of Physicians of Philadelphia, 19 South 22nd Street, Philadelphia, PA 19103, USA www.collegeofphysicians.org/mutter-museum

† National Museum of Health and Medicine, 2500 Linden Lane, Silver Spring, MD 20910, USA www.medicalmuseum.mil

† Old Operating Theatre and Herb Garret, 9A St Thomas's Street, London SE1 9RY, UK www.thegarret.org.uk

† Science Museum, Exhibition Road, London SW7 2DD, UK. www.sciencemuseum.org.uk

† Surgeon's Hall Museums, Nicolson Street, Edinburgh, EH8 9DW, UK www.museum.rcsed.ac.uk

† Thackray Medical Museum, Beckett Street, Leeds LS9 7LN, UK www.thackraymedicalmuseum.co.uk

† University of Edinburgh Anatomical Museum, Doorway 3, Medical School, Teviot Place, Edinburgh EH8 9AG, UK www.anatomy.mvm.ed.ac.uk/museum/index.php

† Wellcome Collection, 183 Euston Road, London NW1 2BE, UK. www.wellcomecollection.org

† Wellcome Library, 183 Euston Road, London NW1 2BE, UK. wellcomelibrary.org

OPPOSITE | Psoriasis of the feet. | INTRODUCTORY ILLUSTRATIONS TO CHAPTERS | 42 | Disseminated psoriasis affecting the torso, arm and hand. | 72 | The head of an elderly man suffering from leprosy. | 94 | Cowpox vesicles on the teats of a cow. | 110 | Ulcerated tuberculosis of the lung, with a pulmonary arterial aneurysm in the lower lobe. | 128 | The appearance of the intestines, serosa and mesentery in a case of 'Asiatic cholera'. | 144 | Disseminated metastatic melanosarcoma in the brain. | 164 | A heart, removed at autopsy and dissected for signs of disease. | 180 | A skin rash associated with the second stage of syphilis infection. | 214 | Microscopic images of the malaria parasite, *Plasmodium falciparum*, in various stages of its life cycle. | 232 | Examples of diseased joints caused by gout.

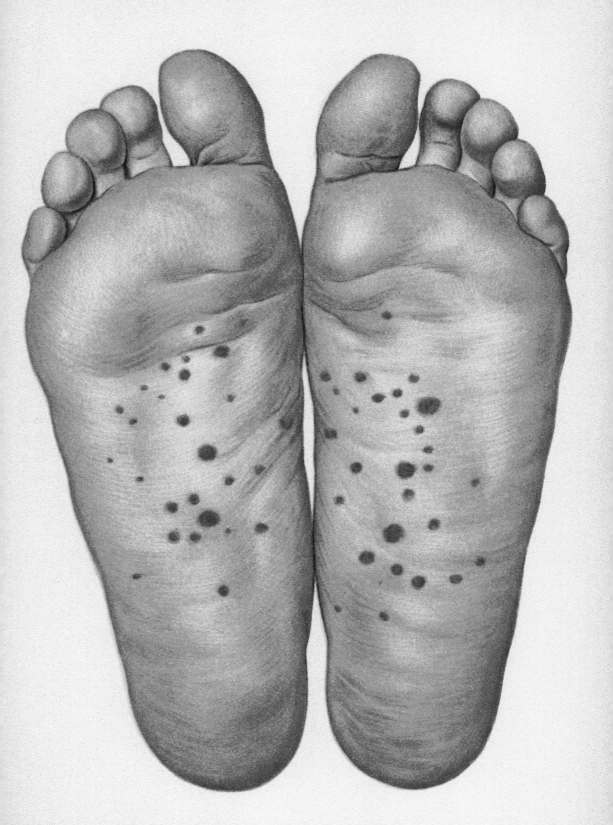

Tab. 30.

SOURCES OF ILLUSTRATIONS

All images courtesy Wellcome Library, London, unless stated otherwise.

Association...for the promotion of social and salutiferous improvements, street cleanliness; and the employment of the poor, London, 1850. p. 135 t | R | John Ring, A treatise on the cow-pox; containing the history of vaccine inoculation, London, 1801–3, p. 101 | John Snow, On the mode of communication of cholera, London, 1855. p. 135 b | S | Dr John Sutherland, Report of the General Board of Health on the epidemic cholera of 1848 and 1849, London, 1850. p. 133 t | T | Friedrich Tiedemann, Tabulae arteriarum corporis humani, Karlsruhe, 1822. p. 39 | George Thin, Leprosy, London, 1891. p. 77 t | V | Andreas Vesalius, De humani corporis fabrica libri septem, 1555. p. 25 t | W | Robert Willis, Illustrations of cutaneous disease, London, 1839–41. pp. 60–61, pp. 192–93 | E. Wilson, The Journal of Hygiene, Cambridge, 1901. p. 221

PAINTINGS AND PRINTS | B | Batelli after Ferdinando Ferrari, Several examples of diseased joints (gout), numbered for key, c. 1843. Coloured lithograph. 36 × 23.7 cm (14⅛ × 9⅜ in.). p. 232 | Edwin Buckman, 'The District Vaccinator – A Sketch at the East-End'. The Graphic, London, 8 April 1871. Wood engraving [dimensions unknown]. p. 99 | W. Bagg, [The head of a boy with a skin disease of the scalp], 1847. Coloured lithograph, 29.7 × 21.9 cm (11¾ × 8 ⅝ in.). p. 231 t | W. Bagg, [The head of a boy with a skin disease of the scalp], 1847. Coloured lithograph, 29.7 × 19.2 cm (11¾ × 7½ in.). p. 231 b | Isaac Basire, [The course of the veins and the arteries through the body], 1743. Etching, 30.3 × 39.8 cm (11⅞ × 15⅝ in.). p. 169 t | Ernest Board, [Patrick Manson experimenting with filaria sanguinis-hominis on a human subject in China], c. 1912. 60.3 × 91 cm (23¾ × 35⅞ in.) p. 218 r | E. Burgess, [Diseased kidneys: five examples], 1877–99. Chromolithograph, 36.1 × 25.5 cm (14¼ × 10 in.) p. 154 tl, l, c | E. Burgess, [Rupia psoriatic lesions on the body of an individual suffering from hereditary syphilis], 1850/1880. Chromolithograph. pp. 16–17 | E. Burgess, [Diseased organs: five examples], 1877–99. Chromolithograph, 35.9 × 26.3 cm (14⅛ × 10⅜ in.) p. 154 tc | E. Burgess, [Diseased organs: eight examples], 1877–99. Chromolithograph, 35.9 × 26 cm (14⅛ × 10¼ in.). p. 154 tr, r, bl, bc, br | R. Casas, [An advert for Dr Abreu's sanatorium for syphilitics in Barcelona], 1900. Colour lithograph, 66.3 × 28.2 cm (26⅛ × 11⅛ in.). p. 187 | C | Gabriele Castagnola, The Palermo Cholera Epidemic of 1835, 1835. Lithograph, 14.3 × 22.7 cm (5⅝ × 9 in.). p. 132 bl | Richard Tennant Cooper, [A female invalid on a balcony; accompanied by Death, representing tuberculosis]. Watercolour, 41.7 × 45.5 cm (16⅜ × 17⅞ in.). p. 114 | Richard Tennant Cooper, Syphilis, 1912. Gouache, 52 × 70.5 cm (20½ × 27¾ in.). p. 184 t | Richard Tennant Cooper, [A nude woman lying on a bed, with Death at her side]. Watercolour drawing [dimensions unknown]. p. 185 | George Cruikshank, Introduction of the Gout, 1818. Coloured lithograph, 20.9 × 32.8 cm (8¼ × 12⅞ in.). p. 236 t | D | Christopher D'Alton, [Back and buttocks of a woman suffering from a skin disease], 1850. Watercolour, 45.6 × 36.3 cm (18 × 14¼ in). p. 46 bl | Christopher D'Alton, [Severe pustule crustaceous lesions on the head of a man suffering from syphilis], 1855. Pencil, chalk and watercolour drawing, 35.2 × 26.5 cm (13⅞ × 10½ in.). p. 199 | Christopher D'Alton, [Head of a woman with a severe disease affecting her face], 1850. Watercolour, 32.9 × 23.9 cm (13 × 9⅜ in.). p. 46 br | Behari Lal Das, [Patient treated in the 1st Physician Ward, Medical College, Calcutta, India, illustrating ichthyosis hystrix of unusual extent], 1906. Watercolour and ink, 38.7 × 28.8 cm (15¼ × 11⅜ in.). pp. 56–57 | William Alfred Delamotte, [Diffused and spotted pulmonary apoplexy in a tubercular lung], 1841–51. Watercolour and ink drawing, 26.3 × 31.4 cm (10⅜ × 12⅜ in.). p. 126 b | William Alfred Delamotte, [Tubercular deposits on the spleen of a eight-year-old boy], 1841–51. Watercolour drawing, 19.4 × 19.7 cm (7⅝ × 7¾ in.). p. 127 bl | Alice Dick Dumas, [Childhood mortality: interior of a nursery with eight babies, watched by Death], c. 1918. Colour lithograph, 86 × 122.3 cm (33⅞ × 48⅛ in.). p. 115 t | G | James Gillray, Un Petit Souper a la Parisienne - or - A Family of Sans-Culottes Refreshing after the Fatigues of the Day, 1792. Hand-coloured etching, 28.7 cm × 36.2 cm (11¼ in × 14¼ in.). © Courtesy of the Warden and Scholars of New College, Oxford. Photo courtesy The Bridgeman Art Library. p. 26 | James Gillray, The Cow-Pock - or - the Wonderful Effects of the New Inoculation!, 1802. Coloured etching, 24.8 × 34.9 cm (9¾ × 13¾ in.). p. 99 | James Gillray, The Gout, 1799. Coloured soft-ground etching, 25.6 × 35 cm (10⅛ × 13¾ in.). p. 237 t | Thomas Godart, [Part of a lung, showing pulmonary tissue condensed and indurated around tubercular deposits and resulting cavities], 1858. Watercolour drawing, 20.1 × 12.7 cm (7⅞ × 5 in.). St Bartholomew's Hospital Archives and Museum. p. 126 t | Thomas Godart, [A tubercular cavity of a lung, from a vessel in the wall of which a fatal haemorrhage occurred], 1861–62. Watercolour drawing, 14 × 18 cm (5½ × 7⅛ in.). St Bartholomew's Hospital Archives and Museum. p. 127 br | Thomas Godart, [Miliary tuberculosis of the lung of a child], 1855. Watercolour drawing, 18.3 × 10.7 cm (7¼ × 4¼ in.) St Bartholomew's Hospital Archives and Museum. p. 127 t | Thomas Godart, [The left eye of a woman, showing the growth of a

melanotic sarcoma], 1884. Watercolour drawing, 23.8 × 16.5 cm (9⅜ × 6½ in.). St Bartholomew's Hospital Archives and Museum. **p. 148 t** | Thomas Godart, [A hand showing a melanotic sarcoma of the middle finger], 1882. Watercolour drawing, 33.6 × 23.8 cm (13¼ × 9⅜ in.). St Bartholomew's Hospital Archives and Museum. **p. 148 b** Thomas Godart, [The face of a man showing a recurrent epitheliomatous tumour of the upper lip], 1881. Watercolour drawing, 24.1 × 33.4 cm (9½ × 13⅛ in.). St Bartholomew's Hospital Archives and Museum. **p. 149** | Thomas Godart, [Hypertrophy of the left half of the tongue of a man suffering from cancer], 1885. Watercolour drawing, 14.1 × 16.8 cm (5½ × 6⅝ in.). St Bartholomew's Hospital Archives and Museum. **p. 162 tl** | Thomas Godart, [The tongue of a child, with a small recurrent papillary growth], 1886. Watercolour drawing, 15.6 × 22.5 cm (6⅛ × 8⅞ in.). St Bartholomew's Hospital Archives and Museum. **p. 162 tr** | Thomas Godart, [A soft, round-celled sarcomatous tumour springing from the angle of the mouth and inside the cheek], 1875–82. Watercolour drawing, 15.1 × 21.8 cm (6 × 8⅝ in.). St Bartholomew's Hospital Archives and Museum. **p. 162 bl** | Thomas Godart, [A case of cancer of the tongue], 1884. Watercolour drawing, 19 × 27.9 cm (7½ × 11 in.). St Bartholomew's Hospital Archives and Museum. **p. 163 tl** | Thomas Godart, [A small recurrent papillary growth on the tongue of a child], 1886. Watercolour drawing, 15.8 × 22.3 cm (6¼ × 8¾ in.). St Bartholomew's Hospital Archives and Museum. **p. 163 tr** | Thomas Godart, [A congential pedunculated tumour on the tongue], 1887. Watercolour drawing, 16.7 × 23.8 cm (6⅝ × 9⅜ in.). St Bartholomew's Hospital Archives and Museum. **p. 163 bl** | Thomas Godart, [A ball of fibrin found in the left auricle of the heart], 1871. Watercolour drawing, 33.5 × 25.6 cm (13¼ × 10⅛ in.). St Bartholomew's Hospital Archives and Museum. **p. 176 t** | Thomas Godart, [A heart], 1862–75. Watercolour drawing, 33 × 22.7 cm (13 × 8⅞ in.). St Bartholomew's Hospital Archives and Museum. **p. 176 b** | Thomas Godart, [Watercolour drawing of the left ventricle and aorta], 1868. Watercolour drawing, 21.2 × 26.3 cm (8⅜ × 10⅜ in.). St Bartholomew's Hospital Archives and Museum. **p. 177 tl** | Thomas Godart, [A heart with the right auricle and ventricle covered with ecchymoses], 1868. Watercolour drawing, 24.5 × 30.2 cm (9⅝ × 11⅞ in.). St Bartholomew's Hospital Archives and Museum. **p. 177 tr** | Thomas Godart, [Purpuric ecchymoses on the surface of the heart], 1841–51. Watercolour drawing, 23.2 × 27.1 cm (9⅛ × 10⅝ in.). St Bartholomew's Hospital Archives and Museum. **p. 177 bl** Thomas Godart, [The ulceration of, with vegetations on, the posterior cusp of the heart's mitral valve], 1866. Watercolour drawing, 20.2 × 25.2 cm (8 × 9⅞ in.). St Bartholomew's Hospital Archives and Museum. **p. 177 br** | Thomas Godart, [Deep fissures and disfigurement produced by tertiary syphilis in a woman], 1884. Watercolour drawing, 13.2 × 18.6 cm (5¼ × 7⅜ in.). St Bartholomew's Hospital Archives and Museum. **p. 208 br** Thomas Godart, [A tongue, from a case of congenital syphilis occurring in a boy, aged seven years], 1887. Watercolour drawing, 15.6 × 19.8 cm (6⅛ × 7¾ in.). St Bartholomew's Hospital Archives and Museum. **p. 208 tl** | Thomas Godart, [A tongue, the left half of which is occupied by a warty papillated growth], 1883. Watercolour drawing, 13.5 × 22.3 cm (5¼ × 8¾ in.). St Bartholomew's Hospital Archives and Museum. **p. 209 tl** | Thomas Godart, [The fissured tongue of a man with tertiary syphilis], 1885. Watercolour drawing, 13.4 × 18.2 cm (5¼ × 7⅛ in.). St Bartholomew's Hospital Archives and Museum. **p. 209 tr** | Thomas Godart, [The indented tongue of a woman, aged sixty], 1883. Watercolour drawing, 13.8 × 18.7 cm (5⅜ × 7⅜ in.). St Bartholomew's Hospital Archives and Museum. **p. 209 br** | Thomas Godart, [A raw and excoriated tongue], 1884. Watercolour drawing, 13.5 × 16.8 cm (5¼ × 6⅝ in.). St Bartholomew's Hospital Archives and Museum. **p. 210 br** | Thomas Godart, [The mouth of a gouty patient], 1883. Watercolour drawing, 22.2 × 29.5 cm (8¾ × 11⅝ in.). St Bartholomew's Hospital Archives and Museum. **pp. 242–43** | Mabel Green, [Diseased foot], from the series *Patients and diseases. Paintings commissioned by Sir Jonathan Hutchinson, ca. 1891-1906*, 1906. Watercolour, 26.6 × 36.7 cm (10½ × 14½ in.). **pp. 14–15** | W. Gummelt, [Trichinosis infection in biceps], 1897. Chromolithograph, [dimensions unknown]. **p. 218 tl** | **H** | Hendrik F. Heerschop. [A physician examining a urine flask brought by a young woman], c. 1800s. Oil on canvas, 45.5 × 55.2 cm (17⅞ × 21¾ in.). **p. 22** | **L** | Charles Landseer, *Lateral view of the trunk of a flayed corpse*, 1815. Chalk on paper, 48.5 × 71.2 cm (19⅛ × 28 in.). **p. 28** | Mondino dei Luzzi, [A man seated in a chair, holding an open book and directing a dissection] c. 1493. Line block after a woodcut. 14.4 × 8.9 cm (5⅝ × 3½ in.). **p. 23** | **M** | Joseph Maclise, [Dissection of muscles and blood-vessels of the shoulder and arm], 1851. Coloured lithograph, 54.5 × 37.7 cm (21⅜ × 14⅞ in.). **p. 29 b** | Joseph Maclise, [Dissection of the trunk of a seated man, showing major blood-vessels], 1851. Coloured lithograph, 54.5 × 37.7 cm (21½ × 14⅞ in.). **p. 38** | Leonard Portal Mark, [Large tophi on the left hand of a woman suffering from chronic gout]. Watercolour drawing, 16.6 × 20.5 cm (6½ × 8⅛ in.). St Bartholomew's Hospital Archives and Museum. **p. 240** | Leonard Portal Mark, [Large tophi on the right hand of a woman suffering from chronic gout]. Watercolour drawing, 24.3 × 16.2 cm (9⅝ × 8⅛ in.).

St Bartholomew's Hospital Archives and Museum. **p. 241** | Leonard Portal Mark, [A tumour growing from the palate of a young woman], 1894. Watercolour drawing, 12.3 × 13.4 cm ($4\frac{7}{8}$ × $8\frac{1}{8}$ in.). St Bartholomew's Hospital Archives and Museum. **p. 162 br** Leonard Portal Mark, [The tongue of a boy suffering from congenital syphilis], 1890. Watercolour drawing, 14.8 × 16.9 cm ($5\frac{7}{8}$ × $6\frac{5}{8}$ in.). St Bartholomew's Hospital Archives and Museum. **p. 208 tr** | Leonard Portal Mark, [A tongue with fissured edges], 1892. Watercolour drawing, 11.3 × 15.7 cm ($4\frac{1}{2}$ × $6\frac{1}{4}$ in.). St Bartholomew's Hospital Archives and Museum. **p. 208 bl** | Leonard Portal Mark, [Hemiatrophy and hemiplegia of the left side of the tongue], 1889–90. Watercolour drawing, 16.3 × 14 cm ($6\frac{3}{8}$ × $5\frac{1}{2}$ in.). St Bartholomew's Hospital Archives and Museum. **p. 163 br** | Franz Mracek, [Ringworm, caused by a fungal infection], 1905. Chromolithograph, [dimensions unknown]. **p. 230** | **N** | Matthijs Naiveu, [A female patient, seated, whilst one physician takes her pulse and another bleeds her foot] *c.* 1700. Oil on wood, 33.2 × 40.7 cm ($13\frac{1}{8}$ × 16 in.). **p. 21** | **P** | J. Pass, [A cow's udder with vaccinia pustules and human arms exhibiting both smallpox and cowpox pustules], 1811. Coloured engraving, 26.4 × 20.2 cm ($10\frac{3}{8}$ × 8 in.). **p. 94** R. Perrette, [Anatomical dissection of the abdomen of a cadaver], 1904. Aquatint, 31.3 × 37.6 cm ($10\frac{1}{4}$ × $14\frac{3}{4}$ in.). **p. 29 t** | **Q** | Lam Qua, [A man with a large pendent tumour hanging from his hip], 1837. 50.7 × 26.3 cm (20 × $10\frac{3}{8}$ in.). **p. 158** | Lam Qua, [A Chinese man with a pendent tumour developed and hanging below his left ear], 19th century. Gouache, 52 × 30 cm ($20\frac{1}{2}$ × $11\frac{3}{4}$ in.). **p. 159** | Lam Qua, [A man with a massive spherical tumour on his neck], *c.* 1838. Gouache, 52 × 35.7 cm ($20\frac{1}{2}$ × 14 in.). **p. 160 tl** | Lam Qua, [A woman with tumours on her forehead and under her left ear], 1838. Gouache, 52 × 36 cm ($20\frac{1}{2}$ × $14\frac{1}{8}$ in.). **p. 160 tr** | Lam Qua, [A woman with a large tumour covering her left eye], *c.* 1838. Gouache, 52 × 36.2 cm ($20\frac{1}{2}$ × $14\frac{1}{4}$ in.). **p. 160 bl** | Lam Qua, [A man with a tumour on the left side of his trunk], *c.* 1837. Gouache, 52 × 30 cm ($20\frac{1}{2}$ × $11\frac{3}{4}$ in.). **p. 160 br** | Lam Qua, [A man with a tumour below and behind his right ear], 1830s. Gouache, 52 × 35.7 cm ($20\frac{1}{2}$ × 14 in.). **p. 161 tl** | Lam Qua, [A woman with a large pendent tumour], 1830-1850. Gouache, 51.8 × 33.3 cm ($20\frac{3}{8}$ × $13\frac{1}{8}$ in.). **p. 161 tr** | Lam Qua, [A seated man from Canton (Guangzhou) with a large tumour on his left arm], *c.* 1836. Gouache, 52 × 30 cm ($20\frac{1}{2}$ × $11\frac{3}{4}$ in.). **p. 161 bl** | Lam Qua, [A man with large pendent tumours on the left side of his face], 1838. Gouache, 52 × 35.6 cm ($20\frac{1}{2}$ × 14 in.). **p. 161 br** | **S** | Enrique Simonet Lombardo, *Anatomy of the heart; And she had a heart!; Autopsy*, 1890. Oil on canvas, 176.5 × 292 cm ($69\frac{1}{2}$ × 115 in.). **p. 20** | Robert Blemmel Schnebbelie, *A lecture at the Hunterian Anatomy School, Great Windmill Street, London*, 1830. Watercolour, 22.8 × 29.3 cm (9 × $11\frac{1}{2}$ in.). **p. 30** | Algernon Francis Stevens, [A uratic deposit in the conjunctival membrane as a result of chronic gout], n. d. Watercolour drawing, 8.1 × 12.8 cm ($3\frac{1}{8}$ × 5 in.). St Bartholomew's Hospital Archives and Museum. **p. 239** | Robert Strüdel, [An advert for an exhibition against tuberculosis in Basel], 1913. Lithograph, 109 × 80.2 cm ($42\frac{7}{8}$ × $31\frac{5}{8}$ in.). **p. 115 b** | **T** | Amedeo John Engel Terzi, *Bacilllus pestis*, *c.* 1900. Coloured drawing, 57.5 × 44.8 cm ($22\frac{5}{8}$ × $17\frac{5}{8}$ in.). **p. 222 tl** | Amedeo John Engel Terzi, *A. luteola c.* 1900. Coloured drawing, 52 × 41.8 cm ($20\frac{1}{2}$ × $16\frac{1}{2}$ in.). **p. 222 tr** | Amedeo John Engel Terzi, *Chrysomyia macellaria*, *c.* 1900. Coloured drawing, 52 × 42 cm ($20\frac{1}{2}$ × $16\frac{1}{2}$ in.). **p. 222 l** | Amedeo John Engel Terzi, *Dermatobia noxialis c.* 1900. Coloured drawing, 52 × 42 cm ($20\frac{1}{2}$ × $16\frac{1}{2}$ in.). **p. 222 r** | Amedeo John Engel Terzi, *Hypoderma bovis*, *c.* 1900. Coloured drawing, 52 × 42 cm ($20\frac{1}{2}$ × $16\frac{1}{2}$ in.). **p. 222 bl** | Amedeo John Engel Terzi, *Lucillia caesar*, *c.* 1900. Coloured drawing, 52 × 42 cm ($20\frac{1}{2}$ × $16\frac{1}{2}$ in.). **p. 222 br** | S. Tresca after G. Moreau-Valvile, [The head of a woman with a skin disease on her face and neck]. *c.* 1806 Coloured stipple engraving. 27.3 × 22.1 cm ($10\frac{3}{4}$ × $8\frac{3}{4}$ in.). **p. 80** | S. Tresca after G. Moreau-Valvile, [A head of a man with a skin disease on his face], *c.* 1806. Coloured stipple engraving. 27.9 × 22.6 cm (11 × $8\frac{7}{8}$ in.). **p. 81** | **U** | Hans Caspar Ulrich, [A girl with tuberculosis appealing for funds for a sanatorium], 1905. Lithograph, 89.8 × 59.7 cm ($35\frac{3}{8}$ × $23\frac{1}{2}$ in.). **p. 117** | Unknown, [Head of a Child], 1892. Watercolour, 31.7 × 22 cm ($12\frac{1}{2}$ × $8\frac{5}{8}$ in.). **p. 2** | Unknown, *Origin of the Vaccine*, *c.* 1800. Coloured etching, 16.1 × 24 cm ($6\frac{3}{8}$ × $9\frac{1}{2}$ in.). **p. 98** | Unknown, *John Bull Catching the Cholera*, *c.* 1832. Coloured lithograph, 25 × 19 cm ($9\frac{7}{8}$ × $7\frac{1}{2}$ in.). **p. 132 br** Unknown, *Picturesque Group*. 1816. Etching, 9 × 15.2 cm ($3\frac{1}{2}$ × 6 in.). **p. 218 tr** | Unknown, [A Viennese woman, aged 23, depicted before and after contracting cholera]. Coloured stipple engraving, [dimensions unknown]. **pp. 136–37** Unknown, [A man suffering from 'rodent disease'], 1829. Watercolour drawing, 56.5 × 43.5 cm ($22\frac{1}{4}$ × $17\frac{1}{8}$ in.). **p. 151**. **W** | Antoine Joseph Wiertz, *L'Inhumation précipitée*, 1854. Photograph after painting, 20.5 × 29 cm ($8\frac{1}{8}$ × $11\frac{3}{8}$ in.). **p. 132** | John Guise Westmacott, [A woman suffering from cancer of the left breast], 1852. Watercolour drawing, 22.4 × 34.2 cm ($8\frac{7}{8}$ × $13\frac{1}{2}$ in.). St Bartholomew's Hospital Archives and Museum. **p. 152** | John Guise Westmacott, [A woman suffering from cancer whose left breast has necrosed and ulcerated, leaving her rib cage exposed], 1852. Watercolour drawing, 22.3 × 34.3 cm ($8\frac{3}{4}$ × $13\frac{1}{2}$ in.). St Bartholomew's Hospital Archives and Museum. **p. 153**

INDEX

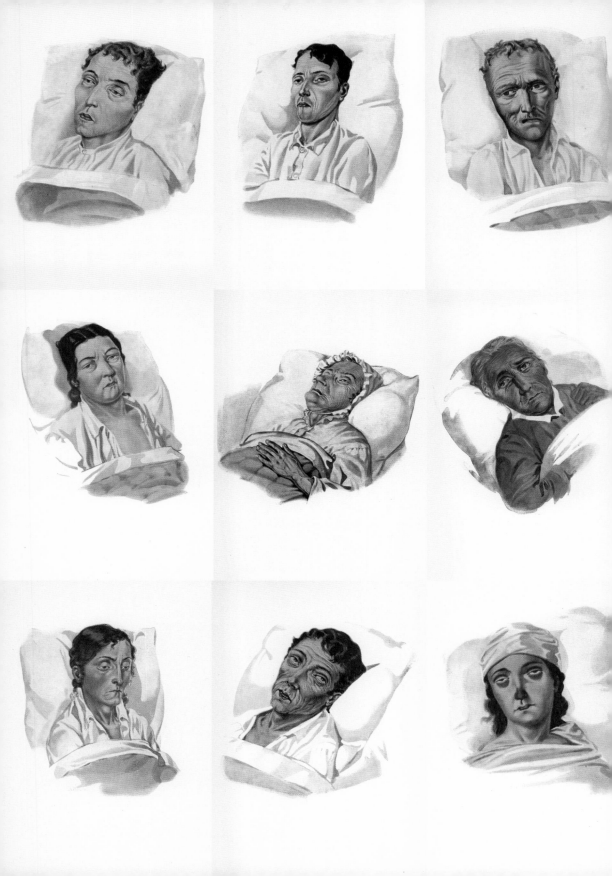

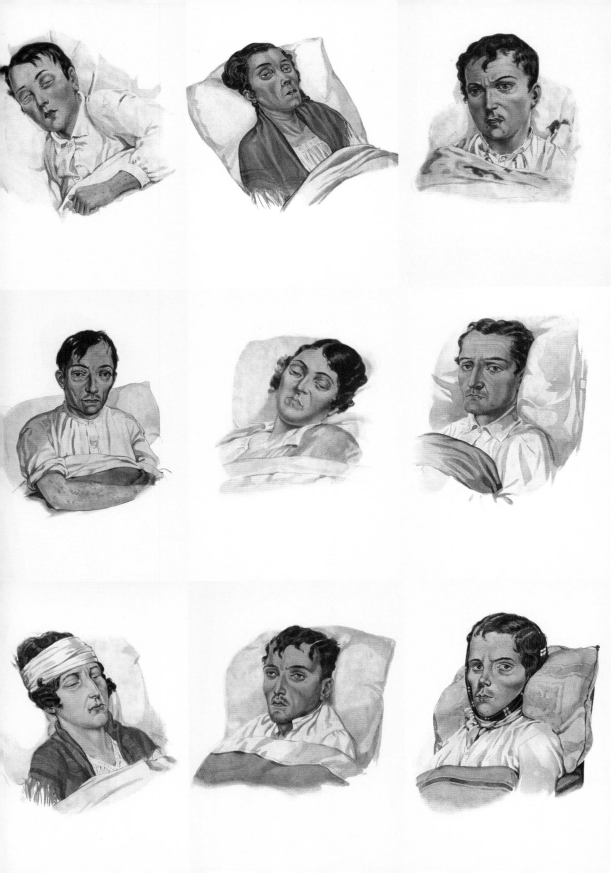

ACKNOWLEDGMENTS

For their manifold and generous professional contributions, many thanks to Tristan de Lancey and Jon Crabb at Thames & Hudson; Alex Goodwin and Peter Robinson at Rogers, Coleridge & White; Simon Chaplin, Phoebe Harkins and Ross MacFarlane at the Wellcome Library; Catherine Draycott, Venita Bryant and Crestina Forcina at Wellcome Images; Ken Arnold and Kirty Topiwala at Wellcome Collection; Nils Fietje, Lisa Lazareck, Clare Matterson and Tom Ziessen at the Wellcome Trust. Once again I am grateful to the Wellcome Trust for their continued support, in the form of an Engagement Fellowship.

For friendship, patience and personal contributions, heartfelt thanks to Rachael Black, Paul Craddock, Joanna Ebenstein, David Feller, Alice Ford-Smith, Patricia Hammond, Theresia Hofer, Dan Kaszeta, Roger Kneebone, Allison Ksiazkiewicz, Anna Maerker, Michael Neve, Mark Pilkington, Lauren Sapikowski, Kelley Swain, Thea Vidnes, Rebecca Wright and Caitlin Wylie. Particular thanks to Kelley, Michael and Ross for their comments on early drafts of the manuscript, and to my colleagues and students on the 2013 Pembroke-King's Programme in Cambridge for providing a congenial setting in which to write.

PREVIOUS PAGE
Various diseases, from
Karl Heinrich Baumgartner's
Kranken-Physiognomik,
first published in 1859.